709. 04 DON

DON'T LEAVE ME THIS WAY
ART IN THE AGE OF AIDS

UNIVERSITY OF WESTMINSTER

Failure to return or renew overdue books may result in suspension of
borrowing rights at all University of Westminster libraries.

Due for return on:		
15/12/95	2 6 NOV 2001	
	1 4 MAY 2002	
2 5 JAN 1996	- 8 FEB 2005	
2 5 OCT 1996		
1 4 APR 1997		
2 0 MAY 1997		
3 0 MAR 1998		
- 1 DEC 1999		
JAN 2000		

ource Services **Harrow Camp**
Northwick Park Harrow HA1 3T
911 5000 ext 4046 (Main) e:

D1355060

Don't Leave Me This Way

ART IN THE AGE OF AIDS

Compiled by
Ted Gott

NATIONAL GALLERY OF AUSTRALIA
Distributed by Thames & Hudson, Melbourne, London and New York

INFORMATION RESOURCE SERVICES
UNIVERSITY OF WESTMINSTER
HARROW IRS CENTRE
WATFORD ROAD
NORTHWICK PARK
HARROW HA1 3TP

© National Gallery of Australia, Canberra, ACT 2600, 1994

All rights reserved. No part of this publication may be reproduced or transmitted in any form or by any means, electronic or mechanical, including photocopy, recording, or any information storage and retrieval system, without permission in writing from the publisher.

Every effort has been made to contact persons owning copyright in the works of art reproduced in this catalogue. However, in cases where this has not been possible, owners are invited to notify the Publications Department of the National Gallery of Australia as soon as possible.

National Library of Australia Cataloguing-in-publication data

Don't leave me this way : art in the age of AIDS.

Bibliography.
ISBN 0 642 13030 2.

1.AIDS (Disease) and the arts — Exhibitions. 2.Arts, Modern — 20th century — Exhibitions. 3.AIDS (Disease) — Literary collections. 4.AIDS (Disease) — Patients — Literary collections. 5.HIV infections — Literary collections. 6.HIV infections — Patients — Literary collections. I.Gott,Ted, 1960- . II.National Gallery of Australia.

704.9493621969792

Edited, designed and produced by the
Publications Department of the National Gallery of Australia, Canberra
Printed by The Craftsman Press, Melbourne

Distributed by:
Thames and Hudson (Australia) Pty Ltd, 11 Central Boulevard, Portside Business Park, Port Melbourne, Victoria 3207, Australia
Thames and Hudson Ltd, 30–34 Bloomsbury Street, London WC1B 8QP, UK
Thames and Hudson Inc, 500 Fifth Avenue, New York NY 10110, USA

(front cover)
Nayland Blake, United States, *Don't Leave Me This Way*, 1989, bus shelter poster, originally commissioned by the American Foundation for AIDS Research (AmFAR). Courtesy of the artist and AmFAR.
(back cover)
Jamie Dunbar, Australia, *Taking Centre Stage. Protester holding white carnation — from ACT UP's mound of white carnations representing Australians who had died of AIDS, fifth national conference on HIV/AIDS, Sydney, November 1992.* 1992, gelatin silver photograph. Courtesy of the artist.

Contents

Sponsor's Statement — *vi*
Director's Foreword — *vii*
Introduction — *viii*

Agony Down Under: Australian Artists Addressing AIDS
Ted Gott — 1

Allan from *Sadness*. A Monologue with Slides
William Yang — 34

Art from the Pit: Some Reflections on Monuments, Memory and AIDS
Simon Watney — 52

America: Where Angels Don't Fear To Tread
Thomas Sokolowski — 63

The War on Culture
Afterword: The War on Culture Continues, 1989—94
Carole S. Vance — 91

Read My Lips
Jimmy Somerville — 112

For a Friend
Jimmy Somerville/Richard Coles — 113

Self-Documentation, Self-Imaging: Australian People Living with HIV/AIDS
Kathy Triffitt, co-ordinator — 114

Aesthetics and Loss
Edmund White — 131

Psycho-Cultural Responses to AIDS
Dennis Altman — 139

Faces of AIDS
Lynn Sloan — 175

Lovers and Friends
Richard Coles — 185

Where the Streets Have New Aims: The Poster in the Age of AIDS
Ted Gott — 187

OI: Opportunistic Identification, Open Identification in PWA Portraiture
Jan Zita Grover — 213

Don't Leave Me This Way: Art in the Age of AIDS — 231
Catalogue of works — 244
Glossary — 245
Acknowledgements

Sponsor's Statement

THE National AIDS Campaign and the National Gallery of Australia joined forces in 1994 to present a major exhibition 'Don't Leave Me This Way: Art in the Age of AIDS' — the largest exhibition on the subject of HIV/AIDS to be staged in Australia, and the first exhibition on this subject to be held at a National Gallery anywhere in the world.

This joint venture reflects the vital role played by the visual arts in fostering education and awareness of the AIDS health crisis. The AIDS epidemic poses an ongoing challenge which no individual, culture or country can ignore. Art is for everyone; and AIDS is every body's business.

The Federal Government's National AIDS Campaign sponsored this exhibition as a means of reaching a wide audience with its safe sex and anti-discrimination messages; and this reflects our recognition of the unique opportunity such vibrant and vital contemporary art can provide for raising awareness about HIV/AIDS education and prevention issues.

This publication was developed independently of the exhibition 'Don't Leave Me This Way: Art in the Age of AIDS'. We are pleased, however, that our sponsorship of the exhibition is raising awareness and generating debate about the complex issues surrounding HIV/AIDS, a discussion that continues in these pages.

Australian National AIDS Campaign of the
Commonwealth Department of Human Services and Health

Director's Foreword

IN writing this preface, I am well aware that many people will feel this is an unusual project for the National Gallery of Australia to undertake — a book and an exhibition on a topic most would rather not think about, much less confront so directly. From my perspective as Director of the National Gallery, 'Don't Leave Me This Way: Art in the Age of AIDS' reflects our commitment, as Australia's premier art institution, to presenting a series of exhibitions and related publications which mirror the collision of contemporary art with the essential fabric of life at the close of our troubled century. This program is designed deliberately to counter the often-held belief that contemporary art is inevitably abstracted and alienated from everyday life. Nothing, surely, could be further from the truth.

For this reason, I am especially pleased that the exhibition 'Don't Leave Me This Way: Art in the Age of AIDS' has been generously sponsored by the Australian National AIDS Campaign, reflecting the Commonwealth Department of Human Services and Health's recognition of the educative significance of the visual arts to the populace at large.

HIV/AIDS is not an easy subject to broach, whatever your personal or political perspective on this catastrophic epidemic. That we have been able to tackle this issue with such widespread support has largely been due to the energy, commitment and sensitivity of Ted Gott, Curator of European Art at the National Gallery, who curated the exhibition and co-ordinated the publication.

This book and the exhibition will challenge and confront our readers and our audiences. The seriousness of this issue demands nothing less.

Betty Churcher
Director
National Gallery of Australia

Introduction

THIS book grew out of an exhibition, also entitled 'Don't Leave Me This Way: Art in the Age of AIDS', mounted at the National Gallery of Australia, Canberra from 12 November 1994 to 5 March 1995. This was not the first exhibition on the subject of HIV/AIDS to be staged in Australia. Among its predecessors, both 'Imaging AIDS' (Australian Centre for Contemporary Art and Linden Gallery, Melbourne, 1989) and '+ Positive: Artists Addressing A.I.D.S.' (Campbelltown City Art Gallery, New South Wales, 1994) helped shape my view of Australia's artistic response to AIDS.

For their immediate and ongoing support of this publication, and its attendant exhibition, I am first and foremost indebted to my Director, Betty Churcher, and Assistant Director (Curatorial), Michael Lloyd. Their recognition of the present and future significance of the artistic response to HIV/AIDS, reflected here, was inspirational, uncompromising and courageous. The scope of this volume reflects the vision of Kevin Munn, Assistant Director (Marketing and Access), who understood the need for frank and forthright discussion of this difficult issue. Alan Froud, Deputy Director, oversaw the entire project in its final, difficult months.

Tragically 'Don't Leave Me This Way: Art in the Age of AIDS', as the largest exhibition of its kind yet unveiled in Australia, reflected the relentless onslaught of HIV/AIDS on the personal, social, moral and political fabric of Western societies. Also tragically, the exhibition and this subsequent publication reveal only a fragment of the extraordinarily gifted and passionate artistic statements being produced, both within Australia and overseas, by artists attempting at once to work through their reactions to the direct and searing impact of AIDS on their own diverse lives *and* create visual statements that will speak to, empower and educate their audiences in the widest sense.

The exhibition, from which this independent publication grew, was sponsored by the National AIDS Campaign, a division of Australia's Commonwealth Department of Human Services and Health. This generous sponsorship

reflected the National AIDS Campaign's recognition of the contribution played by the visual arts in overall AIDS-awareness, community consciousness-raising and specific AIDS education — the critical topics which inform every essay in this volume.

My deepest thanks are offered to all the contributors to this book, and to all the lenders (both acknowledged and those who wished to remain anonymous), artists, artists' estates and dealers whose passion and commitment to the fight against HIV/AIDS is the very life blood of this whole endeavour. The loan of their works, and the granting of permission to reproduce them in this volume, often occasioned renewed grief and deepened loss for all concerned, and deserves the respect of every reader/viewer.

Special acknowledgement is owed to Nayland Blake, who so generously allowed us to use his bus shelter poster *Don't Leave Me This Way*, created in 1989 as part of AmFAR's (American Foundation for AIDS Research) public arts project *On the Road*, for both the title and the leitmotif of our book and exhibition; and to AmFAR for equal permission to utilise this image of such dignity and compassion.

The ideas which shaped this book and exhibition were guided in no small part by the input of four remarkable individuals: in the United States, the sound advice of Thomas Sokolowski; and, in Australia, the constant help of David McDiarmid, Marcus O'Donnell, and Richard Linden. No words can express my gratitude for their generous and often anonymous contributions to the spirit of this endeavour.

Around the world, a myriad of committed people have assisted my every step in organising this project. They are listed at the end of this volume.

HIV/AIDS does affect everybody, everywhere — whether or not they wish to acknowledge this yet. On a very personal level, I would like to dedicate this volume to my own friends and colleagues worldwide who have either succumbed to or are still living with, in their own ways, the daily scourge of HIV/AIDS.

Ted Gott
National Gallery of Australia

Last night it did not seem as if today it would be raining.
Edward Gorey

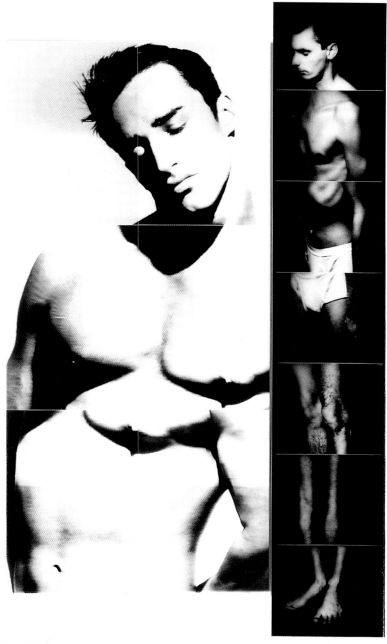

Lex Middleton, Australia, *Gay Beauty Myth* 1992, gelatin silver photographs.
Courtesy of the artist. Photography: Freak Me Productions, Melbourne.

Agony Down Under:
Australian Artists Addressing AIDS

TED GOTT is a Curator of European Art at the National Gallery of Australia, Canberra. He organised the exhibition 'Don't Leave Me This Way: Art in the Age of AIDS', staged at the National Gallery of Australia in 1994.

———

It is hard to open a newspaper in Australia today, listen to a radio broadcast or turn on a television set without encountering some discussion of the 'new' disease AIDS and its causative factor, the HIV virus. In the same fashion, the Australian public now finds its 'entertainment' often engaged in serious debate around issues of illness, prejudice, medical research and death, as HIV/AIDS has come under scrutiny in many forms of Australian cultural response, from theatre and dance, to fiction, poetry, music and soap opera.

To some extent the visual arts were permeated by HIV/AIDS more slowly in this country than in the United States for example; although that situation has definitely changed. There is now a wide range of Australian art dealing with AIDS, as the analysis here amply demonstrates. AIDS does indeed affect everyone in our society; but at the moment in Australia we are seeing predominantly a gay and lesbian artistic response to the epidemic. This is closely related to the current epidemiology of HIV/AIDS in Australia.

At 31 December 1993, Australia had recorded 17,737 cases of HIV infection. Where the cause of transmission was identifiable, 84.2% of cases involved male-to-male sexual contact (including 2.8% involving male-to-male sex *and* recreational intravenous drug use). Of the 4753 Australian people who had progressed to AIDS by the close of 1993 (3212 of whom had died), 83.6% of cases were attributable to male-to-male sexual contact (including 5.7% involving both male-to-male sex and recreational intravenous drug use).[1]

Over 80% of the new HIV diagnoses in Australia still involve male-to-male sexual contact. In the United States, however, where some 339,000 confirmed cases of AIDS had been recorded by the end of 1993, only 55% were attributable to male-to-male sexual transmission (a further 6% were attributable to a combination of male-to-male sex and recreational intravenous drug use), reflecting the manner in which HIV/AIDS has now spread well beyond the borders of the gay population in that country. Given these statistics, it is hardly surprising that the strongest response to the impact of HIV/AIDS in Australia has come from artists who identify as gay or lesbian.

This is not to deny the enormity of the tragedy HIV/AIDS has brought to those infected by medically acquired means (through contaminated blood products or medical procedures), as a result of heterosexual sexual contact or recreational intravenous drug use; and to those infected from birth. Yet it would seem that in Australia heterosexual visual artists on the whole either have not been personally involved with HIV-positive people, or prefer not to address the topic of HIV/AIDS in their work. (These are broad statements. The work of non-gay artists is, of course, also discussed below; and there are numerous Australian gay artists who do not overtly address AIDS in their art.)

Having said this, and while there is still little open discussion of AIDS coming through in the work of non-gay Australian artists, it must be acknowledged that the prevalence of HIV/AIDS in Western society in general is subtly transforming the manner in which art practice currently addresses a whole range of questions. Perhaps it is no longer too sweeping a generalisation to say that any art form dealing with human sexuality today is circumscribed by the intense debates around morality, censorship and 'containment' that have waged across the last AIDS-haunted decade. In a similar way, any artists exploring the themes of death, medicalisation or suffering will inevitably find an AIDS-induced reflectiveness brought to their work by large sections of their audience.

While the predominant discussion in this essay is of gay artists critiquing the social and sexual impact of HIV/AIDS, it would be regrettable if this emphasis were to reinforce the misconception that only gay men are at risk from AIDS. This is clearly not the case, of course; although we are yet to see

such an artistically diverse response in this country (in terms of the sexuality and backgrounds of the artists) as has transformed the art world in the United States, where the devastation of AIDS is so widespread and has permeated into every conceivable corner of the arts.

A number of the artists surveyed here did not wish to be labelled or typecast as 'gay artists', preferring to be identified first as artists, who may also happen to be gay or lesbian. This may reflect their awareness of the marginalised position that art with gay-oriented subject matter continues to hold within mainstream Australian art discourse. The burning energy HIV/AIDS has brought to the work of Australia's gay and lesbian artists is already challenging this outdated stereotype.[2]

The Body in Question

The side effects of DHPG, the drug for which I have come into hospital to be dripped twice a day, are: low white blood cell count, increased risk of infection, low platelet count which may increase the risk of bleeding, low red blood cell count (anaemia), fever, rash, abnormal liver function, chills, swelling of the body (oedema), infections, malaise, irregular heart beat, high blood pressure (hypertension), low blood pressure (hypotension), abnormal thoughts or dreams, loss of balance (ataxia), coma, confusion, dizziness, headache, nervousness, damage to nerves (peristhecia), psychosis, sleepiness (somnolence), shaking, nausea, vomiting, loss of appetite (anorexia), diarrhoea, bleeding from the stomach or intestine (intestinal haemorrhage), abdominal pain, increased number of one type of white blood cell, low blood sugar, shortness of breath, hair loss (alopecia), itching (pruritus), hives, blood in the urine, abnormal kidney function, increased blood urea, redness (inflammation), pain or irritation (phlebitis) ...

If you are concerned about any of the above side-effects or if you would like any further information, please ask your doctor.

In order to be put on the drug you have to sign a piece of paper stating you understand that all these illnesses are a possibility.

I really can't see what I am to do. I am going to sign it.[3]

AIDS, by stripping people of their immune systems, opens up the body to invasion on all fronts. The body becomes a battleground for an ugly war of attrition, as the person affected struggles to fight off one opportunistic infection after another. The body as the site of invasion, or as the defiant battleground in a 'war' of morality versus sexuality, is central to much of the Australian art that is addressing AIDS.

The frank discussion needed to educate the populace in the fight against HIV/AIDS has brought to the foreground 'bodies' that a conservative society would rather not see — gay bodies, lesbian bodies, bisexual bodies, and drug-using bodies. To a great extent these often marginalised groups have rapidly become mainstreamed as debate about HIV/AIDS has entered the 'public' realm of the visual arts.

While the Australian public now knows more than ever before about gay men and their lifestyles, thanks to wave after wave of mostly lurid and voyeuristic press and television reportage in the 1980s, few people have any real consciousness of the searing impact that repeated witnessing of death, anguish and physical suffering has had on Australia's gay communities. This cumulative loss has forced a redefinition of personal identity for many gay men, and has provided ground for thoughtful image-making by a number of Australian artists.

Lex Middleton's *Gay Beauty Myth* 1992 reconsiders Bruce Weber's luscious photography of the naked male body for Calvin Klein's celebrated underwear advertising campaigns of the early 1980s. The proliferation of Weber/Klein glistening pectorals and smouldering body tone across the billboards of the United States was reaching its crescendo at the same time as the gay male 'body' came under threat from a 'new' disease not yet identified as HIV/AIDS. In opposing the rippling musculature and perfect visage of an athlete with the fragmented image of a Calvin Klein Y-fronted 'ordinary' man, Middleton questions the 'gay beauty myth', both as it touches gay men who do not fit the 'look' that advertising has decreed applicable to their sexuality, and from the projected perspective of HIV-positive gay men who face the reality of the daily decay of their bodies.

Andrew Foster's *Untitled* 1992 is also concerned with appearance, perception, deception and self-deception. Gouache portraits of the kind of 'desirable'

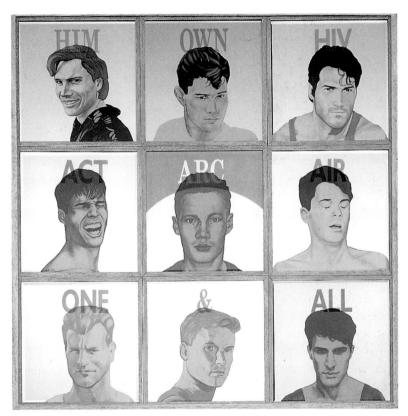

Andrew Foster, Australia, *Untitled* 1992, gouache and ink on paper with sandblasted mirror, nine panels. Courtesy of the artist. Photography: Freak Me Productions, Melbourne.

male familiar from slick advertising imagery are set into mirrored panels, each of which is sand-blasted with a resonant message. (Together the panels spell out the words: Him/Own/HIV/Fire/ARC/Air/One/&/All, which can be read in a number of configurations.) Foster's work critiques the way in which pre-AIDS gay culture to a large extent was defined by its imaging of men as one-dimensional sexual objects. His mirrored installation, in which the viewer's face is reflected back between the painted representations of nine apparently healthy young men, begs the question of how one's sexual antennae will react upon perceiving that these virile 'objects of desire' are in fact infected. Foster asks how a culture formerly built on youth and beauty must now regard itself in the wake of the devastation wrought by AIDS.[4]

The work of Melbourne photographer Peter Lyssiotis stems from a singular perspective — that of a heterosexual man reflecting on the position of gay men in the 1990s. Lyssiotis works in the surrealistic mode of photomontage, which he believes is ideally suited to an artistic engagement with social issues. In his own words, photomontage is 'the pitbull of the Arts world: it's the Dept of Justice, the sliver of glass beneath the nail'.[5]

In preparing his limited edition book *The Harmed Circle* (1992), Lyssiotis turned to the pictorial language of glossy popular magazines with their well-groomed representations of physical and material perfection. Reading the codes underlying the expensive advertisements in these publications, he remarked how consistently they were designed to appeal to gay men, without the magazines ever carrying articles sympathetic to, or revealing any understanding of the community they were cultivating commercially. In *The Harmed Circle*, Lyssiotis chose to work with these same images in a more sympathetic context, by investing them with their true sexuality.

The Harmed Circle (repro. p.79) follows on naturally from Lyssiotis's earlier photographic publications, that looked at migrant workers in Australia, the role of women factory employees, or the victims of racism; it too focuses upon a group of 'outsiders', but in this case it is the gay community whom Lyssiotis perceives to have become the new outsiders in modern society.[6] In essence, *The Harmed Circle* narrates allegorically the fall from grace of a formerly charmed circle, as it descends into a spiralling nexus of eros and thanatos. Death comes within *The Harmed Circle* not in grim-reaper style but hand in hand with love — a passing calmed by beautiful hands that capture for Lyssiotis the dignity he perceives within the besieged gay community in its handling of the AIDS crisis.[7] Fragments of pure poetry ('Billy says that a person's broken heart can sometimes smell of roses') blend with lyrical photomontages to evoke a paeon to the power of a love which transcends death and defeats its ironic power. The sensuality Lyssiotis has brought to the whole production of his book, in which even the paper has been chosen to evoke the feeling of caressing skin as one turns the pages, echoes the sentiment captured so perfectly by Derek Jarman: 'Love is life that lasts forever.'[8]

Brenton Heath-Kerr's creations — part sculpture, part costume — grew out of his involvement with Sydney's enormous gay dance party scene, and his reactions to the narcissistic self-projections of its participants:

The reason I started doing this in the first place was as a reaction against the body culture in the club scene. There are more ways of expressing yourself as being an interesting person than just exposing your muscles. At the same time I wanted to remain as anonymous as I could because it gives me an even greater freedom of expression and peoples' reactions are less controlled.[9]

So successful did he become in the process, that many party-goers recalled vividly his extraordinary outfits (inside which he was completely concealed) without having any idea who Heath-Kerr was; or, if they knew his name, what he looked like in real life. This accorded with Heath-Kerr's belief that 'with my art the whole idea is to create this singular entity so you don't know if I'm black or white. It could be anyone inside it [the costume] and that's the whole thing — it's what's inside that counts.'[10] Few will ever forget their first contact with the 'characters' he invented, such as *Miss Gingham*, unveiled at the 1991 Sleaze Ball, and the *Tom of Finland* which caused a sensation at the 1992 Mardi Gras party.

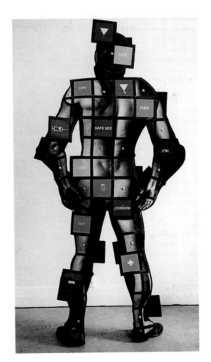

Brenton Heath-Kerr and **Peter Elfes**, Australia, *Ken – The Safe Sex Character* 1992, laminated cibachrome photographs and cloth. Courtesy of People Living With HIV/AIDS Program, Victorian AIDS Council/Gay Men's Health Centre, Melbourne.

Ken — The Safe Sex Character 1992 was conceived in response to a request from the late Bill Hathaway, the Victorian AIDS Council's first HIV Education Officer. Hathaway recognised the mnemonic power of Heath-Kerr's body-suits, and commissioned an outfit aimed at the clientele of Melbourne's gay party circuit. Adopting the compartmentalised technique of Gilbert and George, Heath-Kerr worked with photographer Peter Elfes to construct a life-sized walking safe-sex 'advertisement'. Composite fragments of the body parts of two different male models were combined with colourful pictograms and the use of loaded words (Hot, Safe, Sweat, Fuck, Condom). The outfit was designed to be immediately readable in the context of a crowded, dimly lit dance floor, as it flashed its subliminal messages of responsible drug use and sexual safety to an audience naturally drawn to the universal allure of the piece. *Homosapien* 1994 is Heath-Kerr's most confrontational creation to date, and expresses his wish to reach an audience beyond the parameters of the gay dance culture. *Homosapien* speaks frankly of the politics of every body in the age of AIDS, as it strips the human form of all gender, race or sexual references, and dramatically highlights the fragile workings that lie within all of us.

Jamie Dunbar's 'positihiv' photographs (repr. p.92) were developed in conjunction with Andrew Morgan, who originally conceived the idea of imaging HIV-positive Australians in frank sexual scenarios. These moving, honest works confront directly the issue of human sexuality and its place in an HIV-positive world. The complex intermingling of the themes of disease and desire highlights the courage, compassion and warm humour of the subjects, who have turned themselves and their emotions over to Dunbar's respectful camera lens.

In the United States AIDS has become a major political issue with respect to women, their social visibility and stature, and their access to health care services.[11] Recognition of the needs of women affected by AIDS in Australia is growing; for example, the Positive Women centres which have been established in Melbourne and Sydney provide valuable support and information resources. But the plight of Australian HIV-positive women has yet to capture the attention of large numbers of women artists in this country.

Kate Lohse's *20 Million Whispers* 1992 confronts this problem head-on by announcing in loud pink neon lettering the presence of 'Positive Women' in

our society. Her use of this dramatic light sculpture aims to counter the often-hidden impact of AIDS on women. At the same time Lohse recognises the match advantage of Western women in terms of their comparative ability to mobilise political action. The large pink neon sculpture, 'advertising' the 'loudness' of Western women, contrasts with the second part of her *20 Million Whispers* installation: a small wooden bowl filled with green tea leaves, over which is draped a tiny pendant inscribed with a stirring text in Mandarin, that draws attention to the greater numbers of infected Asian women whose 'quietness' renders their plight invisible.[12]

Melbourne-based painter Ross Watson realised that few artists were addressing the issues of women and HIV/AIDS. With his gentle, reflective composition *Untitled #1* 1993 (repr. p.152) he offers the viewer an easily readable allegory of a woman testing positive for the HIV virus. Painted 'samplings' from Vermeer's *Mistress and Maid* c.1667–68 (Frick Collection, New York) and Caravaggio's *Boy Bitten by a Lizard* c.1596–97 (private collection) provide a non-threatening invitation to consider the complex ramifications of antibody testing. Between these old master quotations, Watson has pasted pages from a wall calendar covered with layers of delicate tissue paper. The passing calendar days, still visible beneath their semi-opaque overlay, refer to the waiting period between testing and results, as well as signalling the woman's confrontation with a foreknowledge of limited time after an HIV-positive diagnosis. Progressively widening holes torn at intervals through the layered tissue paper at once refer to the passing of time (counting the years, akin to the rings on trees) and echo the blemishes left on the body by KS (Kaposi's Sarcoma) lesions, which are the result of a skin cancer affecting a percentage of people suffering from AIDS-related complications. In the centre of the work, a last small 'sampling', of a *vanitas* still-life vignette of book and skull from Caravaggio's *St Jerome* c.1605 (Galleria Borghese, Rome), reminds us of the hard reality that death still has the upper hand over knowledge and research at the close of our century.

Michele Barker's *Let's Fuck* 1992 (repr. pp.76–77) offers a woman's humour in the extreme danger zone — nervous laughter between the sheets. This up-front, 'in your face' diptych speaks frankly about the need for women to empower themselves sexually in the age of AIDS, through recognition of the dangers of unsafe sex and seizure of responsibility for their own sexual health.

Barker likes to play with traditional codes, primarily in order to utterly subvert them. Her work is visually simplistic and cleverly emotive on numerous levels. The symbols she has chosen are obvious — the gun, the woman (read 'victim' or 'agent provocateur') and the loaded word, FUCK. Immediately readable, her computer-generated photographs invite a slick and complacent reaction dependent upon each viewer's preconditioned prejudices. However, anyone pausing to consider Barker's motives will recognise the calculated distancing at work within her computerised image-making. The impact of her work increases in proportion with the degree of sophisticated irony each viewer brings to it.

The four basic visual and semantic elements to *Let's Fuck* — woman, gun, sex, consensuality — point evidently to the principle of 'Russian roulette' operating in unprotected or 'unsafe' sexual play. But they also refer to a contentious debate which has divided aspects of the feminist movement over the past two decades: specifically, the question of whether lesbians who engage in penetrative sex are empowering themselves sexually or falling prey to 'unsound' phallocentric ideology.

Rea's *Lemons I–IV* 1994 (repr. pp.80–81) seduces the eye through crisp computer-generated forms, high-gloss surfaces and dazzling colour. Its combination of flower and lemon imagery symbolises the bitter-sweet nature of sexual contact in a climate of potential infection. Thinly veiled beneath the seductive surface of this glittering polyptych lies a frank instructive text explaining the correct use of dental dams in female oral/genital sexual play. *Lemons* is thus able to broach, through its engaging visual ploys, the still-difficult subject of female sexual health in our time of AIDS.

Kaye Shumack's *Tendances (Tendancies)* 1994 series of photographs plays with the 'delicate' subject of woman-to-woman transmission of HIV. Her use of smooth, 'cool' advertising imagery and montaged words aims to question the elision of lesbian sexuality which operates in Australian society. Shumack's resonant images of women interacting so tenderly, yet elusively, also imply that this avoidance of open discussion of lesbian sexual practice enters even within woman-to-woman relationships, preventing debate around issues vital to the sexual health of lesbian women.

Art works which image the dangers of HIV/AIDS for the heterosexual male are not yet being produced in Australia, to this author's knowledge; although

there are a number of artists in this country who are analysing potential non-sexual modes of HIV transmission, such as intravenous drug use, blood transfusions and tattooing.

Franka Sena's *You Said You Love Me* 1992 is one of the rare Australian works dealing with the transmission of HIV/AIDS through intravenous drug use (in this case woman-to-woman transmission). Its cascade of rose petals (originally the work's individual polaroids were meant to be 'dredged' one by one from a postal box of dried petals) evokes through sensual touch and smell the seasonal ebb of love's demise.

eX de Medici's *Godscience* 1994 cibachrome photographs of post-tattoo blood swabs are an important contribution to the debate around the safety of cosmetic intrusions into the body (such as ear and body piercings, tattooing, and minor surgery). One of Australia's most prominent tattoo artists, eX de Medici has worked closely in Canberra with the AIDS Action Council ACT in developing safe tattooing procedures; she also designed the Council's 1989 *Safe Winter* poster campaign. Her lush cibachromes capture the essence of the vulnerability of the human body and remind us that mankind is no longer impregnable.

The sources behind H.J. Wedge's AIDS images (repr. p.151) have been succinctly described as 'observations of other people's attitudes, his personal response to the media coverage, discrimination and a concern for the empowerment of Aboriginal people'.[13] His *Blood Transfusion* 1994 examines the painful prejudice encountered by the HIV-positive child Eve van Grafhorst, who was born premature and acquired HIV after a lethal blood transfusion, and was forced to leave Australia with her family when her antibody status became 'public property'.[14] Wedge's narration of the story behind his painting, presented in refreshingly direct dialectic, contains a powerful message about the irrational fear and prejudice which accompanied Australian public perception of AIDS in the early days of the epidemic.

> When I heard this on the news or the Current Affair it really pissed me off how the people in that street of hers, she used to talk to, they was her friends. They wasn't much of friends at all — the fucking bastards. Cause they all jacked up about her sending her baby girl to pre-school or day care, whatever it fucking was at the time. She

didn't caught AIDS from nobody else — she got it from somebody who donated fucking blood to save people's life. And the fucking worst thing about it she had to leave Australia to fucking move to Tasmania or New Zealand, I think it was. This what you call good decent fucking people? Well they are not. Discriminating against a little innocent baby who hadn't had a chance to a long happy life. Her life was cut and youse didn't help at all. Youse just turned your fucking back on them.[15]

Marrnyula Mununggurr's bark painting *Untitled (The AIDS Story)* 1993 offers a commentary on the dangers of unprotected sex and its role in the transmission of AIDS to the Aboriginal 'body', itself already suffering from a tragic history of prejudice, racism and neglect. The work was commissioned by the Department of Health and Community Services of the Northern Territory, who have used reproductions of Mununggurr's painting in AIDS education programs around the state. The daughter of Djapu head man Djuta Djuta, Marrnyula Mununggurr paints in a simple and warm vernacular, which can be read alike by her own people and non-indigenous Australians.

Art as Mourning

Our mourning strives to be public, and to engage public institutions, because it is in the public domain that the value of the lives of our dead loved ones is so frequently questioned or denied. Thus the epidemic requires a public art, which might adequately memorialise and pay respect to our dead.[16]

Another stream of Australian AIDS-inspired art concerns itself with projections of the immanence of loss, or reactions to the devastation caused by it.

Juan Davila's *LOVE* 1988 (repr. p.71) proceeds from the same source as *AIDS* 1988 produced by the Canadian artist collective General Idea — Robert Indiana's iconic pop art image *Love* 1966 — but to quite a different end. Where General Idea offered a cool 1980s commentary on love in a changed climate, retaining Indiana's bold, joyful colours, Davila subverts both the look and the message of Indiana's original paean to free love. His canvas highlights

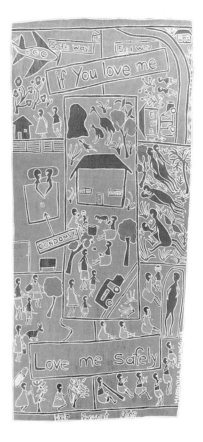

Marrnyula Mununggurr, Australia, *Untitled (The AIDS Story)* 1993, bark painting. Collection Department of Health and Community Services, Nhulunbuy, Northern Territory.

the Western-specificity of Australian society's reaction to AIDS by recasting the acronym in its South American form 'SIDA'. This new phraseology is inundated with a mix of molecular and spermatozoic imagery that resembles nothing so much as a cum-shot from a pornographic movie as dissected by viral researchers. The painting seems wracked with grief, as its sombre tonalities ooze and drip a lament on the death of love.

Ross T. Smith's *L'Amour et la mort (sont la même chose)* (Love and Death (are the same thing)) 1990–92 offers, on an operatic scale, the moving picture of intimacy between two men in a time of grief and physical decay. Smith's use of ripped and crushed photographic sections, roughly adhered to their backing-board with carpet tacks, emphasises the fragility of bodies and souls torn asunder by the epidemic. His method of placing a small piece of tissue-

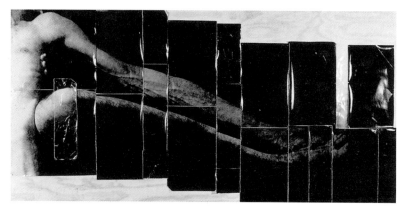

Ross T. Smith, Australia, *L'Amour et la mort (sont la même chose)* 1990–92, gelatin silver photographs, plywood, tacks. Courtesy of the artist.

paper over the negative before exposing it onto paper lends a mottled effect to the finished image that echoes perhaps the suppurating flesh of the dead Christ figure from Grünewald's famous *Isenheim Altarpiece c.*1515 (Colmar Museum). The black void behind Smith's interlocked human forms contributes to the spiritual, almost religious quality of the work. And the melancholic word-play in the chosen title (the phonetic correspondence of the French words for love, *l'amour*, and death, *la mort*) underscores the artist's contemplation of the perplexing continuum of love, life and death.

Monument to Intimacy – The Last Embrace 1987/94 is a refinement of an exhibition Arthur McIntyre staged at Sydney's Holdsworth Contemporary Galleries in 1987. Titled *Riddle of the Tombs*, that original installation incorporated five coffins placed among twelve life-sized drawings inspired by the human skeleton. The coffins bore red and white flowers, symbolising blood and the soul. The nexus of sex and death has been an artistic preoccupation of McIntyre's since the mid-1970s; but it was the media sensationalism surrounding the diagnosis of Rock Hudson with AIDS in 1985, and the subsequent AIDS-related illness of a close friend, that crystallised McIntyre's plans for the *Riddle of the Tombs*. While that show was personally cathartic for the artist, he recalls that public acceptance was not forthcoming for his stark dialogue on the Freudian notion that 'the aim of all life is death'. 'Visitors to the gallery were intimidated by the confronting nature of the installations, especially the presence of the coffins. Many people fled the gallery, without bothering to come to terms with the work and its

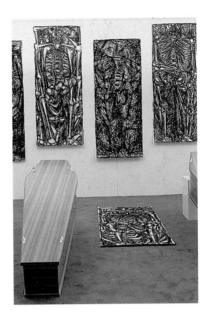

Arthur McIntyre, Australia, *Riddle of the Tombs* 1987, installation at Holdsworth Contemporary Galleries, Sydney, charcoal and oil-stick on paper with coffins. Courtesy of the artist.

implications.'[17] In *Monument to Intimacy — The Last Embrace*, Arthur McIntyre has lain a single life-sized skeletal drawing next to a beautifully crafted coffin, in homage to the memory of Sydney art dealer Garry Anderson who died of AIDS-related complications in 1991.[18]

Marcus Bunyan's poignant photograph of a skull, *How Will It Be When You Have Changed* 1994 (repr. p.53), emerged from a visit to the Australian AIDS Memorial Quilt (see below). Bunyan began by photographing the Quilt in a very abstract manner; he was especially moved, not by the literal or 'readable' designs, but by those panels deliberately left blank for the recording of visitors' written tributes and messages to the deceased. *How Will It Be When You Have Changed* considers the way in which the mourning process begins long before a person dies of AIDS, as lover, family and friends prepare themselves for the worst and confront their hope that they will see their loved one again in the next life. For Bunyan, 'gay people belong to the world as a whole. We may be discriminated against, and ghettoised, but this does not stop us belonging to the earth.'[19] His *Tell Me Your Face Before You Were Born* 1994 seeks to convey a sense of the fourth dimension, in order to project a sense of universal grief and loss.[20] Its record of playground swings at night, shot in double exposure, suggests a perforation into the cosmos, as the canvas

of life is rent asunder by tragic circumstances. The photograph refers gently to the family bonds developed around the innocence of children, and reminds us of the family loss surrounding every AIDS death.

Franka Sena's *Sear* 1993 (repr. p.84) is constructed from pieces of fencing wood the artist found on strolls around Melbourne's St Kilda. Its beautiful weathered wood pieces invite reflection on the passage of time, and refer to the domestic boundaries within which most experience of pain and absence is circumscribed. One also senses here the chill of a Melbourne winter by the seaside, as Sena's inverted heart motif comments softly on the sea of broken hearts in this time of emotional frost. The word inscribed upon it can be read alternately as 'sear', to slash, burn or wither, or a misspelling of 'seer' — prediction of an uncertain future; and, in addition, as both 'fear' and 'tear'. Sena's poignant use of autumnal colours deepens *Sear*'s sense of melancholy, sad introspection and bitter wisdom.

The Power of Metaphor

Other works by Australian artists may not seem to be so immediately AIDS-related. Their approach to the epidemic is linked by a shared use of redolent symbols and metaphorical reference. While their eliptical imagery speaks on many levels, their essential subjects — emptiness, homophobia, martyrdom and transformation of the body — are all direct responses to the AIDS crisis.

Mathew Jones's empty, reversed canvases and blank, stuffed white 'objects' were first seen in two exhibitions the artist prepared in 1991: 'Silence = Death' at 200 Gertrude Street, Melbourne; and 'Over My Dead Body' at Sydney's Artspace Visual Art Centre. In each case the works formed part of complex sculptural and textual installations, commenting on the relevance of AIDS

Mathew Jones, Australia, from *Over My Dead Body* 1991, gesso on cotton duck, dacron, marine ply. Courtesy of Tolarno Galleries, Melbourne.

activism and its sloganeering. For Jones, these white, mute works continue to function independently of their original installation context:

> If the paintings speak at all, they seem to be speaking to the body. People, when they see them, *desire*, they overflow and want to touch them, to fill them up with meaning, to fill them with metaphors ... Anyway, this place, this silence, or gap of meaninglessness that people rush to fill up, that's what I lay down here, like a place for me and other gay men — to fill up, to write in, or to keep empty.[21]

They may stand as solitary sites for the viewer's projection of a personal sense of loss and emptiness in the face of AIDS; or, more obviously, as metaphors for the art which will no longer be produced in the wake of the path of AIDS through the art world.

Ross Moore's *Of the Visible and Hidden* 1992–93 (repr. p.96) employs the power of fractured metaphor to explore the ironic double 'coming-out' that occurred with the AIDS diagnosis of both Rock Hudson and Michel Foucault where the diagnosis also turned the spotlight on their homosexuality. Moore's triptych, which juxtaposes press clippings with quotes from Foucault's *History of Sexuality*, reminds us that the moment a lesion appeared on the skin of these celebrities, their entire body became pathological (typified as a monstrous species) in the eyes of the heterosexual press; and that pathology quickly stretched back to their earliest existence, as if the two men's lives were newly revealed as nothing but sordid incubators of moral morbidity.

In the left panel Moore focuses particularly on the outrage and betrayal that permeated the purple prose of magazines like *Cosmopolitan* and *Cleo* at the time of Rock Hudson's death, as reporters expressed shock, horror *and* appetite at the discovery of the film idol's 'double life' as a closet homosexual. They delighted in the spectacle of gay death, at the same time as railing against it. In their homophobic articles, the gay being loomed large as a morally decayed entity that threatened to rupture their construction of the universal 'heterosexual white body'. Once identified, the gay form was instantly viralised; a process aided by the new scientific study of AIDS, which soon became co-opted as a justificatory measurement of moral stigma. This fed mainstream media commentary which called for a recontainment of the gay body as a means to control in turn the terrifying AIDS 'contagion'.

Moore displays the gay body cut open to show the invasive methods of science. The 'corpse', covered with text, symbolises the media's preying on the visible dead as a way of grotesquely resuscitating its own heterosexual supremacy.

The right panel of *Of the Visible and Hidden* depicts the AIDS patient as a hideous chimera, holding a mirror up to the way the HIV virus has been painted as a kind of monstrous social infiltrator, entering the 'general public' at the point where it has failed to contain the unruly gay body. Throughout this triptych Ross Moore interrupts the flow of text with an intrusion of bodily form, and vice versa. This scopic confusion is designed to confound a monocular viewpoint of the work. It reflects Moore's concern with the measurement and dissection of the gay community by the mainstream media and is an attempt by the artist to reprivatise the body and protect it from the homophobic gaze of the 'pseudo-public'.[22]

Anna Wojak's *Acacius (Stigmata)* 1991 (repr. p.163) belongs to a group of 'saintly' works this Australian-born and Polish-trained artist has collectively entitled *Stigmata*. The series includes *Sebastian*, *Theresa in Ecstasy*, *Mary Magdalen* and *Joan of Arc*. Painted on salvaged wooden doors or table-tops in rich hues of lapis lazuli overlaid with 23 carat gold leaf, the works evoke both Byzantine icons and Italian quattrocento altarpieces, in echo of what Wojak sees as 'the damn good theatre in Catholicism'.[23] Contemplating the relevance of modern-day 'saints' and 'martyrs' to her updated icons, Wojak attended an ACT UP meeting in Sydney in search of role models. Here she encountered Tony Carden, then a member of ACT UP and a volunteer with the AIDS Council of New South Wales. Carden agreed to participate in the *Stigmata* project, and sat for Wojak as a latter-day embodiment of Acacius.

In approaching her 'portrait', Wojak felt strongly that 'being HIV-positive is considered a negative energy, and I wanted to paint a portrait of someone using his HIV status to do something positive'. Carden himself notes: 'the years I have been fighting AIDS have been the most productive of my life'.[24]

Acacius belongs to a mythical group of 10,000 martyrs who were supposedly executed on Mount Ararat at an unspecified date by a pagan army; their cult dates from the time of the Crusades, and focused on Acacius in particular, due to his alleged request to God that whoever venerated the memory of the

martyrs would find health of mind and body. The parallels with Wojak's wishes for Carden (who is still an aggressive AIDS activist and lobbyist) and other AIDS activists are obvious.

Tony Carden himself, while not a trained artist, has produced his own community-based conceptual artwork, *Warrior Blood* 1993–. The piece is at once simple and humane — a panorama of drops of blood collected from people Carden believes to have been warrior braves in the relentless war against the scourge of AIDS. Health officials, activists, fund-raisers, hospital workers and community support workers are among those whose blood droplets, signed and dated, invite us to consider the enormous human toll wrought by the AIDS crisis (the majority of samples are from HIV-negative hosts). No one can fail to be moved seeing the names spelled out here; for example, the nursing sisters of Sydney's St Vincent's Hospital — a fine tribute to the role the Sisters of Charity and other religious orders have played in caring for the terminally ill. It is a tribute which needs to be made to balance other AIDS-inspired art aimed at attacking the self-righteous fulminations of some religious leaders, in particular the stance taken on both homosexuality and AIDS by Pope John Paul II (such as the American demonstration placards, *Stop This Man, Public Health Menace. Cardinal O'Connor* and *Stop The Church. Stop Gay Bashing*, designed by Vincent Gagliostro to denounce both New York's Cardinal O'Connor and official papal pronouncements).

Marcus O'Donnell's *Untitled I* (*This Is My Body* series) 1992 redeploys imagery drawn from Caravaggio's *Entombment of Christ* 1603–04 (Pinacoteca Vaticana) and *The Flagellation of Christ* 1607 (Capodimonte, Naples) to explore the hidden homoerotic content of religious art and the connection between religious and sexual ecstasy. The work is a critique of the repression and the suppression of the sexual and, particularly, the homoerotic in the Catholic tradition. But it is also a reappropriation, a reclaiming of images that had nurtured the artist as a youth, thereby making explicit what he had sensed but dared not name in childhood.

> The images all relate to the gay body, to oppression, to the wound of having your experience denied; but they were also quite explicitly done in reference to the gay body in the age of AIDS which is again the mortified body, the pathologised body.

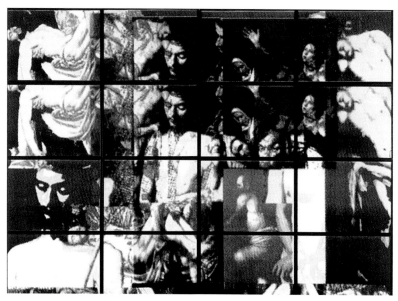

Marcus O'Donnell, Australia, *Untitled I [This Is My Body* series] 1992, Photoshop-generated image on Macintosh, enlarged into tiled print on Canon colour laser copier. Courtesy of the artist. Photography: Freak Me Productions, Melbourne.

> Also in a personal sense these images were all done around the time that I was diagnosed antibody positive so they are quite explicitly about *my* wounded body.[25]

The title of the work, recalling both Christ's words at the Last Supper and the ritual of the Catholic Mass, reflects the manner in which, for O'Donnell, an HIV-positive diagnosis also involves a metamorphosis or 'transubstantiation' of the flesh.

Grief and The Gay Community

> SYDNEY — 5 A.M. and the ashes of a gay man who died from an AIDS-related condition were scattered on the dance floor at the annual Sleaze Ball (where Australian gay culture provides its best expression of 'party'). And so the floorboards and the soles of a thousand shoes host the last physical 'remains' of a person's life.

MELBOURNE — 7 A.M. on the pavement surrounding a theatre where a memorial service for a gay man will soon take place, a Chalker (street artist) is chalking up a larger-than-life full colour picture of the deceased. On conclusion of the service more than a dozen gay men hold hands around the picture and say their goodbyes, there was no coffin to decorate, no ashes to scatter.

SYDNEY — DUSK — and three distress flares are lit outside the house when the body of a gay man (who has died an AIDS-related death) is taken from his home to the funeral parlour.

> 'We wanted to make a statement, something serious had happened, a cause for alarm ... rumour has it that the flares landed on top of the Oxford Hotel.'

Such is the variety of ritual that members of the gay community have utilised in response to the AIDS-related deaths of their gay friends.[26]

It is impossible to describe, to those who have not experienced it directly, the emotion that washes over you in the middle of a crowded dance party at 5 a.m., surrounded by thousands of happy revellers, as the ghosts of missing friends come close to dance around you. It is hard to convey the manner in which AIDS turns one's life into a series of 'lasts' — last dinners with ill or dying friends, last birthdays and festivals, last shopping expeditions, last year of health, last visits to hospitals and hospices — but somehow never last funerals. Only those who live on the razor's edge truly know the sharp cut of its blade.

David McDiarmid's latest candy-coloured laser prints (repr. pp.158–159) come closest to capturing the bitter-sweet essence of life for many gay men in the 1990s. Their kind of tabloid 'joke' sensationalism was first used by McDiarmid in a now legendary obituary for his best friend, artist Peter Tully who died of AIDS in August 1992, which he placed in the gay newspaper *Sydney Star Observer*: this was simply a full-page advertisement in banner headlines screaming 'MOODY BITCH DIES OF AIDS'. The obituary was coded, but also painfully obvious to anyone who knew either Tully or McDiarmid.

Outrage at the dispute over the estate of Peter Tully (who died intestate) led McDiarmid to produce a vitriolic book, *Toxic Queen*, as well as *Standard Bold Condensed* 1992, a wall of screenprinted banner-headline posters. At the time he noted:

> My work ... grew out of anger, frustration, confusion — not my usual inspirations. But one quality that queers have always had is the ability to transform our 'given' situations into something better, by any means necessary.

> These works are made by a queen who refuses to be bitter and twisted, tempting though it may be. I intend to keep on feeling angry and fabulous at the same time.[27]

Both *Toxic Queen* and *Standard Bold Condensed* employed a mixture of texts expressing shocking humour ('POSITIVE QUEEN FEELS NEGATIVE — Goes shopping'; 'DEMENTED QUEEN REMEMBERS HER NAME — Forgets to die'); anger ('AIDS VICTIM DIES ALONE — Family profits'); and frustrated despair ('ACTOR — 70, DIES OF AIDS — Nobody cares'), printed over a bevy of gay icons (Madonna, Freddie Mercury, Barbie, Bart Simpson) and beefcakey slices of homoerotic pornography.

McDiarmid's laser prints replace this specific gay iconography with the pure colours of the rainbow (itself, in a certain chromatic configuration, a gay icon of course[28]) over which sugary lollypop texts spell out acid-tongued truisms: *It's My Party and I'll Die If I Want To, Sugar*; *Lifetimes Are Not What They Used To Be*; *The Family Tree Stops Here Darling*; *Honey, Have You Got It?* Black humour is taken to an almost blasphemous degree, lending a queer new meaning to the term 'sick joke' and the expression 'dying laughing'. These new texts are like games of Scrabble played out on the shores of the Styx. Pushing his black comedy to the limits McDiarmid has also produced, under the auspices of his subsidiary 'Toxic Queen Records', a thoughtfully tasteless cassette, *Funeral Hits of the 90s*, to help wavering gays who can't quite decide what music to have played during their last rites.

The defiant ghetto humour of McDiarmid's confronting rainbow panels is emphasised by his most aggressive text: *That's **Miss** Poofter to You Asshole*. There is a dignity and pride at the core of his macabre/comic creations, that

offers a perfect example of the instructive 'shock' and cathartic release obtainable through AIDS humour. Simon Watney has defended such dark comedy well:

> Are we to dismiss all uses of irony, or punning or wit of any kind, in favour of some lapidary stance of elevated moral rectitude in all our work around the epidemic? Surely not. Far from making death 'cosy', wit is an *indispensable* means to public understanding ...[29]

McDiarmid's sadder panels, such as *Don't Ask, Don't Tell, Die Alone* or *Don't Forget To Remember*, also offer an important commentary on the manner in which the funerals of so many gay men in Australia and the United States have brought blazingly to the foreground the topics of death and grief, normally hidden or avoided and never frankly discussed in Western culture. Gay men have constructed a unique set of public rituals around the day-to-day reality of death for their community.

One of the more cruel ironies of HIV/AIDS lies in the amount of mortal pre-warning it gives those infected. Gay men with AIDS-related illnesses have frequently participated in the designing of their own Quilt panels, organising every detail of their own funeral or memorial service, drafting their own obituary notices, and staging pre-will distributions of their estates. Planned suicide parties (which become wakes at a given moment of the evening) are also not unknown.

The AIDS Memorial Quilt and its ceremonies, candlelight processions, 'remembrance' attendance at the Sydney Gay & Lesbian Mardi Gras Parade, anniversary-of-death dinner parties, private ceremonies to scatter the ashes of the dead in a favourite haunt, and timed 'dance moments' for the deceased at major gay parties are all now common forms of public and semi-public grieving for the gay community which have little or nothing to do with traditional funerary rites.[30]

The wearing of a red ribbon (in the shape of an inverted 'V', signalling that victory over AIDS has not yet been secured),[31] or of rainbow ribbons in the shape of the AIDS Red Ribbon (here the rainbow symbolism has metamorphosed from its gay-pride origins into a gay symbol of hope for a cure at rainbow's end), has become, in Melbourne, not just a commonplace

but an essential item of dress for many people each time they attend a gay or lesbian venue. Its presence signals that the wearer's life has been personally and irrevocably touched by AIDS (in quite a different way from the legions of red ribbon wearing 'well-wishers' who crowd the Academy Awards or any major AIDS fund-raising occasion — where the ribbon can simply indicate sympathy from people not yet personally affected). To witness 200 gay men wearing these symbols at a single event, a kaleidoscope of red and rainbow flashes glimpsed from the corner of one's eye, is to understand how grief and death have been driven like painful cataracts into the gay 'vision' of the close of our century.[32]

David McDiarmid's sparkling/bleak rainbow/text panels are aimed principally at an audience of other HIV-infected gay men. They convey from the heart his response, as an HIV-positive artist, to the epidemic, and his wish, through their pungent humour, to open up a dialogue about the emotional and political issues which shape the lives of people living with HIV/AIDS.

Untitled (AIDS Pietà) 1992 (repr. p.164) by Sister Mary Dazie Chain (aka David Edwards) offers a more gentle use of humour, tinged with sadness and empathy for both the dead and the surviving bereaved. The use of Mother Inferior as one of the models was a natural one for Sister Mary Dazie Chain, himself a member of the Order of the Sisters of Perpetual Indulgence. The artist recalls that inspiration for the pose of the photograph came from a reproduction of Michelangelo's *Pietà* sighted on a field trip to Sydney's St Mary's Cathedral while researching a projected portfolio on the Stations of the Cross recast with an S&M/Leather theme. The lighting effects in *Untitled (AIDS Pietà)* were planned after a visit to the National Gallery of Australia's 'Rubens and the Italian Renaissance' exhibition (1992), and modelled on Edwards's first-hand encounter in Canberra with Rubens's *The Adoration of the Shepherds* 1608 (on loan from the Hermitage Museum, St Petersburg). The photo-shoot was not without some wistful musing: 'If I could light in real life as Rubens did in his mind and hence on canvas? eat your heart out Greenaway/Jarman/Mapplethorpe.'[33]

By its coy replacement of the Virgin Mary with Mother Inferior, and the dead Christ with a svelte symbol of the post-AIDS universal gay body, the *Untitled (AIDS Pietà)* acknowledges the role of the artist's Order in the fight against

HIV/AIDS, while utilising the same irreverent humour the Sisters have brought to their espoused causes of gay liberation and AIDS prevention. According to Sister Mary Dazie Chain:

> The Sisters of Perpetual Indulgence were the first people on the Streets of Sydney, 1986, taking the message to the market place. We immediately had the support of Sr Carmilla Law, the then Director of the Nightingale Centre (the STD Clinic at Sydney Hospital). She maintained an endless supply of condoms that we turned into 'Sisters' own designer condoms'. They were stapled into what may appear to be a match-book. And we would hand them out to men in Gay bars and clubs in Sydney. In one year we distributed more than 25,000 such condoms.

> Mother's Day 1987 saw the Sisters cause what may be called a riot when we went to Wollongong at the invitation of a Psych lecturer from the Gong Uni to launch the windy city's safe sex education program. National television, no less, showing these 'blasphemous people dressing as Nuns'. What's wrong with them? We *are* Nuns!!!![34]

This image, which may well seem blasphemous and provocative to some, is both humorous and heart-rending to others — a perfect symbol of the moral, spiritual and pathological morass surrounding the AIDS débâcle. There is no universal truth or correct stance about HIV/AIDS — there is only your own perspective, based upon where you stand personally in relation to the epidemic.

For many gay and lesbian Australians, the Quilt plays a central part in the grieving process. The NAMES Project Quilt was founded by gay activist Cleve Jones in San Francisco in 1987, and found its first home in the Castro — San Francisco's main gay neighbourhood. The first NAMES Project fabric panels, each dedicated by their makers to a friend who had died of AIDS, were unveiled at the 28 June 1987 Lesbian and Gay Freedom Day Parade in San Francisco, where they were hung from the mayor's balcony at City Hall. From these origins as a new expression of collective gay grief, the American NAMES Project has now grown to incorporate more than 20,000 commemorative cloth panels (each 6 feet by 3 feet — the size of a grave plot); its full display now requires more than 6 hectares of ground space.[35]

The Australian Memorial AIDS Quilt Project was established in September 1988 by Andrew Carter and Richard Johnson, in emulation of the American NAMES Project. While it began here also as a focus primarily for the grief of the gay community, and still provides an important catharsis for the surviving gay bereaved, the Australian Quilt like its American predecessor has crossed over beyond the borders of gay cultural expression to embrace the entire AIDS community.

> Spread out, it graphically underscores the depth and range of the impact of HIV on all our lives. By juxtaposing a panel for a gay man with one for a child with haemophilia and another for the women of Africa, all loss is recognised. None are elevated or ignored; all are recorded for history. The Quilt has helped many to clarify, resolve and remember old joys and tribulations and to redouble our determination to end this scourge as soon as possible. *En masse* the panels form a mosaic of memory, a spread of hope and a giant canvas, rich in lessons and lives.[36]

The Quilt now offers a centre for shared mourning and remembrance, and is particularly useful in providing solace to non-gay AIDS-affected citizens who may have no other sense of belonging to a supportive 'community' such as the gay community. The Quilt can therefore truly be said to be a gift from the gay community to all of the disenfranchised AIDS-bereaved (and it should be remembered that the purpose of the Quilt is as much to help the survivors of an AIDS death, as to memorialise the deceased).[37] The demography of the Australian Quilt is in fact undergoing rapid change, demonstrated by the recent influx to the project of panels representing non-gay commemorations.

For most Australians, the annual Sydney Gay & Lesbian Mardi Gras Parade offers the most cogent and controversial expression of gay visibility in this country. While the parade inevitably means many things (gay and lesbian pride, unity and strength, visibility, dispelling myths, the fight against homophobia and anti-gay violence, etc.), the public televising of the 1994 procession down Sydney's Oxford Street (and its personal witnessing by more than 500,000 spectators) underscored again the extent to which the Sydney Gay & Lesbian Mardi Gras Parade has become in one sense a forum for public mourning and a galvanising call to action in fighting the AIDS crisis. There is no doubt that this aspect to the Mardi Gras will have surprised millions of viewers whose knowledge of the parade was formerly confined

to sensationalising sound-bites of naked bodies in TV news bulletins and condemnatory press reports focusing exclusively on the parade's defiant expressions of gay and lesbian sexuality.

Attendance at the Mardi Gras Parade and its follow-up Party now combines commemoration with celebration for many members of the gay and lesbian community. The 1994 parade itself was marked by its repeated use of Egyptian imagery, evocative of elegaic funerary rituals; moving floats offered thanks to HIV/AIDS support networks (Ankali, CSN, Bobby Goldsmith Foundation, Positive Women, etc.); Brenton Heath-Kerr's monumental AIDS snake surrounded by lantern and incense bearers (commissioned by the AIDS Council of New South Wales); and a legion of flag bearers carrying banners emblazoned with the motto 'Remember Our Friends', who paused in procession periodically as flares in honour of the dead were sent up into the skies above Sydney's gay and lesbian neighbourhoods. It is important to remember that in 1985 elements of the Australian press were actively calling for the Mardi Gras Parade and Party to be cancelled on the grounds that they encouraged the spread of AIDS.[38] The Mardi Gras Parade has become, in one sense, the equivalent of Anzac Day for Australia's gays and lesbians, as they remember their dead, celebrate their communities' survival, and express their fierce will to rise stronger out of the fires of tragedy.

Ron Muncaster's prize-winning Mardi Gras costumes (repr. pp.160–161) are a statement of pride in the individuality and difference of his life as a gay man in Australia, and a sign to the world of his determination to 'carry on' in the face of the grief and loss which have afflicted the gay communities in our country. The costumes are lovingly worked statements of survival triumphing over adversity, and belief in the ultimate joy of life even when surrounded by so many reminders of its impermanence and fragility. Brian Ross's *Man Crab*, which won the Best Costume award at the 1993 Mardi Gras, reveals its maker's architectural training in its complex design and meticulous construction. In that year's parade it was worn dramatically in front of a backdrop of black-and-white clad ACT UP marchers — a perfect demonstration of the blend of celebration and determination that is characteristic of the Mardi Gras.

Just as his earlier photographic book, *Sydney Diary* 1984, captured the faces of Sydney's counter-culture and high-culture life styles before the dawn of

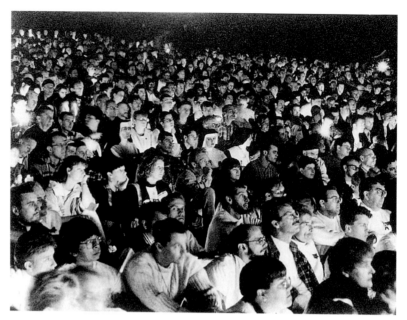

William Yang, Australia, *Vigil* 1994, triptych (detail) gelatin silver photographs. Courtesy of the artist.

AIDS, so William Yang's photography over the past decade has played an essential role in documenting the tragic impact of HIV/AIDS on Australia's gay community and culture. William Yang himself notes: 'I see myself as a photographic witness to our times. I feel compelled to perform these slide shows as social rituals to unburden myself of the things I have seen.'[39]

Yang's sell-out theatrical performance, *Sadness. A Monologue with Slides* (which has been touring Australia since 1992), begins by poignantly examining the artist's Chinese–Australian heritage; but it is the account of the slow death from AIDS of Yang's friends Nicolaas and Allan that has brought whole audiences to open tears time and time again. The sequence of slides of Allan (which is included in this volume) was undertaken in full cooperation with the subject.

> Allan's series is quite a complete series. Some of them are extremely close-up. He cooperated with me to the end. In fact, in some of his delirious talk on his deathbed he was saying he was waiting for me to come and photograph him. He imagined I was coming back to photograph him.[40]

The sequence pivots around the intimacy of Yang's lovingly close-focused portraits of Allan in sickness and health, in combination with a simple, heart-breaking text: 'I hadn't seen Allan for about three years ... I recognised him immediately ... but he had changed. He seemed like an old man and I had a strong desire to burst into tears.'

Yang himself remains philosophical about the loss of friends and the mourning he sees all around him.

> I would like to wish all those spirits who have already departed, well. We should not pull them back to this physical world with our sadness. Let them go. They have a new journey to travel.[41]

William Yang's panoramic, sweeping photographs of candlelight AIDS vigils in Sydney record forever the public mobilisation of, primarily, Sydney's gay and lesbian community in pain, fear, strength, remembrance and hope.

Inevitably, the Australian artistic response to the AIDS crisis will widen out to cover more aspects of the dilemma, as the epidemiology of the disease changes to affect a broader population base. For now, the artistic record of the impact of HIV/AIDS on the gay community stands as a lasting testament to the heroism of the group which, to date, has borne the brunt of grief and infection in our country.

1. These figures are drawn from the April 1994 edition of the *Australian HIV Surveillance Report*, produced by the National Centre in HIV Epidemiology and Clinical Research, Sydney.

2. The marginalised position of Australian gay and lesbian artists has been aptly examined by Marcus O'Donnell. Writing about the curious reception accorded to gay artists, he noted:
 > Gay men present an interesting anomaly in the construction of sexuality and gender in society. We are *visible* as men and thus linked to dominant systems of patriarchal power but only in so far as our sexuality is kept *invisible*. Once seen as gay we quickly become identified with the marginalised, the other. This complex dynamic of both incorporation by and alienation from society frames the development of a gay man's world view.

 > This ambiguous position is reflected in the art world's reaction to the work of [Australian gay] artists. Although a number of the artists are well known and well regarded in the canon of contemporary art there has been little attempt to explore the collective body of their work or the relevance of homosexual identity to their art practice. This is in marked contrast to the proliferation of exhibitions and critical writing regarding gender and

sexuality in women's art, for example. Even the recent Eroticism issue of *Art and Australia* dealt only cursorily with homoeroticism preferring to deal with it in a deflected form through the Anzac myth rather than engage with its expression in the work of contemporaryartists.

Marcus O'Donnell, *Dislocations: body. memory. place,* broadsheet to exhibition at the National Gallery of Victoria Access Gallery, 1993.

3. Derek Jarman, *Blue,* text accompanying the compact disk published by Mute Records Limited, London, 1993 n.p.

4. For reproductions of other HIV/AIDS-inspired works by Andrew Foster, see Steven Carter, 'arcHIVes: Interview with Andrew Foster', *Outrage,* No.106, March 1992, pp.36-39.

5. Letter to the author, 22 June 1994. Lyssiotis writes eloquently of his own technique:
 Photographers, interested as they are in that hybrid realm somewhere between the documentary and its dramatised version, have been hard pressed to find any subject not already pilfered by the media. That's because most photographers resemble, in the end, those jeans that have been pre-shrunk for sale. The world of their photographs seems composed of spectacles whose relevance has been pre-exhausted. This is when photomontage comes to the rescue, by offering meaning to trivialised content ... When I make pictures, I lay out images that have been culled from magazines. I push these separate images into a single, composite image. I'm never sure if I've hit a vein, or missed. Sometimes I know by the next day; sometimes it takes a year before I know ... More so than the original 'real' images, I hope my montages make you think; in the same way that ruins lead to a contemplation more profound than that of the original structure.

Peter Lyssiotis, 'Outside of a Dog', *Overland,* No.133, Summer 1993, p.52.

6. Peter Lyssiotis's other publications in this vein include *Three Cheers for Civilisation,* Melbourne: Champion Books, 1985; and *Industrial Woman* (with Jas Duke and Vivienne Mehes), Melbourne: Industrial Woman Collective, 1986.

7. Interview with the artist, 16 June 1994.

8. Derek Jarman, *Blue,* text accompanying the compact disk published by Mute Records Limited, London, 1993 n.p.

9. Quoted in Paul Hayes, 'Brenton: The Man in the Irony Mask', *Outrage,* No.110, July 1992, p.16.

10. Quoted in Paul Canning, 'The Masquerade Maestro', **NOT ONLY** *Black* + *White,* No.7, June 1994, p.74.

11. Awareness of the 'conspiracy of silence around issues of women and AIDS' rose rapidly in the US at the close of the 1980s, where HIV/AIDS is now the leading cause of death for women under 30 in New York City, for example. ACT UP/New York was instrumental in forcing dialogue on the complex issues of women and AIDS, and exposing inadequacies in the US health system's treatment of women, such as this barely believable, counting system:
 The CDC [Centres for Disease Control, Atlanta] has constructed a hierarchy of exposure categories. For example, a gay man who has had a blood transfusion would be recorded as exposed by homosexual/bisexual contact because it [homosexual contact] is listed first in the hierarchy. A bisexual woman who has sex with a gay man would be listed as exposed by heterosexual contact. And a lesbian intravenous drug user would be categorised as exposed by her IV drug use. This system assumes likelihood of transmission based on a US model where AIDS was seen first in gay men. It does not list woman-to-woman contact as an exposure category and is probably inadequate to explain all the modes by which women get HIV.

Risa Denenberg, 'What the Numbers Mean', in The Act Up/New York Women and AIDS Book Group, *Women, AIDS and Activism,* Boston: South End Press, 1990, p.2.

12. The text of this pendant reads, in translation:
 By the year 2000, 20 million people will be infected by the HIV virus; 90% of these cases will be in the Asian region where the rate of new cases is greater than anywhere else.

By the year 2000, 4–8 million HIV infected children will be born to mothers who will leave most of them orphaned. The burden of HIV/AIDS will be unbearable for women world wide as long as we choose to ignore the inequalities that exist between men and women: inequalities that taint women's ability to access information, education, services and participation in clinical trials. Far too often HIV-positive women have not been identified, or have been misdiagnosed or inappropriately treated. The voices of HIV women have barely been heard and their work often ignored if not suppressed. HOW MANY WHISPERS DOES IT TAKE TO MAKE A ROAR?
Kate Lohse, August 1993.

13. Suellyn Luckett, Introduction to exhibition catalogue, +Positive. Artists Addressing A.I.D.S., Campbelltown City Art Gallery, 4 February – 6 March 1994, n.p.

14. For a moving account of Eve van Grafhorst's story, from her contraction of HIV in 1982 to her family's final relocation to New Zealand, see Vincent Lovegrove, A Kid Called Troy: The Moving Journal of a Little Boy's Battle for Life, Sydney: ABC Books, 1993, pp.17–24. Lovegrove notes tellingly how: 'Within a short time headlines such as "AIDS Girl Banned From Day Care Centre in Kincumber" had escalated to "My Daughter Is Not a Midget Vampire, Not By Any Means', Says Eve's Mother".' (p.20). Eve van Grafhorst died in early 1994.

15. H.J. Wedge, artist's statement on Blood Transfusion, 19 January 1994.

16. Simon Watney, 'Memorialising AIDS: The Work of Ross Bleckner', Parkett, No.38, 1993, p.53.

17. Letter to the author, 10 April 1994.

18. See Terence Maloon, 'Obituary: Garry Anderson', Art Monthly (Australia) No.47, March 1992.

19. Interview with the artist, 16 June 1994.

20. For Bunyan, the following quotation encapsulates his current body of work, which seeks to explore universal connections to the 'world soul':
 Tat tvam asi 'That art thou'
 Man is a little world — a microcosm inside the great universe. Like a foetus, he is suspended, by all his three spirits, in the matrix of the macrocosmos; and while his terrestrial body is in constant sympathy with its parent earth, his astral soul lives in unison with the sidereal anima mundi (world soul). He is in it, as it is in him, for the world-pervading element fills all space and is space itself, only shoreless and infinite.
 (Mme Blavatsky)

21. Mathew Jones, Over My Dead Body, broadsheet to exhibition, Artspace Visual Art Centre, Sydney, 5 March – 6 April 1991.

22. Interview with the artist, 5 July 1994.

23. Quoted in Bronwyn Watson, 'Black Images from a Migrant Childhood', Sydney Morning Herald, 30 October 1992.

24. Quoted in Matthew Westwood, 'Sacred Works: The Making of a Modern Martyr', Campaign, March 1992, p.16. Interview with Tony Carden, 26 August 1994.

25. Letter to the author, 29 June 1994.

26. Michelle Grimshaw, An Anthology of Mourning Rituals Utilised by Gay Men in Response to AIDS-Related Deaths, Brisbane: University of Queensland, National Centre for HIV Social Research, 1992, p.3.

27. David McDiarmid, 'What's the Point?' in You Are Here, Luke Roberts and Scott Redford curators, Institute of Modern Art, Brisbane, 1992, exhibition catalogue, p.30.

28. The six colours of the Gay Rainbow Flag symbolise the following: Red — Light, Orange — Healing, Yellow — Sun, Green — Serenity/Peace with nature, Blue — Art, Purple — Spirit.

I am grateful to David Thomson (1955–1994), Sydney, for this listing. The Gay Rainbow Flag was originally designed by an American gay man, Gilbert Baker, and was first unveiled at the Gay Freedom Day Parade in San Francisco in 1978. See Randy Shilts, *Conduct Unbecoming: Gays & Lesbians in the US Military, Vietnam to the Persian Gulf*, London: Penguin, 1993, pp.311–312. For a full history of the flag, see James J. Ferrigan III, 'The Evolution and Adoption of the Rainbow Flag in San Francisco', *The Flag Bulletin*, No.130, 1989, pp.116–122.

29. Simon Watney, 'Representing AIDS', in *Ecstatic Antibodies*, Tessa Boffin and Sunil Gupta (eds), London: Rivers Oram Press, 1990, p.168.

30. Grimshaw notes: 'Gay men bereaved by the AIDS-related death of their partner are at risk of poor grief adjustment (a measure of healing and reintegration into society) when they participate in less than authentic mourning rituals. Such rituals may be facilitated by fundamentalist ministers and/or the family of the deceased whose ritual making does not represent the relationship the deceased gay man had with the bereaved and grieved gay mourners. These rituals add to the isolation and stigmatisation experienced by men who, by virtue of being gay are already significantly oppressed ... The creation of authentic mourning rituals is a means by which the bereaved and grieved members of the gay community can achieve a measure of individual and communal healing.'

The test community sampled by Grimshaw revealed a high level of frustration with traditional funerary arrangements: 'The most outstanding [unsatisfactory] rituals observed by all workers were funeral (post death) rituals, where the AIDS status and the gay life style of the deceased was *actively concealed*. Such rituals typically consisted of ambiguous eulogies given by people who had little current relationship to the deceased, e.g. the 'high school sweetheart' (female) of a forty-eight-year-old man who had been in a gay relationship for 11 years! The lack of authenticity for the gay bereaved participating in such funerals will, in the long term, lead to incomplete grieving for the bereaved.'

Grimshaw further records: 'The gay community is trying to rectify the lack of authentic funeral rituals by encouraging all members of the gay community (with or without HIV) to make a "will" which identifies the executor of the will who will ensure their post-death requests are met. Recent events in Sydney and Melbourne have seen "the body" and funeral arrangements handed over from the Public Trustees to the family of origin in cases where the gay bereaved wanted to bury his partner but there was no will or the executor of the will had not been named.'

See Michelle Grimshaw, *An Anthology of Mourning Rituals Utilised by Gay Men in Response to AIDS-Related Deaths*, pp.4, 11, 22.

31. The Red Ribbon was originally created by the Visual AIDS group in New York City, a group comprised of artists and arts professionals (a large number of whom are gay men) who wished to create a memorable symbol to raise the American consciousness about the scourge of HIV/AIDS. The Visual AIDS group, deliberately, did not copyright the motif; an admirable gesture of goodwill which may, however, explain why the symbol has been misinterpreted, by ACT UP among other groups.

Its meaning, in the opinion of this author, is particularly misunderstood by gay activists in Australia who are opposed to the ribbon's symbolism: when questioned by the author, no one expressing opposition to the wearing of red ribbons knew the true origin or significance of the 'AIDS ribbon'. Thomas Sokolowski, one of the founding members of Visual AIDS, explains its genesis in his contribution to this publication.

In the author's opinion, an excellent summary of the significance and symbolic intent of the Red Ribbon is provided by the text which is stapled to ribbons sold to assist Canberra's Trevor Daley Fund (which finances people with HIV/AIDS in the ACT): 'Why a Red Ribbon? They don't protect anyone or provide a cure from AIDS and discrimination but they are a gesture. This ribbon is a visible sign of awareness but it is not that simple. The ribbon can mean anything from I'm angry to I sympathise, it covers the spectrum of emotions surrounding AIDS. The colour red is not only for blood but for anger, passion and love as well. The ribbon is an inverted 'V' because there has been no victory.' The author cannot explain why objections to the Red Ribbon seem to be mainly confined to Sydney, while its wearing is becoming increasingly mainstream in gay and lesbian circles in Melbourne.

32. This reflects the author's own experiences, in the circles he moves in, in Melbourne. I am aware that, in Sydney, there is a wave of feeling in some gay circles against the wearing of the Red Ribbon in particular (see note 31 above); and the wearing of rainbow ribbons in the shape of an inverted 'V' is not so prevalent, although it is to be found worn by the clientele of certain bars.

33. Letter to the author, 7 June 1994.

34. Letter to the author, 7 June 1994. The *Sisters of Perpetual Indulgence Broadsheet*, Sydney, April 1987, notes that:
 > The Order is a Gay Liberation Group, collective in its decision making. The Sisters meet regularly at informal *nuncheons*. Our membership reflects the wide variety of beliefs, and philosophies in the gay community. There are radical faerie nuns, nuns who are Marxist, nuns who are Christians, atheist nuns, anarchist and philatelic, haute couture nuns, gourmet nuns, and nuns who don't listen! ... PERPETUAL INDULGENCE is both a name and a way of life. Some traditional religious institutions have granted, and still grant, indulgence to their members, freeing them from the 'temporal punishment due to sin'. *The Sisters of Perpetual Indulgence*, in a similar way, by thought, word and deed, do the same. We claim for gay people a perpetual indulgence which frees them from self-punishment, guilt and despair. It is our earnest wish that by banishing the self-indulgent scruples of the closet, we can come to work more effectively to bring about change that is good and keep our sense of humour at the same time.

35. For the full story of the NAMES Project, see Cindy Ruskin, *The Quilt. Stories from the NAMES Project*, New York: Pocket Books, 1988.

36. Phil Carswell, 'Coloring Our View of AIDS', *Outrage*, No.97, June 1991, p.16.

37. Not all gay Australians lend their support to the Quilt project, however; and this too echoes the American experience:
 > Contrary to the common NAMES Project disclaimer, 'politics' is by no means foreign to the AIDS Quilt. It was born in the gay rights movement and despite both the changing demography of AIDS and the project's desire to be all-inclusive, it continues to be overwhelmingly a memorial to homosexual men. This is not to say, however, that the Quilt is endorsed by the entire gay community. For some activists it is too mild and tearful, to focused on the dead rather than on those still alive or at risk.

 See Peter S. Hawkins, 'Naming Names: The Art of Memory and the NAMES Project AIDS Quilt', *Critical Inquiry*, Vol.19, No.4, Summer 1993, p.772. In this author's opinion, opposition to the Quilt project fails to consider the needs of the surviving bereaved, who naturally come from a wide social spectrum, and whose grieving processes must be respected. Anger at continuing rates of infection and lack of a cure for AIDS should surely be directed elsewhere.

38. The growth in numbers attending the parade, from 60,000 in 1985 to over half a million in 1994, reflects increasing acceptance of the contribution made by the gay and lesbian community to Australian society, and a backlash against such homophobic press coverage, as well as recognition of the need to support this community in its time of greatest visibility and also greatest distress.

39. William Yang, quotation from *Sadness. A Monologue with Slides* 1992.

40. Quoted in Peter Blazey, 'Sadness. A Monologue with Slides', *Outrage*, No.115, December 1992, p.41. Blazey describes *Sadness* perfectly here as 'part theatre, part group therapy and part public wake ... a remarkable event' (p.42).

41. William Yang, quotation from *Sadness. A Monologue wtth Slides* 1992.

Allan
from *Sadness. A Monologue with Slides*

W ILLIAM YANG was born in North Queensland in 1943. He is a third generation Australian: his grandparents migrated from China in the 1880s. After completing a bachelor of architecture degree at the University of Queensland, he moved in 1969 to Sydney where he worked as a playwright and later became a freelance photographer. Yang aspired to be a fashion photographer but discovered that this was not his calling, so he moved to the world of photo journalism.

Yang's first solo exhibition, 'Sydneyphiles', in 1977 at the Australian Centre for Photography caused a sensation because of its frank depiction of the Sydney party scene. It was one of the first times in Australia that the gay subculture became visible in mainstream photographs. Later these photographs became part of a larger work, 'Sydney Diary', exhibited at the Hogarth Galleries in 1984 and published as a book of the same title.

William Yang began to explore his Chinese heritage in 1983 when he met Yensoon Tsai and commenced a study of Taoism. Up to this time he had been totally assimilated into the Australian way of life. Now his photographic themes expanded to include landscapes and the Chinese in Australia. His book *Starting Again* appeared in 1988.

In 1989 Yang integrated his skills as a writer and as a visual artist. He began to include text on his exhibition prints and to perform monologues with slide projection in the theatre. These slide shows, a form of performance theatre, have become his favourite way of showing his work. *Sadness* brings together two themes: William's discovery of his Chinese heritage and the rituals of dying and death in Sydney. The show has been extremely successful and has toured all over Australia as well as to Hong Kong and New Zealand.

William Yang's work is represented in major galleries in Australia and in the State Library of New South Wales. In 1993 he won the Higashikawa-cho International Photographic Festival award of International Photographer of the Year.

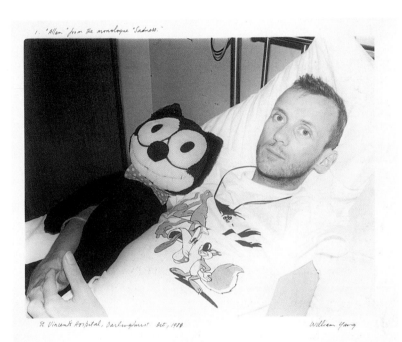

1. "Allan" from the monologue "Sadness."

St Vincent's Hospital, Darlinghurst Oct, 1988 William Yang

I hadn't seen Allan for about three years. I lost contact
with him when he moved to Melbourne. I heard that he was back
in Sydney, I heard that he was sick. I was in Ward 17 of St Vincent's
Hospital, that's the AIDS ward, visiting someone else, when I looked
through one of the doors and I saw Allan and I recognized him
immediately but he had changed.

He seemed like an old man and I had a strong
desire to burst into tears.

35

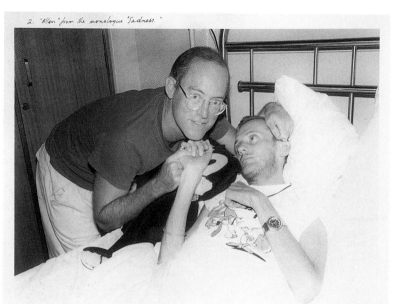

2. "Allan" from the monologue "Sadness."

St Vincents Hospital, Darlinghurst. Oct, 1988.

William Yong

His best friend, Geoffrey, was there to help him. Allan had pneumocystis at the time and we thought he might die but he pulled through.

I was glad I didn't burst into tears that first time I saw him because he told me someone else had come in, thrown themselves on the bed and sobbed at the sight of him – and he didn't think that was a very appropriate way of behaving.

5. "Allan" from the monologue "Sadness"

Spring St, Bondi Junction. Jan. 1989 William Yang.

 He went back to live in Bondi Junction where he lived
with a dealer. His rooms were always heavily decorated with his own
works of art and there was a Louise Hay (Heal Your Body) poster on the
wall above his bed. Among the assorted paraphenalia was a large
cylinder of oxygen as he was often out of breath. The appartment
was quite luxurious, but knowing Allan, it was entirely the
wrong environment for him to be living.

INFORMATION RESOURCE SERVICES
UNIVERSITY OF WESTMINSTER
HARROW IRS CENTRE
WATFORD ROAD
NORTHWICK PARK
HARROW HA1 3TP

4. "Allan" from the monologue "Sadness."

Bronte Rd, Waverley Oct 79 William Yang

He started to improve. He got his appetite back and he
began to put on weight. He came to visit me when I lived at
Waverley and after lunch I took him upstairs, put him under
the studio lights and I took this photo. It was the best he ever
looked during this period.

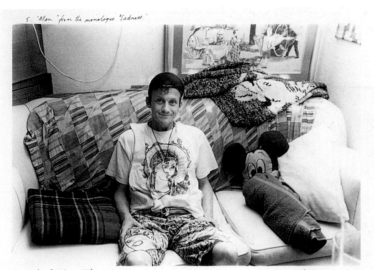

5. "Allan" from the monologue "Sadness."

Arthur St., Surry Hills. Oct. 1989. William Yang

He moved in with Geoffrey at Surry Hills and things were
a lot better. His health was fairly robust although he had to
go five times a week to St Vincent's Hospital. He had Cyto Megalo
Virus (C.M.V.) Retinitis, a condition that destroyed the retina of
the eyes, quite common among people with impaired immune
systems. Gan cyclovir, a drug, was administered intravenously.
His old friend Tony Guthrie was receiving treatment as well and
they refered to the group as the Drip Club.

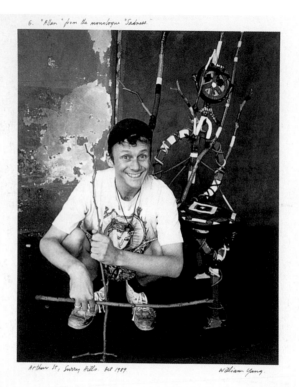

6. "Allan" from the monologue "Sadness."

Arthur St, Surry Hills. Oct 1989 William Yang.

It was a creative period. He did posters for the Bobby
Goldsmith Foundation, a quilt for his lover, Paul and he
decorated this "G'Day" chair which was auctioned off at one of the
AIDS benefits. He asked me to take a photographic portrait of him
with the chair as these were auctioned off at the benefit as well. I'd
always said to him, "Don't smile. It makes you look more tragic," but
this time he insisted on a smiling photo which in the end he didn't
like. "I told you," I said, "You tried too hard."

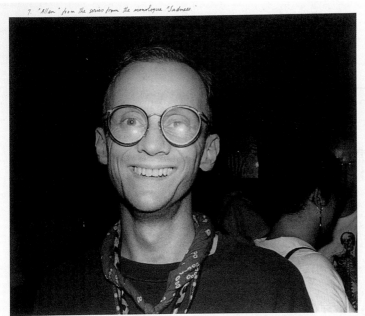

7. "Allan" from the series from the monologue "Sadness"

Belvoir St Theatre, Surry Hills. Feb, 1990. — William Yang.

I saw him at one of the plays at the Belvoir Street Theatre
during the Sydney Gay and Lesbian Mardi Gras theatre festival
(there! I've written it out in full because I remember Susan Harken
said it was the politically correct thing to do, it's not just any Mardi
Gras). We saw "More Intimacies" by Michael Kearns which we liked
and I got this good smiling photo of him in the foyer. I always
meant to show him this photo but I never got around to it.

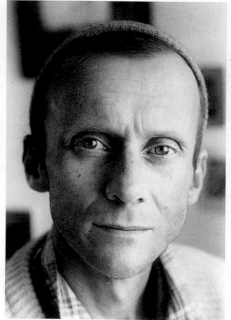

8. "Alan" from the monologue "Sadness."

St. Vincents Hospital, Darlinghurst. April 1/90. William Yang.

He was in hospital and he asked me where I'd been and
I said just been to Tony Guthrie's wake at Gilligan's Bar at the Oxford
and I listed all the people who were there. He was silent. Then I realized
no one had told him that Tony had died a few days ago. He was
very upset and he asked me to leave. It was the only time I ever saw
Allan crack.

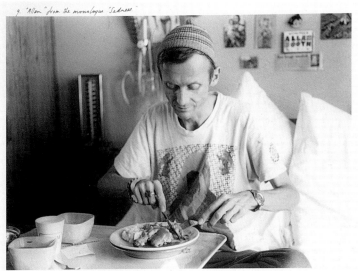

9. "Allen" from the monologue "Sadness"

St Vincents Hospital, Darlinghurst. May, 1990. William Yang.

He tried. He tried really hard to keep up his spirits.
Each time he went back he'd bring decoration, he brought colour to
those drab hospital rooms.

He kept a diary and in it he wrote down all his hopes
and dreams as well as his deepest fears. He wrote, "I think more
people die of self pity than die of AIDS."

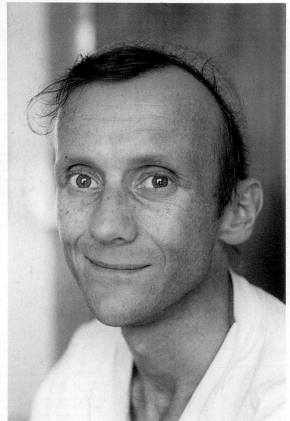

10. "Allan" from the monologue "Sadness."

St Vincents Hospital, Darlinghurst. May'90. William Yang.

I remember another entry: "I made my will today.
It wasn't as scary as I thought."

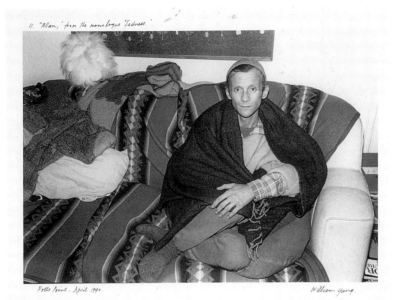

11. "Allan," from the monologue 'Sadness'.

Potts Point. April 1990. William Yang.

They could do no more for him at the hospital so
they let him come home. That was all he wanted: just to be
at home. He had to go back each day, he was still getting the
gan cyclovir treatment. The Tiffy's Transport bus which was run
by the Aids Council of N.S.W. would pick him up each morning and
bring him back in the afternoon.

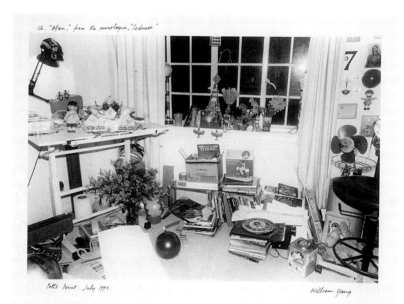

12. "Alan," from the monologue, "Sadness."

Potts Point July 1990.

William Yang

But there came a time when the quality of life wasn't good enough. He knew that the medicinal drugs he was taking were fighting off the infections, propping him up, keeping him alive, nevertheless he made the momentous decision to go off medication.

He'd been off medication for about ten days when I rang up Geoffrey to tell him I was coming over for a visit. He told me that Allan had taken a turn for the worse and he warned me not to expect Allan to be like the last time I saw him.

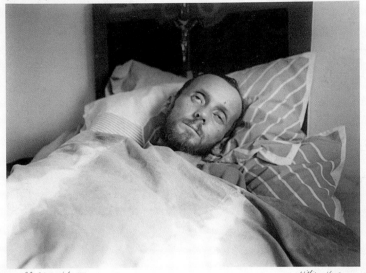

13. "Allan," from the monologue, "Sadness."

Potts Point. July 1992. William Yang.

His whole face seemed to have caved in.
It became apparent that Geoffrey and our friends
could not look after Allan at home. He had his clearer
moments and it during one of these that we asked him
if he would go into the hospice and reluctantly he agreed.

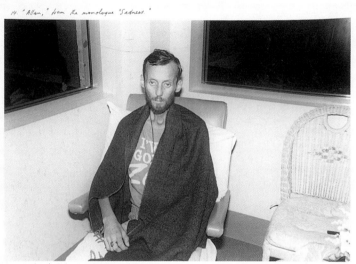

14. "Allan," from the monologue "Sadness."

St Vincents Hospice, Darlinghurst. July, 1990. William Yang.

At the hospice we made up a roster so that there would be someone with him at all times of the day and night. He became so weak you had to listen very hard just to hear what he said.

This day he was in the TV room and he asked me to push him back to his room. I couldn't quite understand him then I realized the chair had wheels. He figured I'd need to hands to do this so he told me to put my camera bag on his lap. He was so frail then, I thought, "If I put my heavy bag on your lap, you will be crushed."

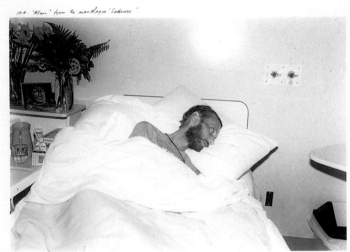

14A. "Allan" from the monologue "Sadness"

St Vincent's Hospice, Darlinghurst, July 1990 William Young

When we got back to his room the nurses were making
his bed and they asked us to wait. He had his hand on the
arm of the chair and I put my hand over his. (I had
already said goodbye to Allan weeks ago, I told him that I
loved him and he had smiled and said, "That's good." It
wasn't the response I wanted, in fact, I thought, "You've
always taken everything for granted.") But as we were
waiting he lifted up my hand and when it was at the level
of his face he lightly dropped his forehead on it.
 He was young when I met him, years ago, and our
relationship had been full of fun, zany, exciting, sexy, but
never tender ... until now in this unexpected moment of grace.

49

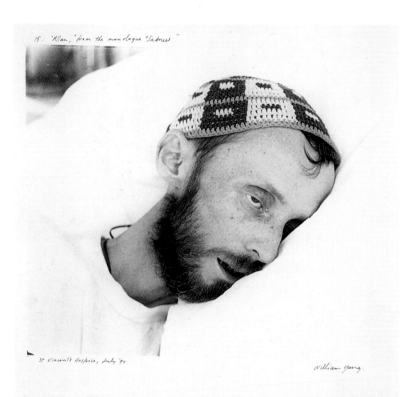

15. "Allan," from the monologue "Sadness"

St Vincent's Hospice, July '90.

William Young.

Then he went into a coma. I saw the nurse give him a glass of water but the water just ran out of his mouth. He didn't respond to touch. I half expected him to be cold but he was burning with fever. His pulse was racing. Later this evening Geoffrey rang me and told me he had died.

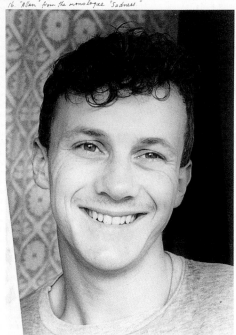

16. "Alan" from the monologue "Sadness."

Ann Street, Surry Hills, Dec, 1980. William Yang

About two weeks before he died I read his diaries (Geoffrey had asked me if I would like to talk at the funeral). AIDS was a tragedy that was for sure, but as well he had an addictive personality and his day to day life was full of desperation. I hadn't realized the extent of this and it came as a shock. Yet there were moments of clarity when his fresh zest for life shone through. I would say at the end he was accepting and courageous.

At the service I read selected extracts from the diaries and I said that I believed in the afterlife and I wished his soul well on his new journey.

Art from the Pit:
Some Reflections on Monuments, Memory and AIDS

SIMON WATNEY is Director of the Red Hot Charitable AIDS Trust, London. He is the author of *Policing Desire: Pornography, AIDS and the Media* (1987) and *The Art of Duncan Grant* (1990). He has written seminal articles on the politics of AIDS representation for journals such as *October* and *Artforum*; and has contributed to numerous anthologies concerning AIDS, including *Fluid Exchanges: Artists and Critics in the AIDS Crisis* (1991) and *Ecstatic Antibodies: Resisting the AIDS Mythology* (1990).

In Britain as in the rest of Northern Europe, Australia, Canada and elsewhere in the developed world, HIV has had a vastly disproportionate impact upon gay and bisexual men compared to its effects on other social constituencies. One of the greatest challenges to the development of effective HIV/AIDS education, care and service provision stems from the fact that throughout the developed world powerful lobby groups — including churches, politicians, newspapers and others — continue to refuse to accept that gay men constitute a valid social constituency. Rather, we are frequently regarded simply as voluntary perverts, who have somehow 'chosen' our sexual orientation and, by extension, are thought to have 'chosen' to be vulnerable to HIV. Writing in the *Daily Telegraph*, Chaim Bermant epitomises widely held opinion:

> When I first heard of them they were known as bum-boys. Then it was nancy-boys, and pansies and fairies, and fruits and fags and faggots and poofs and poofters and queers and gays. Gays was the name they eventually chose. Now they are reverting to queers, but given their disposition should they not be calling themselves kamikazes? I ask the question in all seriousness, for they not only seem to have a death-wish themselves, but an apparent readiness to inflict death on others.[1]

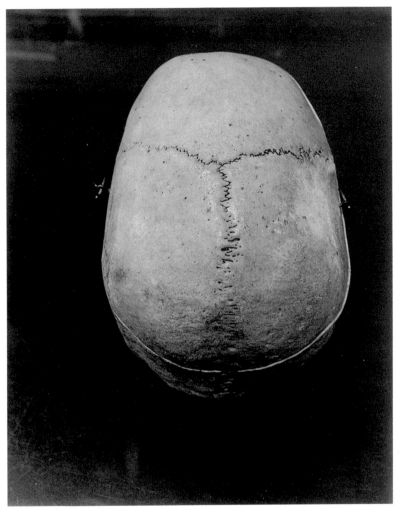

Marcus Bunyan, Australia, *How Will It Be When You have Changed* 1994, gelatin silver photograph. Courtesy of the artist.

When British gay filmmaker Derek Jarman died from AIDS earlier this year (1994) two British tabloid newspapers went to the extraordinary lengths of printing 'counter obituaries', belittling the man and his work at considerable length, whilst Liz Hodgkinson writing in the weekly *Spectator* concluded:

> Healthy he would have been largely ignored, or rightly condemned as a man who knowingly had sexual relations with complete strangers, even after he contracted the AIDS virus.[2]

However warped they may be, such judgements are profoundly instructive if we are seeking to understand the ways in which HIV/AIDS have been managed (and mismanaged) in different parts of the world. For example, it is clear that for Chaim Bermant, HIV is regarded as a voluntary condition, and gay men with HIV are automatically thought of as deliberate murderers. This is echoed by Liz Hodgkinson's evident inability to distinguish between safe and unsafe sex. As far as both are concerned, it is gay sex as such that is deadly, before and independent of HIV. This pathological hostility towards gay men is frequently projected onto us in such a way that the catastrophic effects of the epidemic are rationalised as if they were natural, inevitable and unavoidable. As I have observed elsewhere:

> This epidemic is unique in so far as its prevention has been prevented, rather than transmission. Resources and education campaigns have been remorselessly targeted at those at least risk of contracting HIV, as if the priority of preventing an epidemic amongst heterosexuals had been established at the expense of halting the epidemics that are actually raging throughout the developed world.[3]

Before the AIDS crisis, few gay men could expect to have much direct experience of death before the age of retirement. Older relatives died, and there were always the shocking, unexpected accidents of disease and chance. Now all that has changed in ways that are still frequently hard to acknowledge or make sense of. I am a gay man aged forty-five, and my address book already contains forty-two names of friends and colleagues who have died from AIDS, not including more casual acquaintances. Seven gay men I knew died from AIDS between February and July 1994, ranging from close, lifelong friends, to people who nonetheless make up the ordinary, taken for granted fabric of our social lives.

Friends with whom you shared a few precious, intense months, or years; friends you slept with two or three times and continued to see regularly in the bars and clubs, reassuringly; friends who helped you make sense of the world, and enlarged it for you; friends of friends, and so on. Some have lost more this year, some less.

In the early years of the epidemic many of us read accounts by American gay men about the scale of loss in their personal lives. Such accounts often

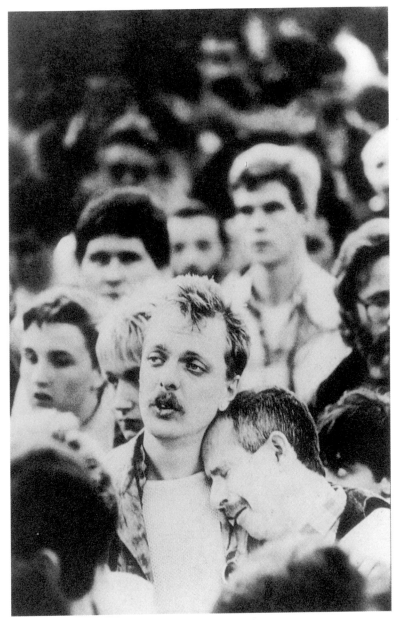

John Cole, United States, works in London, *Candlelight Vigil for AIDS, Trafalgar Square, London* 1986, gelatin silver photograph. Courtesy John Cole/Impact Photos, London.

seemed almost embarrassing, because they were seemingly exaggerated, and at the same time lacking in affectivity — the deaths were described flatly, almost without an emotional response. Indeed, I well remember running into a well-known gay activist in a clothes shop on Christopher Street in New York in the late 1980s. He poured out the story of how he'd set out to go to the funeral of an ex-lover, but instead had gone shopping, unable to face yet another funeral. 'You haven't lived', he explained, 'until you get used to *not* going to your best friends' funerals.' Five years later I understand his words and actions only too well. Writing now in the summer of 1994 in London, where the epidemic is running approximately five years behind the time-scale of mass infection and rate of disease progression in the US, I also understand something of the inner conflicts he must have been experiencing. There are only so many funerals one can attend in a month.

Many of us are now experiencing what amounts to a tidal wave of death, as increasing numbers of those infected in the early years of the epidemic reach the end of the line. We remember 'early' deaths before the mid-1980s, rare, unusual, and terrible for that reason. We also remember the gradual acceleration of deaths, as names disappear from memory, because there are simply too many to recall with the clarity of memory they properly deserve.

Sometimes deaths come in such dense clusters that individual deaths can be easily forgotten, and survivors often feel themselves unreal because we've not had time to mourn equally for everyone we've known and loved who has died. Sometimes the death of a comparative stranger takes on an intensity which stands, as it were, for many others we knew and loved better. One's whole social and emotional sense of the world is transformed. For example, there is only one gay man left who knew me in New York in my twenties and early thirties, and I am far from unusual in such grim experience.

All around the world gay men are living through increasingly routinised, regular processes of the sickness, dying and death of friends, regardless of our own known or perceived HIV status. And whatever films such as *Philadelphia* may suggest, few biological families in reality respond well to the needs of gay men with AIDS. In such circumstances, the task of memorialising the dead takes on a very particular significance. Sociologists who study patterns of death and mourning talk of 'family time' as a social process of care and support in relation to the entire process of dying.[4] Yet for

many (if not most) gay men who have been rejected by their families, such a luxury has never been available. Rather, we might think of the time of friendship, and gay community values, which may sustain us in ways parallel to those taken for granted by heterosexuals, for whom death generally involves direct next-of-kin. As the American writer Cookie Mueller, who died of AIDS in 1989, wrote in her last letter of friends of hers who had already died:

> These were the kind of people who lifted the quality of all our lives, their war was against ignorance, the bankruptcy of beauty and the truancy of culture. They were people who scorned pettiness, intolerance, bigotry, mediocrity, ugliness and spiritual myopia; the blindness that makes life hollow was unacceptable. They tried to make us see.[5]

Thus the questions of seeing and remembering take on a very special significance in relation to AIDS, since so many of those who have died were in any case largely invisible in their lives from the perspective of mainstream, heterosexual society. Furthermore, when so much information about people living with AIDS is obscured or distorted by journalists, priests, teachers and others, it is especially important that we who survive should be able to express something of the complex truth of the lives of those no longer here to speak for themselves. As Timothy Murphy has observed in a fine and thoughtful article:

> The grief of the epidemic and the incentive to memorialise are no mere biological reflexes — they are an assertion against the levelling effect of death that persons are not replaceable, that death does not nullify presence. They can also be important, if less commonly used, vehicles of moral wisdom and social criticism.[6]

In order to comprehend the *cultural* impact of AIDS it is necessary to be catholic and inclusive. In the first decade of the epidemic much activist art was produced with a clear sense of its communicative aims and objectives, much of which continues to stand the test of time. Yet in retrospect it seems to me that a wholly understandable early emphasis on collective political action and personal heroism functioned at least in part to displace deeper anxieties and uncertainties. That is why it is always important to periodise

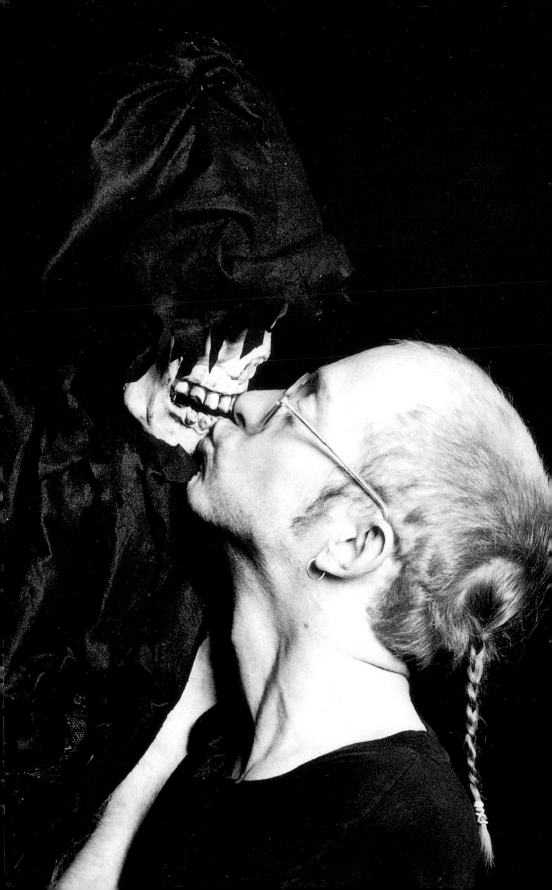

art produced in response to AIDS, and to specify its local context, as Jan Zita Grover has pointed out.[7] We should also strive to understand the institutional and ideological dimension involved in all cultural responses to the epidemic. For example, in her exemplary analysis of the role played by American charities in stimulating AIDS-associated works of art, whether for display or for auction, Kristen Engberg has noted the emergence of a clear strategy for:

> mainstreaming AIDS fundraising efforts ... Framing AIDS as simply a tragic disease to be cured while ignoring the more political aspects of the AIDS movement narrows the focus of concern to the physical body and the laboratory and renders a highly complex epic struggle wholly abstract. Everyone can be 'against AIDS' in the same way that everyone is 'for peace' ... ignoring the superstructure of neglect and legalised oppression (affecting class, race and sex relations) which has made AIDS a social and political crisis.[8]

At an opposite extreme, some contemporary artists regard all forms of public memorial art as intrinsically didactic and dogmatic, and have thus aimed to produce 'counter-monuments', on the grounds that all art reduces audiences to the role of passive spectatorship.[9] Commenting on Jochen Gerz and Esther Shalev-Gerz's 1986 *Monument Against Fascism* in Harburg, Germany, designed to disappear underground, critic James E. Young asks:

> How better to remember forever a vanished people than by a perpetually unfinished, ever-vanishing monument?[10]

One might, however, equally forcefully ask how an invisible monument is supposed to recall an invisible crime against humanity? One wonders what those who were 'effaced' by the Nazis might think of a 'self-effacing monument'.[11] For the issue here is not so much memory, as *forgetting*, at the level of both the social and the psychic. One is appalled but not entirely surprised to find not a single reference to gay men, or gypsies, in Young's monumental study of public memorials to the Holocaust. This is entirely contiguous with the widespread international tendency to deplore 'the global epidemic' whilst systematically repressing all precise references to those who

Bill Bytsura, United States, *Tigger* 1992, gelatin silver photograph. Courtesy of the artist.

Nayland Blake, United States, *Every 12 Minutes* 1991, clock movement, aluminium. Courtesy Matthew Marks Gallery, New York.

are most affected. Thus in Britain as elsewhere one frequently finds vague references to the 'tragedy' of children with AIDS, and 'innocent' heterosexual women, but almost never is there the slightest note of sorrow or regret for the 4291 gay and bisexual men who make up 76 per cent of the total of 5655 deaths from AIDS in the UK up to the end of 1993. The last thing we need in terms of our various local and national cultural responses to AIDS are the types of pretentiously over-intellectualised justifications for politically correct 'invisible monuments', or equally over-aestheticised 'self-destructing memorials' which in effect merely collude with the very processes of selective historical amnesia that effective memorial art is intended to arrest, or at least delay.

All around the world, millions of ordinary bum-boys, nancy-boys, pansies, fairies, fruits, fags, faggots, queers, poofs, poofters and gay men have contracted HIV, and by and large the leading institutions of national and international health have stood by and said and done precisely nothing on their behalf. They were not rounded up and put into cattle trucks and taken away to death camps, but their need for properly supportive HIV education has been equally systematically ignored in all but a handful of countries. In the meantime the arduous struggle to provide adequate health care, better

treatment drugs, proper social services and demonstrably effective community-based health education continues amongst the (largely invisible) carnage. Old political verities count for little in this context, when socialist France has fared even worse than Thatcherite Britain.[12] Certainly there can be no single approach or strategy for representing AIDS adequately or appropriately. To take just one example, sometimes straightforward captioned documentary photography will be necessary, and in other circumstances it will be inappropriate. This is the photographer's decision. We may be sure, however, that the cultural response to AIDS will be as various as its direct experience, ranging from the lives of people living with AIDS to those who have never knowingly set eyes on a person with AIDS.

In the course of the past ten years I have been closely involved in the development of an international cultural response to AIDS — a response that has, at the heart of this terrible crisis, with so much else to be done, nonetheless attempted also to pay heed to the ethical requirement to represent AIDS truthfully. Much bad art has been produced in response to AIDS, art which is every bit as sentimental or sensationalising or exploitative as the worst that the mass media have been able to offer. In a recent British television discussion about film censorship, right-wing Christian zealot Stephen Green from the Conservative Family Campaign, a 'pro-family' lobbying organisation of strongly homophobic disposition, provided a useful definition of how he and his sort think about art. He explained simply: 'Art that is good exalts. Art from The Pit must debase.'[13] I can only hope that our aesthetic responses to the whole subject of AIDS will remain properly and adequately sulphurous.

1. Chaim Bermant, 'Practising Some Lethal Preachings', *Daily Telegraph*, London, 3 September 1991, n.p.

2. Liz Hodgkinson, 'The Joy of Illness', *Spectator*, London: 16 April 1994, p.23.

3. Simon Watney, 'Powers of Observation', in *Practices of Freedom: Selected Writings on HIV/AIDS*, London: Rivers Oram Press, 1994, p.277.

4. See, for example David Clark (ed.), *The Sociology of Death*, Oxford: Blackwell Publishers/The Sociological Review, 1993.

5. Cookie Mueller, *Walking through Clear Water in a Pool Painted Black*, New York: Semiotext(e), 1990, pp.147-148.

6. Timothy F. Murphy, 'Testimony' in Timothy F. Murphy and Suzanne Poirier (eds) *Writing AIDS: Gay Literature, Language and Analysis*, New York: Columbia University Press, 1990, pp.318–319.

7. Jan Zita Grover, *AIDS: The Artist's Response*, Hoyt L. Sherman Gallery, Ohio State University, 1989, p.3.

8. Kristen Engberg, 'Art, AIDS and The New Altruism: Marketing the (ad)just(ed) Cause', *New Art Examiner*, Chicago, Vol.18, No.9, May 1991, p.22.

9. James E. Young, *The Texture of Memory: Holocaust Memorials and Meaning*, New Haven: Yale University Press, 1993, p.28.

10. Ibid., p.31.

11. Ibid. (illustrated pp.32–33).

12. See Simon Watney, 'Muddling Through: The UK Response to AIDS', in *Practices of Freedom: Selected Writings on HIV/AIDS*, London: Rivers Oram Press, 1994, p.3.

13. *Newsnight*, BBC-2, 12 April 1994.

America:
Where Angels Don't Fear To Tread

THOMAS SOKOLOWSKI is Director of the Grey Art Gallery and Study
Centre, New York University. He has curated a series of AIDS-related
exhibitions including 'Rosalind Solomon: Portraits in the Time of AIDS'
(1988), 'Getting the Word Out Down Under: Australian AIDS Posters' (1992),
and 'From Media to Metaphor: Art About AIDS' (1992, with Robert Atkins).
He is a founding member and current president of the board of the Visual
AIDS group, which is actively involved in the running of a number of AIDS-
responsive programs, such as Day Without Art.

The following thoughts are a somewhat free-form diary and remembrance
of the war against AIDS which has been raging in America for the last fourteen
years. It traverses many boundaries and enters many kingdoms: those of the
healthy and those of all the ill, some gay and some straight, some white and
some Black, some activist and others spiritual. All have their sentinels which
some might call angels. These sentinels are always watchful. In a sense, this
is their history.

Tony Kushner's monumental play, *Angels in America*, a Brobdingnagian
melodrama in two parts, struck a sensitive chord for those members of its
American audience who were open to its clarion warning about our national
discordance. Hardly the all-encompassing epic of gay life in the earliest days
of the AIDS epidemic — as it had been so anointed by well-meaning members
of the liberal press — the story, in truth, underlines the revelation that when
an American traverses prescribed boundaries of behaviour, norms of accepted
values, or breaks tribal taboos, disaster strikes. Ultimately, as the story plays
itself out, the tragedy is revealed to be not AIDS, but ostracism from one's

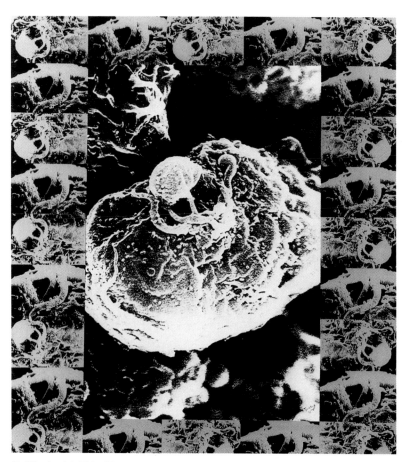

Carl Tandatnick, United States, *AIDS Virus on White Blood Cell / Grey (Virus) Border* 1993, silkscreen ink and paint on canvas. Private collection. © 1994 Carl Tandatnick, Photography: T. Schank.

people. Hence, in the final prologue, Prior Walter, the long-suffering AIDS patient, becomes the heroic Everyman; while the nefarious Roy Cohen, the tortured Jewish intellectual Louis Ironson (Prior's former lover) and the pathetic Mormon lawyer-factotum Joe Pitt — in Don Giovanni-like fashion — are consigned each to his own private hell. No tears shed. They did wrong. They transgressed. Using individual prologues as his mechanism, Kushner lets us know what we are in for: the first is delivered by an old Yiddish rabbi and the second by a resurrected Bolshevik — each a drag role played by the same actress. In the first prologue, the playwright, speaking in the heavily-accented voice of the aged rabbi, tells us that only those who have made the great journey across the ocean from the Old World to a New Land can know who they really are; the rest of us aimlessly wander in search of our own identities. In the second, a phantom anarchist regales us with his appreciation of the beauty of theory; theory that could send nations into tumult and workers into the streets, that would result in torrents of blood and never-ending suffering — all for the sake of theory. However, in the end, even when the battle would be forfeited, theory could not lose its lustre. If ever, he tells us, such a theory would arise again 'just imagine what we could do. All we need is a beautiful theory!'

In thinking about these angels in America, fenced in by their own myths and strictures, I am also drawn to another part of the New World, to Australia, and to the 'evil angels' who presided over the Azaria Chamberlain saga which convulsed the nation for six years. While Americans were only aware of the strange story of baby Azaria's disappearance through foreign news reportage and the second-hand re-telling in Fred Schepsi's film *Evil Angels* (re-titled *A Cry in the Dark* for American audiences), it was clear that the fate of the mother, Lindy Chamberlain, was decided not by the weight of the accumulated evidence brought against her, but by the hostile and unbelieving response of the public to her cool and detached demeanour. Worse still was her membership of the Seventh Day Adventist Church — the precepts of which seemed alien to most, and her loyalties suspect to even more. Who was she? What did she believe? How could she believe? How could she appear so calm when her baby had just been killed? She must be guilty. Her oddness was written all over her face. Regular people did not act like that. She must have done something wrong.

The antipodean response to an unthinkable act of nature was to absolve nature and brand Lindy Chamberlain a liar. Back in the USA the seemingly plain-spoken righteousness of Floridian, Kimberly Bergalis was equally emblematic of the American attitude towards AIDS. Bergalis, a twenty-something young woman, had reached national attention in 1991 with her claim that she had been exposed to the HIV virus during routine dental procedures performed by her doctor who, unbeknownst to her, was ill and subsequently died due to complications from HIV illness. Bergalis adamantly stated that she had never engaged in sexual activity nor had she ever used intravenous recreational drugs. In a posthumous note to family and friends, the dentist's confession caused a near hysterical response not only among the patients in his private practice, but also in many Americans; a situation which the American Dental Association has yet to completely mollify. All scientific evidence to the contrary, Bergalis's statement of purity and of no wrongdoing inveigled the American populace. Bergalis clinched her putative saint's, nay martyr's status during a dramatic seven-minute appearance before a Congressional Committee on AIDS in Washington in which the gaunt and clearly terminally-ill young woman intoned her well-rehearsed mantra: 'I did nothing wrong.' The nation believed her. She died three months later. Bergalis became — along with the haemophiliac teenager from Kokomo, Indiana, Ryan White, who had been beatified several years before — America's second acceptable votary in the AIDS pandemic. Unfortunately for Bergalis, during the summer of 1994 evidence seems to be growing that her purported chastity and guilelessness were a sham. Nevertheless, whatever the result of current ongoing medical investigations, the symbolic damage has already been done. In the minds of most Americans, certain of their fellow citizens *could* 'do nothing wrong' and still 'fall victim' to the effects of AIDS brought into the country by callous, sexually-promiscuous individuals — homosexual confederates of Patient Zero — who had done something wrong. Like Lindy Chamberlain, like Kimberly Bergalis, they fit the part. And certainly in a war, especially one sanctified by notions of moral probity and middle-class rectitude, one needs both victims and villains. All too easily the parts had been written and the roles cast.

A crisis is sustained by and is remembered through its symbols. Facts become muddled. Diagnoses tumble about one another. Cures are sought.

ACT UP/New York, United States, *No title [Screaming Head]*, T-shirt. Private collection, Canberra.

Causes are named. Medications are prescribed; some work, others do not. Body counts rise. Yet it is the symbols that remain long after the last death has been recorded and the first Nobel Prize has been awarded. While many in the AIDS activist movement have been critical of rhetorical gestures and emblematic devices, it has been in this realm that the art world has chosen to navigate and, I believe, in which it has been the most effective. Let's be clear to begin, lest there be any confusion. Art does not save lives in the way that drugs, medical care, and government-supported health care systems can save lives. Poetic elegies fall flat against a panoply of suffering and indifference. Street smarts serve a real purpose; ACT UP members indelibly proved this. Yet the street demonstrations by the members of ACT UP — so important in the early days of the pandemic in bringing public awareness of AIDS that resulted in lowering the costs of drug therapies like AZT — are remembered not so much for shrill cries and shouts or for the limp bodies of the resisting demonstrators, but for the terse, shocking and, yes, clever slogans which were highlighted in brilliant graphic treatment on each of the placards. In fact, for many, these slogans: 'Men use a condom or beat it', 'Women don't get AIDS. They just die from it', 'Silence = Death', become as indelible as the words of Kimberly Bergalis. (Douglas Crimp has artfully outlined the basis and genesis of such street graphics and their usage in his book *AIDS Demo graphics*.)

If there is an answer to the question, Is there an AIDS style?, it is the following: Yes, and it is hard, clean and fast, just like the activism which it supports and like the quick sell approach of American advertising that gave rise to it. The array of posters, T-shirts, and other ephemera that accompanies

Keith Haring (1958–1990) (for ACT UP/New York), United States, *Ignorance = Fear / Silence = Death / Fight AIDS / ACT UP* 1989, colour screenprint. National Gallery of Australia, Canberra, Gift of the Keith Haring Foundation 1993. © 1994 The Estate of Keith Haring.

'Don't Leave Me This Way' — itself a memorable phrase — makes this point perfectly clear. Spawned by an industry that could sell anything from washing-up powder to automobiles, the young artist-designers who were some of the founding members of ACT UP, and the artist collective Gran Fury that grew out of its membership, created a verbal and visual syllabary that is still effective today.

Perhaps the one symbol that has achieved international attention and acceptance more than any other has been the Red Ribbon. Officially a project of Visual AIDS, the Ribbon Project was created by members of that organisation's Artists' Caucus in an attempt to create an inexpensive, easily produced, user-friendly signifier to respond to the AIDS crisis. The ribbon itself was the direct descendent of the yellow ribbon, sometimes corsages of the stuff, which festooned the bosoms of grandmothers and war veterans alike during the jingoistic heyday of Operation Desert Storm in early 1991. (The yellow ribbon had been derived from a lyric in an old popular tune which encouraged young women to 'tie a yellow ribbon 'round the old oak tree' to remember a lover who was far away from home in gaol.) Since our fellow citizens had literally taken these decorations to wear 'over their hearts', the Artists' Caucus felt that such enthusiasm could be channelled as a vehicle for AIDS outreach. The rest is history. Ribbons now can be found everywhere: almost as portable bits of the NAMES Project Quilt, their homespun appeal

does not seem to slacken, even with time. Elizabeth Taylor, Miss America, Liza Minnelli, and, even for a scant moment, the former First Lady, Barbara Bush, have all sported red ribbons. As originally designed, they could be made by anyone, were not meant to be sold, co-opted or commodified. Their very neutrality has occasioned jewelled versions, balloon versions, and even edible candy versions, as well as their ubiquitous accessorising at each and every awards ceremony from the Academy Awards to the Country and Western Music Hall of Fame Gala. Such popularisation has brought criticism from activist circles, particularly from many within the gay community, who decry the ribbon as a sop for middle-class do-gooders. Everyone who wears one becomes suspect. People who wear red ribbons, say critics, are not serious. They eschew serious AIDS actions in favour of facile heart-on-the-sleeve trinkets. Certainly, some wear ribbons for the wrong reasons. Yet, for many, far from large urban areas where AIDS information and circles of AIDS supporters are legion, the ribbon has become an emblem of support in places where AIDS disinformation is rife and where bigotry still needs to be fought. For the mothers of PWAs in rural communities, the making and wearing of red ribbons becomes as much a heroic act as any street demonstration in New York City. If the critical response to the Red Ribbon has taught Americans (and Australians, as Ted Gott explains elsewhere in this publication) anything, it is that people will help, can be made to understand, and will be supportive if they are consulted about their own needs and concerns.

As one moves out from the streets into the galleries and museums, the situation becomes cloudy. Motives become suspect. Players and their plays are not quite so clearly and easily demarcated. It had been in this arena that Visual AIDS, an organisation of artworkers dedicated to bringing about an end to the ignorance that surrounds the AIDS pandemic, chose to work. Visual AIDS, of which I was one of the four founders in 1988 — the other founders were Robert Atkins, an art critic for the *Village Voice* newspaper; Gary Garrels, curator at the DIA Art Foundation; and the late William Olander, curator at the New Museum of Contemporary Art — has been extremely active in the organisation of nationwide events to encourage, facilitate, and highlight AIDS-related exhibitions and programs in the art world 'to increase awareness and encourage discussion of these programs and the pressing social issues that AIDS raises within American Society'. Given the sacrosanct image with

Rosalind Solomon, United States, *Untitled*, from *Portraits in the Time of AIDS*, a series of 60 works (*No I*) 1988, gelatin silver print. Courtesy of the artist.

which Americans have imbued our cultural institutions, it was felt appropriate to use these hallowed halls as fertile ground upon which to plant the educational seeds which would then blossom in the face of an unsuspecting public.

The best-known activity of Visual AIDS has been the annual Day Without Art, a commemoration on the first day of December, which coincides with the World Health Organisation's AIDS Awareness Day. Subtitled 'a national day of action and mourning in response to the AIDS crisis', this event hoped to encourage all methods of remembrance and pro-active participation; a duality which Douglas Crimp has so eloquently discussed in his essay 'Mourning and militancy'. It became immediately clear that any cookie-cutter franchising of the nation's art institutions (let alone the communities that supported them) under a single artistic rubric would not work. Rather, an eclectic call for action, whether it be elegiac, memorialising, or activist in tone seemed to be in order. For the first year, namely 1989, some eight hundred cultural institutions responded. By the fifth anniversary of the event in 1993, over eight thousand museums, galleries, alternative spaces, cinemas, dance and opera companies, and universities worldwide produced a rich banquet of events to recognise PWAs and their care-givers. Recalling my invocation at the beginning, of those American angels who guard territorial boundaries, each venue chose to speak in the tongue that would touch its respective audience, resulting in a kind of artistic Pentecost. Thus, the Jewish Museum in New York City led a prayer/discussion service which encouraged Jews to view the AIDS crisis in the light of past oppressions and to use the Jewish religious and ethnic cultural traditions as bulwarks in this conflict;

(continued on page 87)

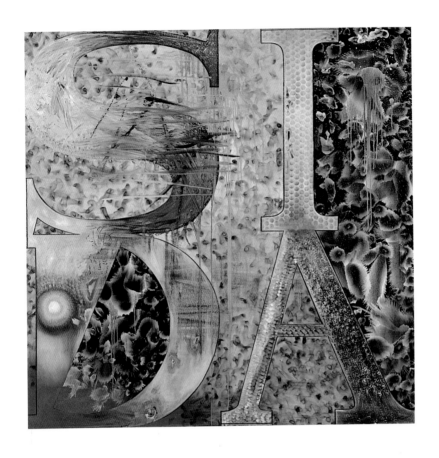

Juan Davila, Chile/Australia, *LOVE* 1988, oil on canvas.
Courtesy Tolarno Galleries, Melbourne.

RIDGEWAY BENNETT, South Africa/Great Britain, *Reactive Armour* 1990, semen, wax, vinyl, resin on metal studs. Courtesy of the artists and Wessel O'Connor Gallery, New York.

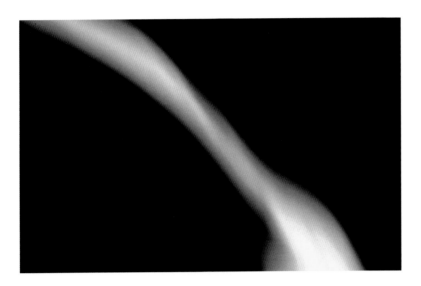

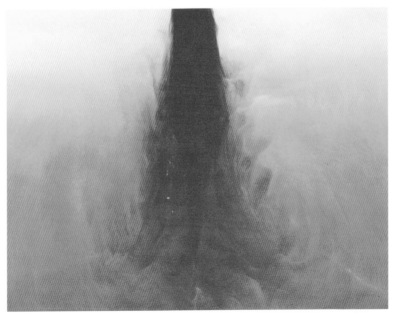

Andres Serrano, United States, *Untitled XIII (Ejaculate in Trajectory)* 1989, cibachrome. Courtesy Paula Cooper Gallery, New York.

Andres Serrano, United States, *Bloodstream* 1987, cibachrome. Courtesy Paula Cooper Gallery, New York.

James Barrett and **Robin Forster,** Great Britain, *X-Ray Series #1* (top), *X-Ray Series #3* (bottom) 1992, x-rays. Collection James Barrett and Robin Forster.

Brenton Heath-Kerr, Australia, *Homosapien* 1994, laminated photomechanical reproductions and cloth. Collection Brenton Heath-Kerr. Concept/design: Brenton Heath-Kerr, Photography: John Weber, Art direction: Brendon Williamson.

(following pages) **Michele Barker**, Australia, *Lets Fuck* 1992, Type C photographic prints. Collection Michele Barker.

Lets...

Cindy Sherman, United States, *Untitled #179* 1987, colour photograph. Courtesy Metro Pictures, New York.

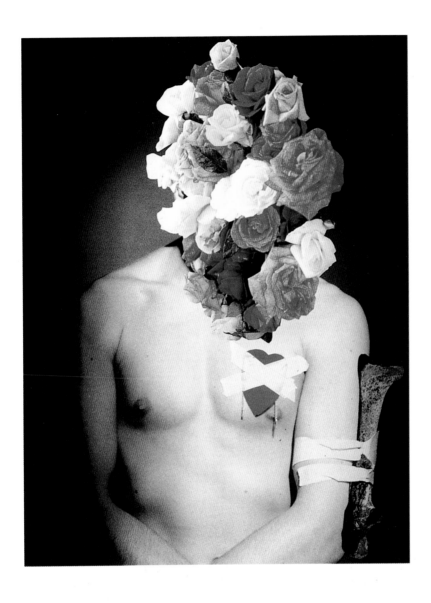

Peter Lyssiotis, Australia, *'Billy Says That a Person's Broken Heart Can Sometimes Smell of Roses'* from *The Harmed Circle* 1992, cibachrome photograph. National Gallery of Australia, Canberra.

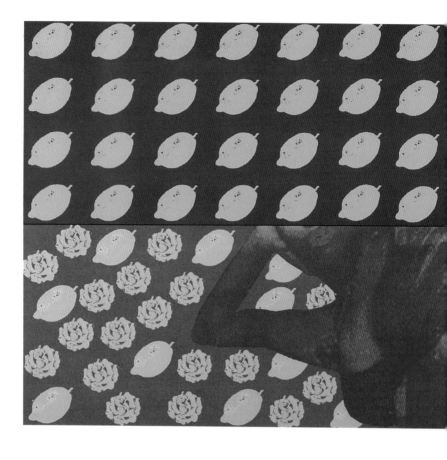

Rea, Australia, *Lemons I–IV* 1994, four computer-generated Type C photographs. Panel I, Collection David Abello, Sydney; Panels I I–IV, Collection of the artist.

 HOW TO USE A DAM **HOW TO USE A DAM**

possible transmission of HIV during Oral sex, spread the dam over the entire vulva opening and clitoris, holding the edges of the Dam ntact, use the Dam to cover the anus. 3. Use a water-based lubricant between the dam and partner. 4. Always use separate Dams for nd oral/anal sex. 5. Use a new Dam each time. Dams may take a bit of getting used to, they may slow sex down... but think about it se.

 HOW TO USE A DAM 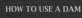 **HOW TO USE A DAM**

possible transmission of HIV during Oral sex, spread the dam over the entire vulva opening and clitoris, holding the edges of the Dam ntact, use the Dam to cover the anus. 3. Use a water-based lubricant between the dam and partner. 4. Always use separate Dams for nd oral/anal sex. 5. Use a new Dam each time. Dams may take a bit of getting used to, they may slow sex down... but think about it se.

 HOW TO USE A DAM **HOW TO USE A DAM**

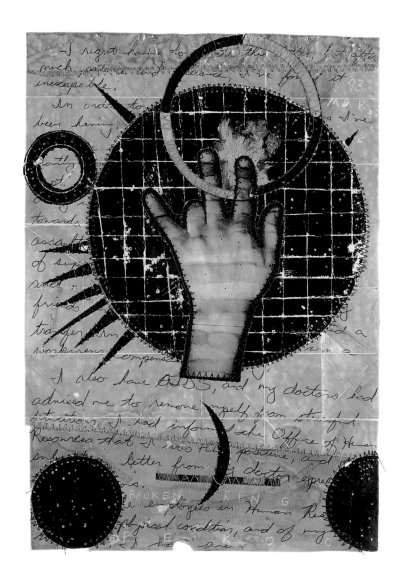

Christopher Pekoc, United States, *Broken Ring* 1993, paper, shellac, colour and black and white photocopies with machine stitching. Courtesy Julie Saul Gallery, New York.

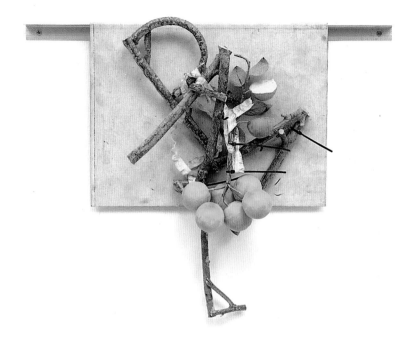

Nayland Blake, United States, *Bouquet #6* 1991, aluminium, wood, artificial fruit and leaves, fabric ribbon. Courtesy Matthew Marks Gallery, New York.

Franka Sena, Australia, *Sear* 1993, construction (wood, paint). Courtesy of the artist.
Photography: Freak Me Productions, Melbourne.

"If I had a dollar to spend for healthcare I'd rather spend it on a baby or innocent person with some defect or illness not of their own responsibility; not some person with AIDS..." says the texas healthcare official and I can't even remember what he looks like I reached in through the t.v. screen and ripped his face in half I was told I have ARC recently and this was after watching seven friends die in the last two years slow vicious unnecessary deaths because fags and dykes and drug addicts are expendable in this country "If you want to stop AIDS shoot the queers..." says the ex-governor of texas and I'm carrying this rage like a blood filled egg and there's a thin line between the inside and the outside a thin line between thought and action and that line is simply made up of blood and muscle and bone I'm waking up more and more from daydreams of tipping amazonian blowdarts in 'infected blood' and spitting them at the exposed necklines of certain politicians or nazi-preachers or government healthcare officials or the rabid strangers parading against AIDS clinics in the nightly news suburbs there's a thin line a very thin line and as each T-cell disappears from my body it's replaced by ten pounds of pressure ten pounds of rage and I focus that rage into non-violent resistance but that focus is starting to slip my hands are beginning to move independent of thought the egg is starting to crack america seems to understand murder as a self defense against those who would murder us and it's been murder on a daily basis for eight long years in this killing machine called america and I know there's certain politicians that better increase their security forces there's walking swastikas in the forms of religious leaders and healthcare officials that had better get bigger dogs and higher fences and more complex security alarms for their homes and queer-bashers better start doing their work from inside howitzer tanks because the thin line between the outside and the inside is beginning to erode and at the moment I'm a sixteen foot tall five hundred and seventy two pound man inside this six foot frame and all I can feel is the pressure all I can feel is the pressure and the need for release.

David Wojnarowicz (1954–1992), United States, *Untitled (for ACT UP)* 1990, silkscreen, two panels. Courtesy P.P.O.W. Gallery, New York.

Rosalind Solomon, United States, *Untitled*, from *Portraits in the Time of AIDS*, a series of 60 works (*No XV*) 1988, gelatin silver print. Courtesy of the artist.

(Afro PoMo Homos, a collective of gay African–American performance artists appeared at the Studio Museum in Harlem in front of a predominantly Black audience and chronicled the struggles of being gay in an aggressively homophobic Black community; the Guggenheim Museum in New York draped the façade of its landmark rotunda with a massive black mourning banner; university galleries engaged groups of students in candlelight memorial processions and protest cordons around their facilities to focus academic administrative attention on the needs of PWAs. The very heterogeneity of the participants' programming reflects the varying needs and concerns of their respective communities. We on the New York City steering committee of Visual AIDS quickly saw that a celebration of the diversity of communities could only help in the fight against AIDS. No one community could attempt to speak for any other, to strive to untie tongues which the pandemic had silenced. As Visual AIDS begins to plan for the sixth convening of Day Without Art, we are aware that the event has perhaps become calcified and we are endeavouring to suit the program to the needs of our diverse communities by turning to the needs of PWA artists as our chief concern, aka *our* immediate community. Through the establishment of archival photographing and registration of bodies of work of PWA artists, the creation of an emergency fund, and a facilitation of a system that would link artists with suppliers of free art materials, Visual AIDS continues to serve the needs of the arts community at large.

(left) **Derek Jarman** (1942–1994), Great Britain, *Blood* 1992, oil on photocopy on canvas. Courtesy Richard Salmon Ltd, London.

Elsewhere in this publication, Jan Zita Grover speaks of the complex and bloody history of AIDS documentary photography and AIDS portraiture, a history that, at times, has pitted artists against PWAs, artists against activists, and even activists against PWAs. Remarkably, work by photographers such as Rosalind Solomon and Nicholas Nixon, that was decried in 1988, is now seen as historically important and even moving. The notion of the imaging of AIDS has been the key issue in the art world during the past eight years. And while the discussion has been an important one, at base, dialogue too often has turned into diatribe from every side. As I have been noting throughout these remarks, the notion of just who will speak for and on behalf of whom is the contentious sticking point. The fourteen years of the AIDS crisis have taught us here in America that there are simply no universals and any attempt to impose them is not only foolhardy, but also destructive. A recent exhibition, 'From Media to Metaphor: Art About AIDS', travelled for over two years to nine venues in North America. Robert Atkins and I served as co-curators, and we tried to give some shape to the history and variety of AIDS-related art; an approach which, I believe, is being mirrored in 'Don't Leave Me This Way'. By its very title, 'From Media to Metaphor' took the widest of berths by including representational and abstract works, media-derived graphics, video and projection installations as well as diaristic photography and activist materials. Culled from over six years of art produced during and about the AIDS crisis, the work was as diverse as the nation whose artists produced it. Some works could be seen to be both formally and theoretically in conflict with one another, yet the overall quality and impact of the aggregate was not questioned. (The same could be said for all of the works included in the present exhibition at the National Gallery of Australia.) Just to give one example: whereas Andres Serrano's *Untitled XIII* *(Ejaculate in Trajectory)* might be confused as pure abstraction, its milky-white burst of sexual release tainted with the HIV virus, Donald Moffett's *Call the White House (for ACT UP)* street handout makes obvious the message and the action to be taken — its indictment: Do this or else! Yet, as the exhibition concluded its tour at the Grey Art Gallery and Study Centre of New York University — the institution for which I serve as the director — it became obvious that artwork dealing with the AIDS crisis had reached a watershed.

With the election of Bill Clinton to the American presidency in November of 1992, the AIDS activist movement succeeded in bringing the issue of AIDS to the American people and one could feel, for the first time, that a federal administration would respond quickly and wisely to the needs of all people with AIDS. The double-headed Republican monster of the Reagan–Bush years had been slain. As we have come to learn after some eighteen months into the Clinton administration, the rhetoric has continued to be silky, but action has been slow and, too oftentimes, invisible. While the current President has proved himself to be ineffectual on this and other issues, he and his administration cannot, at least as yet, be deemed as demons. And without a monster to slay, the battle loses some of its direction and speed. Thus, membership in activist groups like ACT UP has diminished; fundraising events planned by the American Foundation for AIDS Research (AmFAR) — the big daddy of AIDS philanthropy — have failed to fill their coffers; politicians' attention to the AIDS crisis since the November 1992 campaign has flagged; communities of colour, in large part, have not been properly addressed by mainstream white or gay-centric organisations; the infection rates of adolescents in the United States, even among young gay men who previously had adhered diligently to safer sex practices, are up; and none of these points even begins to look at the problematics of AIDS in developing nations. Therefore, it should not be surprising that the numbers of new artworks created about AIDS have also been on the decline.

I think that to attribute this general diminution to simple organisational and individual burn-out misses the point. Certainly, the ranks have been severely weakened by the myriad deaths of members who were themselves PWAs. Survivors have been savagely undermined by losses of compatriots for whom they have not given themselves the time to mourn. The epidemic has moved out of the white, gay male community from which all of the aforementioned organisations have drawn their direction, support and, yes, money. The gay community has been loath to give up control of the AIDS movement as the epidemic has turned to new breeding grounds.

As of this writing in mid-1994, the AIDS movement in America, throughout all of the islands that comprise its complex archipelago, is searching for a new voice or voices to speak about a crisis that has not ended, but simply has mutated into something else. The harsh, frightening rhetoric of the early 1980s now seems unnecessarily strident and ineffectual. The ghastly images

needed to jolt us out of our complacency have lost their sting, perhaps through extended use, perhaps because the public has become more aware. Those angels in America seem to be sitting on their wings. No flaming tongues are flickering atop our heads to free our tongues. I am confident that new voices, speaking in new tongues, certainly will arise to take the place of the old. And, lest I sound too biblical about it, a new covenant will be struck. Art about AIDS will continue to help abate ignorance and bigotry. It cannot help to save lives, but it can help the rest of us to live. What form it will take as we move towards the next millennium remains to be seen. The focus will be upon us. And, perhaps, it will take root outside of America and make its way back to us on the same journey that we all once made. No matter, the sentinels will be there.

Thomas W. Sokolowski
New York City
August 1994

The War on Culture

CAROLE S. VANCE, an anthropologist at the Columbia University School of Public Health in New York, writes about sexuality, gender and policy. She is the editor of *Pleasure and Danger: Exploring Female Sexuality* (1984; 2nd edition, Pandora, 1992), a contributor to *Caught Looking: Feminism, Pornography, and Censorship*, and the author of many articles about representation and cultural politics. She has been a visiting Fellow in Sexualities and Culture at the Humanities Research Centre, Australian National University.

Carole Vance's essay, 'The War on Culture' was first published in the September 1989 issue of *Art in America*; and we are grateful to both the author and to *Art in America* for permission to reprint it here. The 'Afterword: The War on Culture Continues, 1989–94' was written especially for this volume.

As recent congressional attacks on public funding of controversial art works testify, the right-wing campaign against 'blasphemous' and 'pornographic' images, previously aimed at the mass media, is now being directed at high culture.

The storm that had been brewing over the National Endowment for the Arts (NEA) funding broke on the Senate floor on 18 May [1989], as Senator Alfonse D'Amato rose to denounce Andres Serrano's photograph *Piss Christ* as 'trash'. 'This so-called piece of art is a deplorable, despicable display of vulgarity', he said. Within minutes over 20 Senators rushed to join him in sending a letter to Hugh Southern, acting chair of the NEA, demanding to know what steps the agency would take to change its grant procedures. 'This work is shocking, abhorrent and completely undeserving of any recognition whatsoever', the Senators wrote.[1] For emphasis, Senator D'Amato

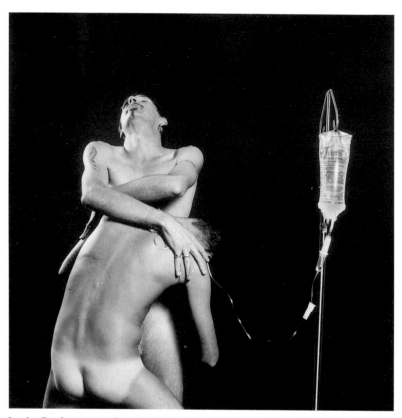

Jamie Dunbar, Australia, *Posithiv Sex Happens* 1993, gelatin silver photograph. Courtesy of the artist.

dramatically ripped up a copy of the exhibition catalogue containing Serrano's photograph.

Not to be outdone, Senator Jesse Helms joined in the denunciation: 'The Senator from New York is absolutely correct in his indignation and in his description of the blasphemy of the so-called art work. I do not know Mr Andres Serrano, and I hope I never meet him. Because he is not an artist, he is a jerk.' He continued, 'Let him be a jerk on his own time and with his own resources. Do not dishonour our Lord.'[2]

The object of their wrath was a 60 x 40 inch Cibachrome print depicting a wood-and-plastic crucifix submerged in yellow liquid — the artist's urine. The photograph had been shown in an uneventful three-city exhibit organised by the Southeastern Centre for Contemporary Art (SECCA), a recipient of NEA funds. A juried panel appointed by SECCA had selected Serrano and nine others from some 500 applicants to win $15,000 fellowships and appear in the show, 'Awards in the Visual Arts 7'. How the Senators came to know and care about this regional show was not accidental.

Although the show had closed by the end of January 1989, throughout the spring the right-wing American Family Association, based in Tupelo, Mississippi, attacked the photo, the exhibition and its sponsors. The association and its executive director, United Methodist minister Rev. Donald Wildmon, were practised in fomenting public opposition to allegedly 'immoral, anti-Christian' images and had led protests against Martin Scorsese's film *The Last Temptation of Christ* the previous summer. The AFA newsletter, with an estimated circulation of 380,000 including 178,000 churches, according to association spokesmen,[3] urged concerned citizens to protest against the art work and demand that responsible NEA officials be fired. The newsletter provided the relevant names and addresses, and letters poured in to congressmen, Senators and the NEA. A full-fledged moral panic had begun.

Swept up in the mounting hysteria was another photographic exhibit scheduled to open on 1 July at the Corcoran Gallery of Art in Washington, DC. The 150-work retrospective, 'Robert Mapplethorpe: The Perfect Moment', was organised by the University of Pennsylvania's Institute of Contemporary Art (ICA), which had received $30,000 for the show from the NEA. The show

included the range of Mapplethorpe's images: formal portraiture, flowers, children and carefully posed erotic scenes — sexually explicit, gay and sadomasochistic. The show had been well received in Philadelphia and Chicago but, by 8 June, Representative Dick Armey (R-Tex) sent Southern a letter signed by over 100 congressmen denouncing grants for Mapplethorpe as well as for Serrano, and threatening to seek cuts in the agency's $170-million budget soon up for approval. Armey wanted the NEA to end its sponsorship of 'morally reprehensible trash',[4] and he wanted new grant guidelines that would 'clearly pay respect to public standards of taste and decency'.[5] Armey claimed he could 'blow their budget out of the water'[6] by circulating the Mapplethorpe catalogue to fellow legislators prior to the House vote on the NEA appropriation. Before long, about 50 Senators and 150 representatives had contacted the NEA about its funding.[7]

Amid these continuing attacks on the NEA, rumours circulated that the Corcoran would cancel the show. Director Christina Orr-Cahall staunchly rejected such rumours one week, saying, 'This is the work of a major American artist who's well known, so we're not doing anything out of the ordinary.'[8] But by the next week she had caved in, saying, 'We really felt this exhibit was at the wrong place at the wrong time.'[9] The director attempted an ingenious argument in a statement issued through a museum spokesperson: far from being censorship, she claimed, the cancellation actually protected the artist's work. 'We decided to err on the side of the artist, who had the right to have his work presented in a non-sensationalised, non-political environment, and who deserves not to be the hostage for larger issues of relevance to us all', Orr-Cahall stated. 'If you think about this for a long time, as we did, this is not censorship; in fact, this is the full artistic freedom which we all support.'[10] Astounded by the Corcoran decision, artists and arts groups mounted protests, lobbied and formed anti-censorship organisations, while a local alternative space, the Washington Project for the Arts (WPA), hastily arranged to show the Mapplethorpe exhibition.

The Corcoran cancellation scarcely put an end to the controversy, however. Instead, attacks on NEA funding intensified in the House and Senate, focusing on the 1990 budget appropriations and on new regulations that would limit or possibly end NEA subcontracts to arts organisations.[11] Angry representatives wanted to gut the budget, though they were beaten back in the House by more moderate amendments which indicated disapproval of

the Serrano and Mapplethorpe grants by deducting their total cost ($45,000) from next year's allocation. By late July, Senator Jesse Helms introduced a Senate amendment that would forbid the funding of 'offensive', 'indecent' and otherwise controversial art and transfer monies previously allocated for visual arts to support 'folk art' and local projects. The furore is likely to continue throughout the fall, since the NEA will be up for its mandated, five-year reauthorisation, and the right-wing campaign against images has apparently been heartened by its success. In Chicago, for example, protesters assailed an Eric Fischl painting of a fully clothed boy looking at a naked man swinging at a baseball on the grounds that it promoted 'child molestation' and was, in any case, not 'realistic', and therefore bad art.[12]

The arts community was astounded by this chain of events — artists personally reviled, exhibitions withdrawn and under attack, the NEA budget threatened, all because of a few images. Ironically, those who specialise in producing and interpreting images were surprised that any images could have such power. But what was new to the art community is, in fact, a staple of contemporary right-wing politics.

In the past ten years, conservative and fundamentalist groups have deployed and perfected techniques of grass-roots and mass mobilisation around social issues, usually centring on sexuality, gender and religion. In these campaigns, symbols figure prominently, both as highly condensed statements of moral concern and as powerful spurs to emotion and action. In moral campaigns, fundamentalists select a negative symbol which is highly arousing to their own constituency and which is difficult or problematic for their opponents to defend. The symbol, often taken literally, out of context and always denying the possibility of irony or multiple interpretations, is waved like a red flag before their constituents. The arousing stimulus could be an 'un-Christian' passage from an evolution textbook, explicit information from a high school sex-education curriculum or 'degrading' pornography said to be available in the local adult bookshop. In the anti-abortion campaign, activists favour images of late-term foetuses or, better yet, dead babies displayed in jars. Primed with names and addresses of relevant elected and appointed officials, fundamentalist troops fire off volleys of letters, which cowed politicians take to be the expression of popular sentiment. Right-wing politicians opportunistically ride the ground-swell of outrage, while centrists feel anxious and disempowered to stop it — now a familiar sight in the political landscape. But here, in the NEA controversy, there is something new.

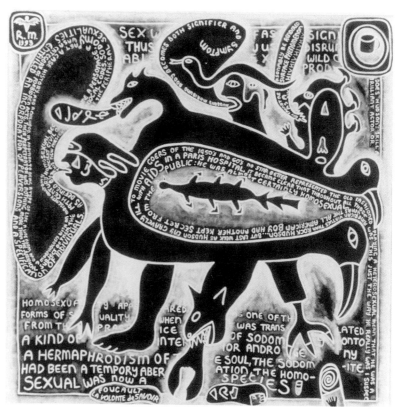

Ross Moore, Australia, *Of the Visible and Hidden* 1992–93 (detail), acrylic on linen (triptych). Courtesy of the artist.

Fundamentalists and conservatives are now directing mass-based symbolic mobilisations against 'high culture'. Previously, their efforts had focused on popular culture — the attack on rock music led by Tipper Gore, the protests against *The Last Temptation of Christ* and the Meese Commission's war against pornography.[13] Conservative and neo-conservative intellectuals have also lamented the allegedly liberal bias of the university and the dilution of the classic literary canon by including 'inferior' works by minority, female and gay authors, but these complaints have been made in books, journals and conferences, and have scarcely generated thousands of letters to Congress. Previous efforts to change the direction of the NEA had been made through institutional and bureaucratic channels — by appointing more conservative members to its governing body, the National Council on the Arts, by selecting

a more conservative chair and in some cases by overturning grant decisions made by professional panels. Although antagonism to Eastern elites and upper-class culture has been a thread within fundamentalism, the NEA controversy marks the first time that this emotion has been tapped in mass political action.

Conservative columnist Patrick Buchanan sounded the alarm for this populist attack in a *Washington Times* column last June [1989], calling for 'a cultural revolution in the '90s as sweeping as the political revolution in the '80s'.[14] Here may lie a clue to this new strategy: the Reagan political revolution has peaked, and with both legislatures under Democratic control, additional conservative gains on social issues through electoral channels seem unlikely. Under these conditions, the slower and more time-consuming — though perhaps more effective — method of changing public opinion and taste may be the best available option. For conservatives and fundamentalists, the arts community plays a significant role in setting standards and shaping public values: Buchanan writes, 'The decade has seen an explosion of anti-American, anti-Christian, and nihilist "art" ... [Many museums] now feature exhibits that can best be described as cultural trash',[15] and 'as in public television and public radio, a tiny clique, out of touch with America's traditional values, has wormed its way into control of the arts bureaucracy.'[16] In an analogy chillingly reminiscent of Nazi cultural metaphors, Buchanan writes, 'As with our rivers and lakes, we need to clean up our culture: for it is a well from which we must all drink. Just as a poisoned land will yield up poisonous fruits, so a polluted culture, left to fester and stink, can destroy a nation's soul.'[17] Let the citizens be warned: 'We should not subsidise decadence.'[18] Amid such archaic language of moral pollution and degeneracy, it was not surprising that Mapplethorpe's gay and erotic images were at the centre of controversy.

The second new element in the right's mass mobilisation against the NEA and high culture has been its rhetorical disavowal of censorship per se and the cultivation of an artfully crafted distinction between absolute censorship and the denial of public funding. Senator D'Amato, for example, claimed, 'This matter does not involve freedom of artistic expression — it does involve the question whether American taxpayers should be forced to support such trash.'[19] In the battle for public opinion, 'censorship' is a dirty word to mainstream audiences, and hard for conservatives to shake off because their

recent battles to control school books, libraries and curricula have earned them reputations as ignorant book-burners. By using this hairsplitting rhetoric, conservatives can now happily disclaim any interest in censorship, and merely suggest that no public funds be used for 'offensive' or 'indecent' materials.[20] Conservatives had employed the 'no public funds' argument before, to deny federal funding for Medicaid abortions since 1976, and explicit safe-sex education for AIDS more recently. Fundamentalists have attempted to modernise their rhetoric in other social campaigns, too — anti-abortionists borrow civil rights terms to speak about the 'human rights' of the foetus, and anti-porn zealots experiment with replacing their language of sin and lust with phrases about the 'degradation of women' borrowed from anti-pornography feminism. In all cases, these incompatible languages have an uneasy coexistence. But modernised rhetoric cannot disguise the basic, censorious impulse which strikes out at NEA public funding precisely because it is a significant source of arts money, not a trivial one.

NEA funding permeates countless art institutions, schools and community groups, often making the difference between survival and going under; it also supports many individual artists. That NEA funds have in recent years been allocated according to formulas designed to achieve more democratic distribution — not limited to elite art centres or well-known artists — makes their impact all the more significant. A requirement that NEA-funded institutions and artists conform to a standard of 'public taste', even in the face of available private funds, would have a profound impact. One obvious by-product would be installing the fiction of a singular public with a universally shared taste and the displacement of a diverse public composed of many constituencies with different tastes. In addition, the mingling of NEA and private funds, so typical in many institutions and exhibitions, would mean that NEA standards would spill over to the private sector, which is separate more in theory than in practice. Although NEA might fund only part of a project, its standards would prevail, since non-compliance would result in loss of funds.

No doubt the continuous contemplation of the standards of public taste that should obtain in publicly funded projects — continuous, since these can never be known with certainty — will itself increase self-censorship and caution across the board. There has always been considerable self-censorship in the art world when it comes to sexual images, and the evidence indicates that it

is increasing: reports circulate about curators now examining their collections anew with an eye toward 'disturbing' material that might arouse public ire, and increased hesitation to mount new exhibitions that contain unconventional material. In all these ways, artists have recognised the damage done by limiting the types of images that can be funded by public monies.

But more importantly, the very distinction between public and private is a false one, because the boundaries between these spheres are very permeable. Feminist scholarship has shown how the most seemingly personal and private decisions — having a baby, for example — are affected by a host of public laws and policies, ranging from available tax benefits to health services to day care. In the past century in America and England, major changes in family form, sexuality and gender arrangements have occurred in a complex web spanning public and private domains, which even historians are hard put to separate.[21] In struggles for social change, both reformers and traditionalists know that changes in personal life are intimately linked to changes in public domains — not only through legal regulation, but also through information, images and even access to physical space available in public arenas.

This is to say that what goes on in the public sphere is of vital importance for both the arts and for political culture. Because American traditions of publicly supported culture are limited by the innate conservatism of corporate sponsors and by the reduction of individual patronage following changes in the tax laws, relegating controversial images and art work to private philanthropy confines them to a frail and easily influenced source of support. Even given the NEA's history of bureaucratic interference, it is paradoxically public funding — insulated from the day-to-day interference of politicians and special-interest groups that the right wing would now impose — that permits the possibility of a heterodox culture. Though we might reject the overly literal connection that conservatives like to make between images and action ('When teenagers read sex education, they go out and have sex'), we know too that diversity in images and expression in the public sector nurtures and sustains diversity in private life. When losses are suffered in public arenas, people for whom controversial or minority images are salient and affirming suffer a real defeat. Defending private rights — to behaviour, to images, to information — is difficult without a publicly formed and visible community. People deprived of images become demoralised and isolated,

and they become increasingly vulnerable to attacks on their private expressions of nonconformity, which are inevitable once sources of public solidarity and resistance have been eliminated.

For these reasons, the desire to eliminate symbols, images and ideas which they do not like from public space is basic to contemporary conservatives' and fundamentalists' politics about sexuality, gender and the family. On the one hand, this behaviour may signal weakness, in that conservatives no longer have the power to directly control, for example, sexual behaviour, and must content themselves with controlling by proxy, images of sexual behaviour. The attack on Mapplethorpe's images, some of them gay, some sadomasochistic, can be understood in this light. Indeed, the savage critique of his photographs permitted a temporary revival of a vocabulary — 'perverted, filth, trash' — that was customarily used against gays but had become unacceptable in mainstream political discourse, a result of sexual liberalisation that conservatives hate. On the other hand, the attack on images, particularly 'difficult' images in the public domain, may be the most effective point of cultural intervention now — particularly given the evident difficulty liberals have in mounting a strong and unambivalent response and given the way changes in public climate can be translated back to changes in legal rights — as, for example, in the erosion of support for abortion rights, where the image of the foetus has become central in the debate, erasing the image of the woman.

Because symbolic mobilisations and moral panics often leave in their wake residues of law and policy that remain in force long after the hysteria has

John Schlesinger, United States, *Untitled* 1992-1994 (detail), selenium-toned gelatin photograph mounted on steel saw-blade. Courtesy Julie Saul Gallery, New York.

subsided,[22] the fundamentalist attack on art and images requires a broad and vigorous response that goes beyond appeals to free speech. Free expression is a necessary principle in these debates, because of the steady protection it offers to all images, but it cannot be the only one. To be effective and not defensive, the art community needs to employ its interpretative skills to unmask the modernised rhetoric that conservatives use to justify their traditional agenda, as well as to deconstruct the 'difficult' images that fundamentalists choose to set their campaigns in motion. Despite their uncanny intuition for culturally disturbing material, their focus on images also contains many sleights of hand (Do photographs of nude children necessarily equal child pornography?), and even displacements,[23] which we need to examine. Images we would allow to remain 'disturbing' and unconsidered put us anxiously on the defensive and undermine our own response. In addition to defending free speech, it is essential to address why certain images are being attacked — Serrano's crucifix for mocking the excesses of religious exploitation[24] (a point evidently not lost on the televangelists and syndicated preachers who promptly assailed his 'blasphemy') and Mapplethorpe's photographs for making minority sexual subcultures visible. If we are always afraid to offer a public defence of sexual images, then even in our rebuttal we have granted the right wing its most basic premise: sexuality is shameful and discrediting. It is not enough to defend the principle of free speech while joining in denouncing the image, as some in the art world have done.[25]

The fundamentalist attack on images and the art world must be recognised not as an improbable and silly outburst of Yahoo-ism, but as a systematic part of a right-wing political program to restore traditional social arrangements and reduce diversity. The right wing is deeply committed to symbolic politics, both in using symbols to mobilise public sentiment and in understanding that, because images do stand in for and motivate social change, the arena of representation is a real ground for struggle. A vigorous defence of art and images begins from this insight.

Afterword: The War on Culture Continues, 1989–94

On 5 September 1991, a zap group associated with ACT UP inflated a giant 4.5m condom on the roof of Senator Jesse Helms's (R-NC) suburban Washington home. Their unfurled banner proclaimed, 'A condom to stop unsafe politics, Helms is deadlier than a virus'.[26]

This witty effort to indict and contain Helms's lethal agenda acknowledged that right-wing politicians like Helms, aided by powerful fundamentalist organisations such as the American Family Association, have conducted a decade-long, no-holds-barred campaign to control and reshape public cultural institutions in the United States. Their ambitious and surprisingly successful attempts to control information, education and imagery targeted AIDS, sexuality, homosexuality, and indeed almost any expression about sex or gender unpalatable to moral conservatives. Their goal, ostensibly to limit images and expressions supported by public funds, is in fact a much more ambitious one — to limit what is available in the public sphere.

Their efforts drew on a century-long tradition of sex panics in English-speaking countries, episodic and volatile eruptions of sex, sensation, scandal and popular mobilisation that often left permanent imprints on law and policy. Fundamentalist and moral conservative groups, however, contributed something new: a finely honed visual demagoguery, in which the image is both the subject of controversy and the fuel that inflames the debate. Stunningly effective, seemingly elusive of logic and rationality, this new visual demagoguery took aim at art, popular culture, and education alike. Conservative efforts also exploited the slippage between 'obscenity' (the small percentage of sexual material defined and prohibited by law), 'pornography' (a larger domain of pejoratively named and subjectively defined, but quite legal, material) and the vast body of words and images with sexual content. Increasingly, fundamentalist critics assailed work about AIDS, sexuality, or homosexuality as 'pornography', or even 'obscenity', suggesting that entire content areas were illegitimate, inappropriate for public funding or display, or illegal.

Major conservative achievements in this war on culture include:
- content restrictions on HIV/AIDS educational material

From 1987–92, Congress prohibited federal funding of any HIV/AIDS educational material which would 'promote or encourage, directly, homosexual or heterosexual activity'.[27] The instigator of this legislation was Senator Helms, who on the Senate floor brandished a comic book (produced by Gay Men's Health Crisis with private funds) which showed safe sex between men. 'This subject matter is so obscene, so revolting, it is difficult for me to stand here and talk about it', Helms said, 'I may throw up.'[28]

Despite widespread support for effective public health education, Senators supported his ban (98 to 2), fearful of being portrayed as endorsing 'pornography'. During the ban, special review panels vetted all proposed educational material, disapproving any sexually explicit information or visuals about AIDS prevention, as well as any content that might be 'offensive' to the general public (rather than the target audience). The ban greatly hampered AIDS education efforts (a Congressional committee later found 'the decidedly chilling effect of such prohibitions has been extensive'[29]) and was challenged by a coalition of health departments and organisations. It was overturned by a federal district court in 1992. Unbelievably, the Centres for Disease Control promptly issued new directives, requiring review panels to ensure that CDC funds are not used to produce prevention materials that are 'obscene' or 'promote or encourage directly homosexual or heterosexual activity'.[30]

- 'sex loyalty oaths' for NEA artists which implied that sexual and homoerotic content was obscene and prohibited

In the wake of the initial round of attacks on the NEA in 1989, Congress passed legislation requiring artists who received NEA grants to swear that they would not use funds to produce material 'which may be considered obscene, including but not limited to depictions of sadomasochism, homoeroticism, the sexual exploitation of children, or individuals engaged in sex acts ...'[31] This regulation contained several prejudicial sleights of hand, putting into wide circulation the mistaken idea that art could be obscene,[32] although Supreme Court definitions made it clear that material — even the

most sexually explicit — with 'serious artistic value' was excluded from the definition of obscenity (Miller v. California, 1973).[33] In addition, the oath went far beyond the sexually explicit, implying that mere depictions of homoeroticism were both obscene and unfundable, thus constituting a major attack on all gay and lesbian images. The oath, as well as the news coverage which endlessly and uncritically repeated its terms, gave wide circulation and currency to the oxymoron 'obscene art', a major propaganda victory for the right wing. An eccentric rhetorical convention previously common only in fundamentalist circles — equating virtually all sexuality with obscenity — had now become mainstreamed.

Despite massive protest by the arts community, the oath remained in effect for over one year, when it was replaced by regulations requiring artists to return funding for work found to be obscene by the courts,[34] and an injunction that required that grantees take into consideration 'general standards of decency'.

> • withdrawal of funds from a major exhibition on AIDS and
> continued attacks against artists

The wide impact of NEA content restrictions was soon apparent. How else do we understand the actions of *both* John Frohnmayer, new head of the NEA, and Susan Wyatt, executive director of the respected New York

Michael Rosen, United States, *John and Frank* 1992, gelatin silver photograph. Courtesy Michael Rosen.

alternative gallery, Artists Space, who each seemed to believe that the ban on funding obscene art somehow applied to 'Against Our Vanishing', a 23-artist exhibition about AIDS? The show, containing wrenching and sorrowful new work about the impact of the disease, was partially funded by the NEA and seemed uncontroversial until the month before its opening. The director, suddenly nervous about the exhibition's political and sexual content, alerted the NEA, concerned that its chair not be 'blindsided' by a newly erupting controversy. Frohnmayer expressed concern about the sexual content of the show and rescinded the grant, later claiming that its content had become too 'political'. He referred chiefly to a catalogue essay by artist David Wojnarowicz, an HIV-positive gay man, who angrily assailed political and religious officials for what he regarded as their homicidal role in blocking AIDS education. The gallery refused to return the money, Frohnmayer backed down, and the show opened amid great notoriety.[35]

Soon, moral conservative groups and right wing politicians attacked David Wojnarowicz directly, assailing his new retrospective, 'Tongues of Flame', at the University Galleries at Illinois State University. (Both the exhibition and catalogue were partially funded by the NEA.) Representative Dana Rohrabacher (R-CA) sent a 'Dear Colleague' letter to fellow congressmen, decrying the work as 'sickeningly violent, sexually explicit, homoerotic, anti-religious and nihilistic'.[36] Not to be outdone, the Rev. Donald Wildmon, head of the American Family Association, sent a mass-mailing to hundreds of thousands of churches and followers, profusely illustrated with allegedly 'pornographic' and objectionable details lifted from the artist's work. Art critic C. Carr dubbed this sensational and decontextualised copyright violation a 'penis-hunt'. The artist promptly retaliated by filing a million-dollar lawsuit against Wildmon and the AFA for copyright infringement and defamation of character. The court granted the artist a permanent injunction against further misuse of his images and ordered a corrective letter sent to original recipients, but awarded only nominal damages.[37]

Attacks against other exhibitions and artists continued, as obscenity charges were filed in 1990 against the Contemporary Art Centre in Cincinnati and its director, Dennis Barrie, in conjunction with the exhibition, 'Robert Mapplethorpe: The Perfect Moment'. Both the museum and director were acquitted after a highly publicised trial which consumed significant resources in the arts community.[38]

• cancellation of NEA grants to four performance artists — all of whom were feminist, gay or lesbian — because of the political content of their work

Four performance artists whose grants had been unanimously approved by NEA peer panels in 1990 found their awards postponed and then overturned after informal and highly irregular consultations between the chair and the governing National Council.[39] Details of one grant application had been leaked to conservative columnists Evans and Novack, inspiring their vitriolic attack on artist Karen Finley, which ridiculed her as a 'nude, chocolate-smeared young woman'.[40] As the conservative pressure increased, Council members and the chair discussed the awards to Finley, Holly Hughes, John Fleck and Tim Miller (the 'NEA Four') in frankly political rather than artistic terms, finally deciding to veto their grants while approving all others recommended by the peer panel. The conservative press approvingly noted that the NEA was finally getting the message, rejecting politically objectionable art (Finley's work, for example, was said to 'advance her aggressive feminism', while Holly Hughes 'wants to advance lesbianism'.[41]) The artists, along with a coalition of art and civil liberties groups, filed suit in 1990, claiming that the NEA had violated its own procedural regulations, evaluating the grants according to political rather than artistic criteria.[42] The suit also challenged the 'decency' language instituted by Congress.

After lengthy preliminary court proceedings, the NEA settled part of the suit before trial in 1993, awarding grants to all four artists.[43] Observers attribute this settlement to the frank and embarrassing comments made by the since-fired John Frohnmayer, which made the political basis of the rejections unmistakably clear. The 'decency' language was also found unconstitutional at the end of 1992. To the dismay and consternation of the arts community, however, this decision is being challenged by the Clinton administration in what is widely regarded as a sop thrown to the right wing.

•withdrawal and cancellation of programs on publicly-funded television

Attacks and a direct mail campaign against the Public Broadcasting Service, a national non-profit television consortium receiving public funds, caused many stations to refuse to air *Tongues Untied*, a critically praised film by gay,

African–American filmmaker Marlon Riggs. The artist and his work also became targets in Republican presidential primaries, when extreme right-wing candidate Patrick Buchanan used clips from the film in his campaign ads, denoucing the images of black gay men as 'pornographic' and attacking then President Bush as 'soft' on the NEA.[44]

In 1994, the Rev. Donald Wildmon launched an aggressive campaign to prevent the airing of the drama, *Tales of the City*, because of allegedly objectionable sexual content. He failed, and the program proved wildly popular, breaking all ratings records and attracting critical acclaim and almost fourteen million viewers. PBS, however, rejected plans to produce and show a sequel, reportedly in response to conservative pressure.[45]

Five years after the opening salvo against the NEA in 1989, the war on culture in the United States shows no sign of abating. Moral conservatives and fundamentalists are still energetically working to establish a 'no fly zone' in public institutions and culture, where expressions about sexuality, gender, and politics antithetical to their own are shot down. Visual images remain central to their project and method. In the past few months, the Congress prepared crippling budget cuts for the NEA's visual and performance arts programs[46] which, one Senator frankly explained, 'have been at the centre of recent controversies'.[47] On the Senate floor, 63 of 100 senators voted to withhold federal funds from school districts that expose students to material that portrays homsexuality 'as a positive life style alternative'.[48] A children's book about a lesbian couple and their daughter — called 'disgusting, obscene material'[49] — was offered as an example of what needs to be routed from the public schools. And in their most recent rampage, conservative columnists and politicians lambasted the latest NEA scapegoat, the HIV-positive and gay performance artist Ron Athey.[50]

Worst dream, best nightmare, Athey was raised as a Pentecostal — steeped in visions, stigmata, bleeding Jesus, and speaking in tongues. Part shaman, part survivor, he incorporates transformative ritual and body modification into his admittedly difficult and intense performances about suffering and healing.[51] A fusillade of right-wing criticism — written by critics who had not attended his performances — charged that he had exposed an audience in Minneapolis to HIV-infected blood (untrue) and that theatre goers had fled in panic (also untrue). Conservatives then assailed the NEA chair, Jane

Alexander, for defending the 'slopping around of AIDS-infected blood'[52] and, in retaliation for the $150 which Athey received, proposed slashing the NEA budget by over eight million dollars.

The vast difference between what actually happened and what conservatives made of it maps the slippery ground — sex, AIDS, homosexuality and primal anxiety about the body — that sexual panics and visual controversies exploit. Despite some victories in the past five years, it is increasingly obvious that the struggle to resist cultural cleansing is for the long term. At stake is not just visual imagery, but who is represented and who is banished from public culture and — ultimately — from the body politic.

The War on Culture

Thanks to Ann Snitow, Daniel Goode, Sharon Thompson and Edna Haber for conversations which helped shape my thoughts (though none of the individuals are responsible for the ideas expressed here). Thanks also to Brian Wallis, my editor at *Art in America*.

1. Senator D'Amato's remarks and the text of the letter appear in the *Congressional Record*, Vol.135, No.64, 18 May 1989, S5594.

2. Senator Helms's remarks appear in the *Congressional Record*, Vol.135, No.64, 18 May 1989, S5595.

3. William H. Honan, 'Congressional Anger Threatens Arts Endowment's Budget', *New York Times*, 20 June 1989, p.C20.

4. 'People: Art, Trash and Funding', *International Herald Tribune*, 15 June 1989, p.20.

5. Ibid.

6. William H. Honan, 'Congressional Anger', p.C20.

7. Elizabeth Kastor, 'Funding Art that Offends', *Washington Post*, 7 June 1989, p.C1.

8. Ibid., p.C3.

9. Elizabeth Kastor, 'Corcoran Cancels Photo Exhibit', *Washington Post*, 13 June 1989, p.C1.

10. Elizabeth Kastor, 'Corcoran Decision Provokes Outcry', *Washington Post*, 14 June 1989, p.B1.

11. Barbara Gamarekian, 'Legislation Offered to Limit Grants by Arts Endowment', *New York Times*, 21 June 1989; Carla Hall, 'For NEA, an Extra Step', *Washington Post*, 22 June 1989; Elizabeth Kastor, 'Art and Accountability', *Washington Post*, 30 June 1989.

12. The Fischl painting *Boys at Bat* 1979, was part of a travelling exhibition, 'Diamonds Are Forever', on view at the Chicago Public Library Cultural Centre. Ziff Fistrunk, executive director of the Southside Chicago Sports Council, organised the protest. He objected that 'I have trained players in Little League and semi-pro baseball, and at no time did I train them naked.' *In These Times*, 1 August 1989, p.5. Thanks to Carole Tormollan for calling this incident to my attention.

13. Carole S. Vance, 'The Meese Commission on the Road: Porn in the U.S.A.', *The Nation*, 29 August 1986, pp.65–82.

14. Patrick Buchanan, 'How Can We Clean Up Our Art Act?', *Washington Post*, 19 June 1989.

15. Ibid.

16. Ibid.

17. Ibid.

18. Ibid.

19. *Congressional Record*, Vol.135, No.64, 18 May 1989, S5594.

20. Another ploy is to transmute the basic objection to Serrano's photograph, the unfortunately medieval-sounding 'blasphemy', to more modern concerns with prejudice and civil rights. Donald Wildmon, for example, states, 'Religious bigotry should not be supported by tax dollars', *Washington Times*, 26 April 1989, p.A5.

 The slippage between these two frameworks, however, appears in a protest letter written to the *Richmond News-Leader* concerning Serrano's work: 'The Virginia Museum should not be in the business of promoting and subsidising a hatred and intolerance. Would they pay the KKK to do work defaming blacks? Would they display a Jewish symbol under urine? Has Christianity become fair game in our society for any kind of blasphemy and slander?' (18 March 1989).

21. For 19th-century American history regarding sex and gender, see John D'Emilio and Estelle Freedman, *Intimate Matters*, New York: Harper & Row, 1988; for British history, see Jeffrey Weeks, *Sex, Politics and Society: The Regulation of Sexuality Since 1800*, New York: Longman, 1981.

22. The 19th-century Comstock Law, for example, passed during a frenzied concern about indecent literature, was used to suppress information about abortion and birth control in the United States well into the 20th century. For accounts of moral panics, see Jeffrey Weeks, *Sex, Politics and Society*; Judith Walkowitz, *Prostitution and Victorian Society: Women, Class and the State*, Cambridge: Cambridge University Press, 1980; and Gayle Rubin, 'Thinking Sex: Notes for a Radical Theory of the Politics of Sexuality', in Carole S. Vance, ed., *Pleasure and Danger: Exploring Female Sexuality*, Boston: Routledge & Kegan Paul, 1984, pp.267–319.

23. Politically, the crusade against the NEA displaces scandal and charges of dishonesty from the attackers to those attacked. Senator Alfonse D'Amato took on the role of the chief NEA persecutor at a time when he himself is the subject of embarrassing questions, allegations and several inquiries about his role in the misuse of HUD low-income housing funds in his Long Island hometown.

 The crusade against 'anti-Christian' images performs a similar function of diverting attention and memory from the recent fundamentalist religious scandals involving Jim and Tammy Bakker and Jimmy Swaggart, themselves implicated in numerous presumably 'un-Christian' acts. Still unscathed fellow televangelist Pat Robertson called upon followers to join the attack on the NEA during a 9 June [1989] telecast on the Christian Broadcasting Network.

24. Andres Serrano described his photograph as 'a protest against the commercialisation of sacred imagery'. See William H. Honan, 'Congressional Anger', p.C20.

25. For defences of free speech that agree with or offer no rebuttal to conservative characterisations of the image, see the comments of Hugh Southern, acting chair of the NEA, who said, 'I most certainly can understand that the work in question has offended many people and appreciate the feelings of those who have protested it ... I personally found it offensive (quoted in Elizabeth Kastor, 'Funding Art that Offends', p.C3), and artist Helen Frankenthaler, who stated in her op-ed column, 'I, for one, would not want to support the two artists mentioned, but once supported, we must allow them to be shown' ('Did We Spawn an Art Monster?' *New York Times*, 17 July 1989, p.A17).

Afterword: The War on Culture Continues, 1989–94

Thanks to Allison Bryant for research assistance, and to Gayle Rubin and Frances Doughty for conversation.

26. 'AIDS Group Puts Giant Condom on Roof of Jesse Helms' House', *San Francisco Chronicle*, 6 September 1991, p.A3.

27. For excellent accounts of this legislative history, see Scott Burris, 'Education to Reduce the Spread of HIV', in Scott Burris, Harlon L. Dalton, Judith L. Miller and the Yale AIDS Law Project (eds), *AIDS Law Today: A New Guide for the Public*, New Haven: Yale University Press, 1993, pp.82–114; and 'The Politics of AIDS Prevention: Science Takes a Time Out', Report 102–1047, 102nd Congress, second session, Union Calendar No.584, especially pp.18–20; 'After Fiery Debate, Senate Passes AIDS Bill', *Congressional Quarterly*, 30 April 1988, pp.1167–1169.

28. 'Safe-Sex Comic Book for Gays Riles Senate', *San Francisco Chronicle*, 15 October 1987, p.A7. For an account of the House, see 'Congress Takes a Swipe at AIDS Education "Comic Book"', *San Francisco Chronicle*, 21 October 1987, p.A4.

29. 'The Politics of AIDS Prevention: Science Takes a Time Out', Report 102–1047, 102nd Congress, second session, Union Calendar, No. 584, p.20.

30. Ibid., p.19.

31. 101st Congress, Public Law 101–121, 3 October 1989. See Martin Tolchin, 'Congress Passes Bill Curbing Art Financing', *New York Times*, 8 October 1989, p.27; and 'Congress Bans Funding of Obscene Art', *New Art Examiner*, December 1989, p.10. For accounts of earlier legislative efforts, see 'Congress Votes for New Censorship,' *Art in America*, September 1989, p.33; Michael Oreskes, 'Senate Votes to Bar U.S. Support of "Obscene or Indecent" Artwork', *New York Times*, 27 July 1989, pp.A1, C18; William H. Honan, 'Helms Amendment Is Facing a Major Test in Congress', *New York Times*, 13 September 1989, pp.C17, C19; William H. Honan, 'House Shuns Bill on "Obscene" Art', *New York Times*, 14 September 1989, pp.A1, C22; Nicholas Fay,' Helms Ups the Ante', *New Arts Examiner*, October 1989, pp.20-23; 'House Passes Compromise on Federal Arts Financing', *New York Times*, 4 October 1989, p.C19.

32. For a more detailed discussion of the meaning and impact of this legislation, see Carole S. Vance, 'Misunderstanding Obscenity', *Art in America*, May 1990, pp.49–55.

33. 413 US 15 at 24 (1973). See also Franklin Feldman, Stephen E. Weil and Susan Duke Biederman, *Art Law: Rights and Liabilities of Creators and Collectors*, New York: Little and Brown, 1986, pp.2–108. The single exception to this definition is material that would be considered 'child pornography', for which serious artistic value is not a defence.

34. Public Law 101–151, 5 November 1990.

35. For more detailed accounts of the controversy, see William H. Honan, 'Arts Endowment Withdraws Grant for AIDS Show', *New York Times*, 9 November 1989, pp.A1, C28; 'NEA Recalls, Then Returns Artists Space Grant', *New Art Examiner*, January 1990, p.11; John Loughery, 'Frohnmayer's Folly', *New Art Examiner*, February 1990, pp.20–25; Carl Baldwin, 'NEA Chairman Does Turnabout on AIDS Exhibition', *Art in America*, January 1990, pp.31–33; Allan Parachini, 'Arts Groups Say NEA Future at Risk', *Los Angeles Times*, 10 November 1989, pp.F1, F30.

36. C. Carr, 'War on Art', *Village Voice*, 5 June 1990, pp.25–30.

37. C. Carr, 'War on Art'; Paula Span, 'Judge Blocks Anti-NEA Pamphlet', *Washington Post*, 26 June 1990, pp.D1,4.

38. For more detailed accounts of the trial, see C. Carr, 'War on Art', *Village Voice*, 5 June 1990, pp.25–30; Steven Mannheimer, 'Cincinnati Joins the Censorship Circus', *New Art Examiner*, June 1990, pp.33–35; Isabel Wilkerson, 'Trouble Right Here in Cincinnati: Furore Over Mapplethorpe Exhibit', *New York Times*, 29 March 1990, p.A21; Isabel Wilkerson, 'Selection of

Jurors Begins in Obscenity Trial', *New York Times*, 25 September 1990, p.A16; Isabel Wilkerson, 'Jury Selected in Obscenity Trial,' *New York Times*, 28 September 1990, p.A10; Isabel Wilkerson, 'Focus Is on Judge in Trial of Museum', *New York Times*, 2 October 1990, p.A16; Isabel Wilkerson, 'Obscenity Jurors Were Pulled Two Ways', *New York Times*, 10 October 1990, p.A12; Elizabeth Hess, 'Art on Trial: Cincinnati's Dangerous Theatre of the Ridiculous', *Village Voice*, 23 October 1990, pp.109–112.

39. For more detailed accounts of the NEA decision and its aftermath, see Barbara Garamekian, 'Frohnmayer Said to See Peril to Theatre Grants', *New York Times*, 29 June 1990, p.C15; Allan Parachini, 'NEA Panel Asks to Meet After Grant Denials', *Los Angeles Times*, 2 July 1990, p.F7; David Gergen, 'Who Should Pay for Porn', *US News and World Report*, 30 July 1990, p.80; Doug Sadownick, 'The NEA's Latest Bout of Homophobia', *The Advocate*, 14 August 1990; Holly Hughes and Richard Elovich, 'Homophobia at the NEA', *New York Times*, 28 July 1990, p.21.

40. Rowland Evans and Robert Novak, 'The NEA's Suicide Charge', *Washington Post*, 11 May 1990.

41. David Gergen, 'Who Should Pay for Porn', *US News and World Report*, 30 July 1990, p.80.

42. *Karen Finley, John Fleck, Holly Hughes and Tim Miller v. National Endowment for the Arts, and John E. Frohnmayer*, US District Court, Central District of California, Case 5236; Allan Parachini, '"NEA Four" Suit Seeks Rejected Grant Funds', *Los Angeles Times*, 28 September 1990, p.B3.

43. 'Endowment to Pay Four Artists It Rejected', *New York Times*, 5 June 1993, p.A13.

44. John Carman, 'Local Gay Filmmaker Finds New Foes', *San Francisco Chronicle*, 13 July 1991, p.E1; 'Tongues Untied' (editorial), *Washington Times*, 27 June 1991, p.G2; Bill Hafferty, 'Film Maker Reacts to Buchanan Commercial, *San Francisco Chronicle*, 28 February 1992, p.A8; Marlon T. Riggs, 'Meet the New Willie Horton', *New York Times*, 6 March 1992, p.A33.

45. John Carman, 'PBS Backs Out of Sequel to "Tales of the City"', *San Francisco Chronicle*, 8 April 1994, p.A1; Judith Michaelson, '"Tales" Author: PBS Is Being Pressured by Religious Right', *Los Angeles Times*, 11 April 1994, p.F2; Jeffry Scott, 'PBS Won't Finance Racy "Tales" Sequel', *Atlanta Constitution*, 11 April 1994, p.B6.

46. William Grimes, 'House Votes A Cut in Arts Endowment's Budget', *New York Times*, 24 June 1994, p.C3; William Grimes, 'Arts Cuts Are Sought in Senate', *New York Times*, 29 June 1994, p.C18; William Grimes, 'Senate Passes 5% Art Cut', *New York Times*, 27 July 1994, p.C13.

47. Statement of Senator Robert C. Byrd (D-W.VA), in William Grimes, 'Senate passes 5% Art Cut'.

48. Katharine Seelye, 'Senate Backs Cuts for Schools that Endorse Homosexuality', *New York Times*, 2 August 1994, p.A16.

49. Statement by Senator Robert C. Smith (R-NH), in Katharine Seelye, ibid.

50. William Grimes, 'House Votes a Cut in Arts Endowment's Budget', *New York Times*, 24 June 1994, p.C3; Frank Rich, 'The Gay Card', *New York Times*, 26 June 1994, sec.4, p.17; Frank Rich, 'Trail of Lies', *New York Times*, 17 July 1994, sec.4, p.17.

51. For an excellent piece, especially on Athey's background and performance, 'Four Scenes From a Harsh Life', see C. Carr, 'Washed in the Blood: Congress Has a New Scapegoat', *Village Voice*, 5 July 1994, p.16.

52. Ibid.

Read My Lips

Here we are
and we're standing our ground,
and we won't be moved by what they say,

So, we'll shout (shout!), as loud as we can,
and we'll shout (shout!), 'til they hear our demands,
Money is what we need, not complacency.

Read my lips
and they will tell you,
Enough is enough is enough is enough.

Finding cures is not the only solution,
and it's not a case of sinners absolution,

So we'll fight (fight!), for love and with pride,
and we'll fight (fight!), standing together
for the right to live and die with dignity.

Read my lips
and they will tell you,
Enough is enough is enough is enough.

The power within,
We can use it to win.

So we'll shout (shout!), as loud as we can,
and we'll fight (fight!), 'til they meet our demands,
Money is what we need, not complacency.

Read my lips
and they will tell you,
enough is enough is enough is enough

J. Somerville
© Jess-e Musique/Emi Virgin Music Ltd,
by permission: EMI Virgin Music Publishing Australia Pty Ltd

For a Friend

I never cried the way I cried over you,
As I put down the telephone and the world it carried on.
Somewhere else, someone else is crying too,
Another man has lost a friend, I bet he feels the way I do.
Although I'm left without, I know your love within.
As I watch the sun go down, watching the world fade away,
All the memories of you come rushing back to me.
As I watch the sun go down, watching the world fade away,
All I want to do is kiss you once goodbye.

Summer comes and I remember how we'd march,
We'd march for love and peace, together arm in arm.
Tears have turned, turned to anger and contempt,
I'll never let you down, a battle I have found
And all the dreams we had, I will carry on.
As I watch the sun go down, watching the world fade away,
All the memories of you come rushing back to me.
As I watch the sun go down, watching the world fade away,
All I want to do is kiss you once goodbye, goodbye.
Goodbye, goodbye.

And all the dreams we had, I will carry on.
As I watch the sun go down, watching the world fade away,
All the memories of you come rushing back to me.
As I watch the sun go down, watching the world fade away,
All I want to do is kiss you once goodbye, goodbye.
Goodbye, goodbye.

J. Somerville/R. Coles
© Jess-e Musique/EMI Virgin Music Ltd, by permission:
EMI Virgin Music Publishing Australia Pty Ltd
© Mistramark Ltd/Rocket Music Ltd/Zomba Music Publishing Ltd
Reprinted by permission of Rondor Music Australia

self-documentation
self-imaging
australian people living with h-i-v / aids
1988-
kathy triffitt, co-ordinator

24 may 1992

dear kathy

i have been thinking more about the 'self-documentation, self-imaging' project and my contribution to it ... i'm feeling excited about it.

i'd like my contribution to really give people a quite deep and personal insight into what it's like to have aids — a glimpse of the issues one confronts, the pain of the diverse fears and unknowns and the, at times, terrifying uncertainties and potential future.

i don't want to be portrayed by a 'leigh in the lounge room' or 'forlornly wandering along the beach' picture ... that may work well for some people.

i want to do something which is graphically strong, especially as i am a very visually oriented person (pity i'm bloody well losing vision ... why can't i go deaf instead?).

there is a range of recent quite extraordinary visual material we can draw upon:

1. an ultra-sound of my dilated liver canals.
2. x-rays of my stomach, when swollen severely.
3. scan of my brain (it was ok, thankfully).

and i am trying to also organise:

4. photos of the retina of both eyes, showing the damage done by c-m-v.

5. photos of my bowels, which are to be examined on tuesday, 2 june.

6. photos of skin conditions, including k-s ... perhaps while being treated with liquid nitrogen.

maybe also:

7. photos of sessions with the psychiatrist, in hospital and / or on a drip treatment.

 part of the experience of having aids is that lots of different and alarming things are all happening at once. one has to deal with a frightening number of new issues, simultaneously.

8. i am not sure how one can portray the search for courage and strength ... that's also a vital part of coping.

9. as well, i'd like to show that life continues amid all the medical confusion. so, i want to have photos of me enjoying gardening, theatre, travel, music, food and with friends / family. after all, these are the things that make it worthwhile to keep on living.

10. it's also just occurred to me that it may also be good to include an image of one coping with the virus's impact upon my friends. i'm not alone in living with aids. it's happening to numerous of my friends too — and, of course, some have already died. that's a more than small part of the nightmare of aids.

i am very much looking forward to hearing from you and working on this together.

enough from me ... tell me your responses.

warm, good wishes,

leigh

... my parents live in a country town. they don't know about me being hiv positive. that is my fear about going public, being photographed. i don't want them to know. i don't want to put them through all of that. then i think about the fact that they wouldn't have anyone that they could talk about it to. the fact that they are up there, they might go through social isolation if they told people. i can imagine they may be rejected from their community. they might do it to themselves.

i would like, sometimes, to get it all out in the open. it's so much to take on, so much explaining to do, so much for them to go through. i don't feel like taking it on ...

deborah (extracts from a personal history, april 1989)

... i have very ferocious, protective instincts towards my four year old. i also have a very vivid imagination. i can see all sorts of terrible things happening to her at kindergarten and school if people knew i was hiv positive, though there is nothing wrong with her. i don't even know what would happen. the children, or probably more likely, their parents would try to isolate their children from her. children who wouldn't know what they were talking about being cruel to her. it is the sort of situation even if it is in your own imagination, you can't test it out to find out. you can't say, 'we will tell them a bit, then if it doesn't work we will take it back again'. once you have done it, you have done it.

that really frightens me ... i couldn't be photographed because of my daughter ...

sue (extracts from a personal history, june 1989)

what i have tried to spend a lot of time doing is undoing the myth that h-i-v = aids = death.

when i am talking about it publicly i just say that's not the case ... h-i-v = aids = death. i make an emphasis on the fact that now it has been 6-1/4 years since i became positive and i am still alive and well.

there is one achievement that i am really happy about ... we have managed to change the language in this country so that we talk about people living with aids. i just sit back and when i hear that expression from a whole range of people i think, yes, you didn't understand that before did you?

emphasise the living rather than the dying.

i have quite often thought about the aboriginal culture's emphasis on bone pointing ... it's strange how that works and quite often, when i am talking, i will use that as an example. there are so many things that people's friends and family do in terms of reinforcing that. people working in this area need to be constantly vigilant about what sort of message they are reinforcing for the person they are trying to assist.

talking about living with aids, that's quite an exciting idea but occasionally i have lapses. i just need to work on that ... yes, well it is great, it has been 6-1/4 years now. i mean, saying 6-1/4 years sounds precise as though you are really hanging onto that.
i am quite confident within myself that is not the case.
i tend to keep on forgetting how long i have been h-i-v positive.
i think it is getting to a stage that it is relevant to be reasonably accurate, to have that figure at my finger tips, because the longer that time goes on the more hope there is for other people coming on behind me and for other people who were diagnosed at about the same time as myself.

my concern about the treatment of people with h-i-v and aids is that, in order to get the benefits out of being sick, the incentive is to get sicker. this is one of the reasons why i will still shout from the roof-tops, don't get tested ... because the thing is that you don't know, until you get that result back, how you are going to react about being h-i-v positive ... everybody that i have spoken to about this has been quite surprised about the way they have reacted.
it is not what they expected.
while there is no reason for a person being tested and by that i mean if a person is physically ... apparently quite well, then in being tested they are running the risk of going downhill once they have got those results back, if it is h-i-v positive.
the incentives in the system are to be sick and the reality is, at the moment, unless your t-cell count is 200 or less you are not going to get any of the goodies.
you are not going to get aids accommodation, you are not going to get a-z-t, you are not going to get the pension ... there are so many things that are rewards for people for being sick. we have to change our way of handling things about people being sick so that the incentives are to be well rather than to be sick.

i have become used to having my photographs in newspapers, so when it came to the h-i-v issue, with the exemption of a case where i felt it was important for the person that i was living with not to be photographed revealing my face, i have done that.

i have been one of the advocates in the h-i-v infected movement. i have always emphasised that it is important to try to get a very positive image.

in the early days it was difficult to try to convince the press about that. in 1986 ... there was a photograph taken of me for the sydney 'sun herald' that looked as though i was about to die tomorrow.

having gone through that experience and dealing with other bits of the press of having this looking down, woe is me type attitude, we started to insist on more positive images.

when the article appeared in the 'herald' last year, over the mersey hospital incident, the photograph was very positive.

i was dressed in a suit, looking very business like ...

what we are trying to do is present a very positive image about people who are infected with h-i-v.

i prefer to be photographed in colour.

i suppose part of my reason about colour is that i think it has much more life about it.

i don't know whether it is responsibility or just a feeling, i am very conscious of the tendency to photograph people in what i call negative ways.

that is something that is really difficult to get across to photographers. i know some photographers have problems about direct eye shots ... i think it is good to be looking directly on, looking upwards and not looking down, not looking melancholic.

chris (extracts from a personal history, february 1990)*

a lot of people are really surprised when i tell them that i have been h-i-v positive for nearly six years.

they are all five years into the virus and they are really surprised ... how come you are so well? that answers the question i might have ... how come you are so well?

it completely answers any doubtful questions that i have had about myself ever, it really proves to myself that i know what i have been doing, i have been positive about it.

*(chris's self-portrait appears on page 162)

mark

i have lost fear of it.
fear is the biggest, biggest killer, i think, before p-c-p or anything ...

my diagnosis of aids positive was in 1984 ... i was scared.
i didn't know what was going to happen.
death was something that i really didn't want to look at. the fear that it might be around the corner in the next year or so was terribly frightening given the gloom and doom surrounding aids ... media hype and sensationalism about the virus ... the new killer virus that's going around.
also, doctors facing something completely new and knowing not much more than patients who had the virus.
so yes ... fear was a big thing.

i have been doing well for the last three years but just recently i had some news that my t-cells had taken a dramatic dive which was almost like getting the news of being h-i-v positive again. it was quite shocking because i had seen myself as almost invincible ...
i don't feel any different.
i don't feel like i am sick or anything like that but there is obviously a substantial amount of viral replication going on in me at the moment and a-z-t will interfere with that ...

i am looking into how i was after i was first diagnosed and those strong steps that i took and i am starting to take them again to get myself into a good physical condition ...

i think i would prefer to have the safety net of a-z-t as well as combining the natural therapies like acupuncture, vitamins and meditation.

my self-image ... i see myself, at the moment i am aspiring to it, an image of being physically fit and productive and energetic.
having lots of energy is something that i would love to have all the time ...

i look at photographs of myself taken in natural surroundings like on a friend's farm ... catching yabbies in a dam and how healthy and good looking i look with all of that brown grass around me and with the trees.
just the natural surroundings ...

i like space ... no boundaries because i don't like putting boundaries on myself.
i don't want to contain myself.

a positive image ... being strong and healthy.
keeping myself informed, i think that's a good support network ... keeping yourself informed. find out about the enemy that you are fighting.
realise what it can do, find out about it, do a bit of espionage on it.
forewarned is forearmed to use that old cliche ... you need to know and you can inform yourself.

i talk to people who are on a-z-t now because my t-cells are now 160 ... well, i talk to people with 231 t-cells. they seem pretty relaxed and easy going and they can help me too.
i still need that support.
i might seem to you that i am together and self-supportive but i am a human being and i still need to reach out for that support.
i have all of those insecurities still there.

i qualify for the pension now. i can go on the pension but what would i do if i went on the pension?
i would sit around and probably would get sick by putting myself in that victim class. once you step out of that victim class you are not a victim anymore.
some of these guys who go on the pension and take all sorts of tranquillisers and things like that, i have seen them go down. i have

watched them. they have convinced themselves that it's the end of the road and that makes me really angry ...

there is no embarrassment or guilt to being h-i-v positive.
that's what people need to understand.
that's what has been instilled by sensationalist press.
if you are gay you have been through the whole guilt trip anyway.
society deals with being gay as wrong.
it's wrong and you should be heterosexual and contributing ...
it shows remarkable resilience and individual strength of people who can be gay and proud and be h-i-v positive and still come out smiling.

we need success stories with h-i-v.
people who have had serious aids related conditions and have won and beat them ...
the media won't print those because they prefer to have aids and h-i-v as the all powerful, frightening thing that people will worry about.
if people pick up the paper and they see aiDs in huge black print on the front page, that will make an aids scare ...

mark (extracts from a personal history, march 1990)

it's hard for me to think of life before h-i-v.
it's this all encompassing thing.

i was first diagnosed in 1985 ... mid 1985. so it's coming up nearly seven years now and it's really hard for me to think of what my life was like before then ...

i think one of the things that h-i-v has given me is a search for identity, a search for meaning and purpose. it has given me something to focus on that i didn't have before. it's like a hobby for me now, in some ways ... like looking after myself. i read a lot — metaphysical, self-empowerment type books which i get a lot of enjoyment out of. i think, for me, that's sort of like a nurturing thing and if i don't constantly read and keep myself together, i get very depressed.

i am a firm believer, now, that i have the power to keep myself well. i try to do a lot of work on the emotional side of things, but you can only accelerate the growth process so much.
at the moment i am trying to find a purpose.

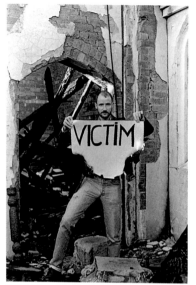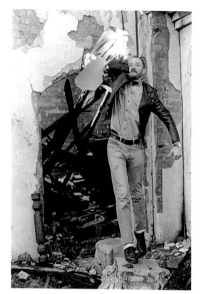

stephen

the biggest thing for me is giving up work. this is part of a process of finding what i want to do and what i am meant to be doing which is crucial for me.

i think one of the things that's with h-i-v and i suppose with any other illness like cancer, leukaemia or whatever, you adjust. you adjust to your physical symptoms.
you may not like what is happening to you, but i think that mentally you adjust and i find that really interesting.

i mean, most people are freaked out by aids and h-i-v but to me it's a perfectly natural thing to have.
i don't feel guilty about having h-i-v ... i did in the beginning and i don't anymore.
a lot of people talk about it as being a gift — i am not quite there yet ...

the images that i have been working with over the past couple of days ... i really get crapped off with the way the australian media use the word victim.
i don't want to be a victim and they just use it time and time again. in the early stages of aids and h-i-v, there was this paranoia, these scare tactics.

the other image that i have been working with is anger. i am not
angry i have h-i-v but i am angry at the way people perceive us.
i am angry that people perceive it as a gay disease.
i am angry about the way we are represented ... we are human beings.
we have family ...
i am someone's brother, i am someone's uncle, i am someone's son.
we are members of the community but the community is pushing us
away and the media have a lot to answer for that.
i don't think the grim reaper campaign helped.
i think it just isolated and stereotyped.

another image i have been working with is fear.
i don't have a fear of dying at all.
i am not worried or fearful about dying because i know i will die one
day but i do fear being sick.
i do fear, because i am slim in build ... skinny in build as some people
call it ... i fear losing weight.
the other thing that i am fearful of is k-s.
i have a real fear of getting k-s because i don't know how i will deal
with that.
it's a self-image thing and i have got a lot of work to do on my self-
image ... self-identity.
h-i-v is challenging the way that we see ourselves and the way we
represent ourselves.
i mean there is a lot of suffering ... i know that ... and a lot of pain but
there is also a lot of joy.

i just hope that people can see us living with h-i-v and that we are just
like everybody else and it's just another disease.
i don't want people's sympathy ... i want their support, their
encouragement, their love, their help and their acceptance.

i think we all make judgements, i don't think we can help that ... but
it's when you start boxing people in and saying they are heterosexual
or homosexual that you are really classifying a person and a person is
much more than just what they are and what they do. it's an ideal
situation, i think, if we could just accept people more as whole human
beings.
maybe out of h-i-v we are challenging that.

stephen (extracts from a personal history, july 1991)

i was diagnosed february 1985, so it was quite early.
the doctor said it was a gay disease and i said, 'well, how come i have got it?'

... they didn't know anything about aids. they were basing all their information on gay men and that was really frustrating ... they couldn't tell me what was going to happen to my body. there was nothing there, no information ... the aids council was just setting up ... there were no women ... none ... so, gay men became my support system.

... it wasn't long after that, that i had a court case pending. i went to court and i was banned ... they wouldn't let me in the courtroom because the magistrate said i would infect all the staff ... that hit the headlines in the newspapers.

... because of all of that media hype, i actually pushed my son away from me for two months ... i was frightened he would get aids because everybody was telling me that. i stopped listening to me and started listening to everybody else. i put him in a foster home for two months ... my doctor kept reinforcing my feelings that he couldn't catch it, but i was feeding into everything else, all the hysteria ... that was really hard ... it was horrible, but i got back on track again and got my son back and just believed what i did believe ... that he couldn't contract aids in that way ... it wasn't transmitted by casual contact.

i was in prison for nearly two years, the first time, and then i went back for a year ... the women sat out, they didn't want me in the prison.
the gaol management gave me a choice of being in isolation for my whole sentence which i wasn't going to do.
i remember all of these women, there were about thirty-five to forty of them, sitting in the dining room and i had to go and speak to them ... there was all of this hate ...
i guess, that's where i became vocal about being h-i-v positive because they wouldn't let me work in any of the work areas.
it was quite a fight, but it changed things, certainly, for women that go into prison ...

as a woman, you are left in limbo because medical practitioners and politicians never, really look at us ...

aids is often seen as censored faces and people dying.

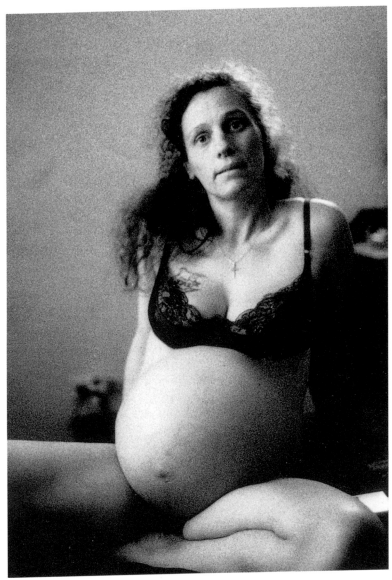

michelle

i think, it's really important for people to realise that people actually live with this virus.

it's important for the community to see that it's not just men, there are women too.

there is a lot of discrimination and fear.

i am public because a lot of women are isolated ... so, if they can see another woman, then, maybe, that will encourage them, not to be public, but to contact somebody ...

self-imaging ... i will do it because i think it's needed, especially for women.
there is also something there for myself ... self-imaging leaves me existing ...

it's important, to me, that people are reminded of this virus ...
it doesn't go away.

... *child killer,* was sprayed on the front door.
the neighbours have never come out and admitted to doing it ...

i was diagnosed as pregnant by a doctor who is working in the aids field ... her attitude was, she had some bad news for me.
there were mixed responses to my pregnancy ... my friends weren't supportive, but they are getting better.

pregnancy is an individual choice.
it's not something we went into lightly. it's not an easy decision, its a hard decision. it was unexpected and we had to discuss it. it was something that we tossed over for four weeks ... whether to go ahead with it or not.

i was really excited, i was really happy, but then the fear set in ...
what about the future?
what happens when i die?
is my partner going to be able to take care of a child? what's he going to do financially? neither of us have families that we associate with, that associate with us ... there is nobody for him to lean on ...
there are all of those questions and decisions ... we decided to go ahead with the pregnancy, but with trepidation.
it's not over by a long shot because there's the worry of whether the child will be h-i-v positive ... i have put that to the back of my mind because i have to or i would probably go insane ...
there's only a slight chance she will test positive.
we have just got to hope for the best ... any pregnancy carries a risk, that's what i have had to tell myself ... no pregnancy is guaranteed.

i believe that positive women have got every right to have children should they choose to as long as they think it through ... other people's judgements do not enter into it ...

guilt ... i think that's a big one for a woman.

i have seen women who have got positive children and there are a lot of guilt factors there ...

i don't think they should be feeling guilty ... why are there major judgements on positive women having children when there are women who carry other things ... like muscular dystrophy?

... giving birth ... it's just so beautiful to watch a live human being. it's the most amazing thing i have ever been through.

there is so much love and so much that you would do for your own child.

there is a love there that you never experience with anybody else.

my mother was very conditional with me, but with my own it's very much unconditional ... they will always be my children.

i need to be able to spend time with my son and daughter ... that's important for me to do, very important, before i let go ...

i know that i will have to let go.

i am actually dealing with grief and loss now ...

i guess, it's accepting that i am sick which is quite hard, for me, because i have been well for such a long time.

i am not actually frightened of dying, it's more that i am frightened of not existing.

i really want to see my son and daughter grow up ... to see what kind of people they will become.

i am really frightened of not being able to see that, of leaving them to other people ...

michelle (extracts from a personal history, november 1991 and may 1993)

I would like to acknowledge the following organisations which have financially supported this documentation over the past seven years: Visual Arts/Craft Board, Australia Council (1989); Community Cultural Development, Australia Council (1990); the AIDS Trust of Australia (1990); Sydney Gay & Lesbian Mardi Gras (1990); AIDS Action Council, ACT (1992); Victorian AIDS Council (1993); University of Newcastle, School of Art, Design and Architecture.

Kathy Triffitt 1994

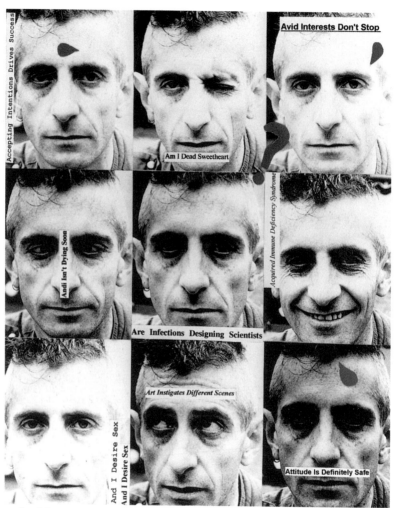

andi nellsün
matr'x 1993

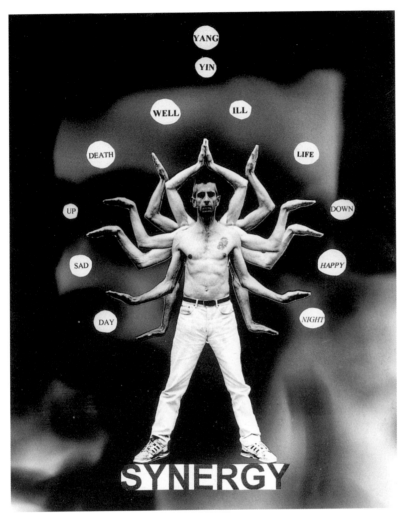

andi nellsŭn
synergy 1993

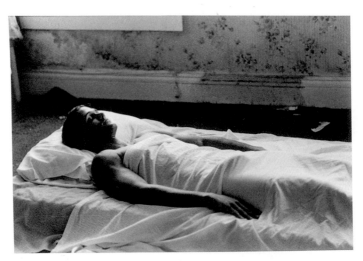

THE FATHER PREPARES HIS DEAD SON FOR BURIAL.
HE WASHES HIS BODY SLOWLY, DELIBERATELY, LOOKING HARD AT HIM
 FOR THE LAST TIME.
HE TOUCHES HIM WITH OIL, CAREFULLY AS IF NOT TO AWAKEN HIM.
THE FATHER LEANS TO HIS SON'S EAR AND WHISPERS SOMETHING.
HE WRAPS HIM IN COTTON LIKE A CHILD ASLEEP AND EMBRACES HIM
 THEN THE FATHER BEGINS TO QUIVER WITH GRIEF,
 AND THE VIBRATION OF HIS MOVEMENT BECOMES A SOUND,
 LIKE A DEEP MOAN THAT GROWS LOUDER AND LOUDER.
 INTO A TERRIBLE SHOUT OF ANGUISH.

Duane Michals, United States, *The Father Prepares His Dead Son for Burial* 1991, gelatin silver photograph. Courtesy of the artist.

Aesthetics and Loss

EDMUND WHITE is a novelist, critic and biographer who currently lives
in Paris. His novels include *A Boy's Own Story* (1983), *Caracole* (1986),
The Beautiful Room Is Empty (1988); he is author of the travel study *States of
Desire: Travels in Gay America* (1986); and he published a collection of short
stories *The Darker Proof: Stories from a Crisis* (1987) with Adam Mars-Jones.
He edited *The Faber Book of Gay Short Fiction* (1991); and is author of the
biography *Genet* (1993). His latest publication is *The Burning Library: Writings
on Art, Politics and Sexuality 1969–1993* (Chatto & Windus 1994).
'Aesthetics and Loss', originally appeared in *Artforum* in January 1987, and
we are grateful to Edmund White for permission to reprint his essay here.

I had a friend, a painter, named Kris Johnson, who died two years ago of
AIDS. He was in his early thirties. He'd shown here and there, in bookstores,
arty coffee shops, that kind of thing, first in Minnesota, then in Los Angeles.
He painted over colour photos he'd first colour-xeroxed — images of
shopping trolleys in carparks, of giant palms, their small heads black as warts
against the smoggy sun: California images.

He read *Artforum* religiously; he would have been happy to see his name in
its pages. The magazine represented for him a lien on his future, a promise
of the serious work he was about to embrace as soon as he could get out of
the fast lane. Like many people who are both beautiful and gifted, he had to
explore his beauty before his gift. It dictated his way of living until two years
before his death. His health had already begun to deteriorate and he'd moved
to Santa Fe, where he painted seriously during his last few months.

By now everyone knows about how the AIDS virus is contracted and how it
manifests itself. The purely medical horrors of the disease have received the

attention of the world press. What interests me here is how artists of all sorts — writers, painters, sculptors, people in video and performance art, actors, models — are responding to AIDS in their work and their lives. If I narrow the focus, I do so not because I think artists are more important than any other group but because of the impact the epidemic has had on aesthetics and on the life of the art community, an impact that has not been studied.

The most visible artistic expressions of AIDS have been movies, television dramas, and melodramas on the stage, almost all of which have emphasised that AIDS is a terribly *moving* human experience (for the lover, the nurse, the family, the patient) which may precipitate the coming-out of the doctor (the play *Anti Body* 1983, by Louise Parker Kelley) or overcome the homophobia of the straight male nurse (*Compromised Immunity* 1986, by Andy Kirby and the Gay Sweatshop Theatre Company, from England) or resolve longstanding tensions between lovers (William M. Hoffman's play *As Is* 1985, and Bill Sherwood's beautifully rendered movie *Parting Glances* 1985). Although Larry Kramer's play, *The Normal Heart* 1985, is almost alone in taking up the political aspects of the disease, it still ends in true melodramatic fashion with a deathbed wedding scene. John Erman's *An Early Frost* 1985, a made-for-television movie on NBC, is the *Love Story* of the 1980s. The best documentary is perhaps *Coming of Age* 1986, by Marc Huestis, who filmed scenes from the life of a friend of his diagnosed with the virus.

But even on artists working away from the limelight, AIDS has had an effect. Naturally, the prospect of ill health and death or its actuality inspires a sense of urgency. What was it I wanted to do in my work after all? Should I make my work simpler, clearer, more accessible? Should I record my fears, obliquely or directly, in my work, or should I defy them? Is it more heroic to drop whatever I was doing and look disease in the eye, or should I continue going in the same direction as before, though with a new consecration? Is it a hateful concession to the disease even to acknowledge its existence? Should I pretend Olympian indifference to it? Or should I admit to myself, 'Look kid, you're scared shitless and that's your material'? If Yeats thought sex and death were the only two topics worthy of adult consideration, then AIDS wins hands down as subject matter.

It seems to me that AIDS is tilting energies away from the popular arts (including disco-dancing, the sculpturing of the living body through working

out the design of pleasure machines — bars, clubs, baths, resort houses) and redirecting them toward the solitary 'high' arts. Of course I may simply be confusing the effects of ageing with the effects of the disease; after all, the Stonewall generation is now middle-aged, and older people naturally seek out different pursuits. But we know how frightened everyone is becoming, well beyond the 'high risk' group that is my paradigm and my subject here.

What seems unquestionable is that ten years ago sex was a main reason for being for many gay men. Not simple, humdrum coupling, but a new principle of adhesiveness. Sex provided a daily brush with the ecstatic, a rehearsal of forgotten pain under the sign of the miraculous — sex was a force binding familiar atoms into new polymers of affinity.

To be sure, as some wit once remarked, life would be supportable without its pleasures, and certainly a sensual career had its melancholy side. Even so, sex was, if not fulfilling, then at least engrossing — enough at times to make the pursuit of the toughest artistic goals seem too hard, too much work given the mild returns. 'Beauty is difficult', as Pound liked to remind us, and the difficulties held little allure for people who could take satisfaction in an everyday life that had, literally, become ... sensational. Popular expressions of the art of life, or rather those pleasures that intensified the already heady exchange within a newly liberated culture, thrived. The fortune that was lavished on flowers, drugs, sound systems, food, clothes, hair: people who were oppressed by the brutality of the big city or by their own poverty or a humiliating job could create for at least a night, or a weekend, a magical dream-like environment.

Now all this has changed. I feel repatriated to my lonely adolescence, the time when I was alone with my writing and I felt weird about being a queer. Art was a consolation then — a consolation for a life not much worth living, a site for the staging of fantasies reality couldn't fulfil, a peopling of solitude — and art has become a consolation again. People aren't on the prowl any more, and a seductive environment is read not as an enticement but as a deathtrap. Fat is in; it means you're not dying, at least not yet.

And of course we do feel weird again, despised, alien. There's talk of tattooing us or quarantining us. Both the medical and the moralistic models for homosexuality have been dusted off only fifteen years after they were

shelved; the smell of the madhouse and the punitive vision of the Rake Chastised have been trotted out once more. In such a social climate the popular arts, the public arts, are standing still, frozen in time. There's no market, no confidence, no money. The brassy hedonism of a few years back has given way to a protective grey invisibility, which struck me forcibly when I returned to New York recently after being away for several months. As Joe Orton quotes a friend in his diaries, all we see are all these old norms, all norming about.

But if the conditions for a popular culture are deteriorating, those promoting a renewed high culture have returned. Certainly the disease is encouraging homosexuals to question whether they want to go on defining themselves at all by their sexuality. Maybe the French philosopher Michel Foucault was right in saying there are homosexual acts but not homosexual people. More concretely, when a society based on sex and expression is de-eroticised, its very reason for being can vanish.

Yet the disease is a stigma; even the horde of asymptomatic carriers of the antibody is stigmatised. Whether imposed or chosen, gay identity is still very much with us. How does it express itself these days?

The main feeling is one of evanescence. It's just like the Middle Ages; every time you say goodbye to a friend you fear it may be for the last time. You search your own body for signs of the malady. Every time someone begins a sentence with 'Do you remember Bob ...' you seize up in anticipation of the sequel. A writer or visual artist responds to this fragility as both a theme and as a practical limitation — no more projects that require five years to finish.

THE DREAM OF FLOWERS

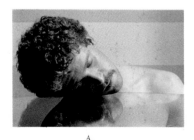

A

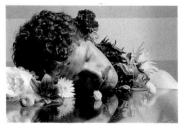

1.

134

The body becomes central, the body that until recently was at once so natural (athletic, young, casually dressed) and so artificial (pumped up, pierced, ornamented). Now it is feeble, yellowing, infected — or boisterously healthy as a denial of precisely this possibility. When I saw a famous gay filmmaker recently, he was radiant with a hired tan: 'I have to look healthy or no one will bankroll me.' Most of all the body is unloved. Onanism — singular or in groups — has replaced intercourse. This solitude is precisely a recollection of adolescence. Unloved, the body releases its old sad song, but it also builds fantasies, rerunning idealised movies of past realities, fashioning new images out of thin air.

People think about the machinery of the body — the wheezing bellows of the lungs, the mulcher of the gut — and of the enemy it may be harbouring. 'In the midst of life we are in death', in the words of the Book of Common Prayer. Death — in its submicroscopic, viral, paranoid aspect, the side worthy of William Burroughs — shadows every pleasure.

The New York painter Frank Moore told me last fall that in developing possible sets and costumes for a new Lar Lubovitch ballet he worked out an imagery of blood cells and invading organisms, of cells consuming themselves — a vision of cellular holocaust. In his view the fact of death and the ever-present threat of mortality have added a bit to the sometimes empty rhetoric of East Village expressionism. 'Until now anger has been a look, a pose,' he told me. Now it has teeth.

The list of people in the art world who have died of AIDS is long and growing longer. I won't mention names for fear of omitting one — or including one

Duane Michals, United States, *The Dream of Flowers* 1986, four gelatin silver photographs. Courtesy of the artist.

P

S

that discretion should conceal (it's not always possible to verify how much a patient told his family).

Maybe it's tactless or irrelevant to critical evaluation to consider an artist, writer, dealer, or curator in the light of his death. Yet the urge to memorialise the dead, to honour their lives, is a pressing instinct. Ross Bleckner's paintings with titles such as *Hospital Room, Memoriam* and *8,122+ As of January 1986*, all 1986, commemorate those who have died of AIDS, and incorporate trophies, banners, flowers and gates — public images.

There is an equally strong urge to record one's own past — one's own life — before it vanishes. I suppose everyone both believes and chooses to ignore that each detail of our behaviour is inscribed in the arbitrariness of history. Which culture, which moment we live in determines how we have sex, go mad, marry, die and worship, even how we say Ai! instead of Ouch! when we're pinched. Not even the soul that we reform or express is God-given or eternal; as Foucault writes in *Discipline and Punish* 1978: 'The soul is the effect and instrument of a political anatomy; the soul is the prison of the body.' For gay men this force of history has been made to come clean; it's been stripped of its natural look. The very rapidity of change has laid bare the clanking machinery of history. To have been oppressed in the 1950s, freed in the 1960s, exalted in the 1970s, and wiped out in the 1980s is a quick itinerary for a whole culture to follow. For we are witnessing not just the death of individuals but a menace to an entire culture: all the more reason to bear witness to the cultural moment. The sincerity and romanticism of Duane Michals's images possess exactly this commemorative feeling.

Art must compete with (rectify, purge) the media, which have thoroughly politicised AIDS in a process that is the subject of a book to be published shortly in England. It is *Policing Desire: Pornography, AIDS and the Media*, by Simon Watney. (Watney, Jeffrey Weeks, Richard Goldstein and Dennis Altman rank as the leading English-language intellectuals to think about AIDS and homosexuality.)

This winter [1986–87] William Olander at the New Museum in New York has organised 'Homo Video: What We Are Now', an international gay and lesbian program that focuses in part on AIDS and the media. For instance, Gregg Bordowitz's '*... some aspects of a shared lifestyle*' 1986, deals with the contrast between the actual disease and the 'gay plague' image promoted by the media. John Greyson's *Moscow Does Not Believe in Queers* 1986, inserts

lurid Rock Hudson headlines into a taped diary of ten days at a 1985 Moscow youth festival, where Greyson functioned as an 'out' homosexual in a country that does not acknowledge the rights — or even the legitimate existence — of homosexuals. And Stuart Marshall's *Bright Eyes* 1986, tracks, among other things, the presentation of AIDS in the English media.

If art is to confront AIDS more honestly than the media have done, it must begin in tact, avoid humour, and end in anger.

Begin in tact, I say, because we must not reduce individuals to their deaths; we must not fall into the trap of replacing the afterlife with the moment of dying. How someone dies says nothing about how he lived. And tact because we must not let the disease stand for other things. AIDS generates complex and harrowing reflections, but it is not caused by moral or intellectual choices. We are witnessing at long last the end of illness as metaphor and metonym.

Avoid humour, because humour seems grotesquely inappropriate to the occasion. Humour puts the public (indifferent when not uneasy) on cosy terms with what is an unspeakable scandal: death. Humour domesticates terror, lays to rest misgivings that should be intensified. Humour suggests that AIDS is just another calamity to befall Mother Camp, whereas in truth AIDS is not one more item in a sequence but a rupture in meaning itself. Humour, like melodrama, is an assertion of bourgeois values; it falsely suggests that AIDS is all in the family. Baudelaire reminded us that the wise man laughs only with fear and trembling.

End in anger, I say, because it is only sane to rage against the dying of the light, because strategically anger is a political response, because psychologically anger replaces despondency, and because existentially anger lightens the solitude of frightened individuals.

I feel very alone with the disease. My friends are dying. One of them asked me to say a prayer for us all in Venice 'in that church they built when the city was spared from the ravages of the plague'. Atheist that I am, I murmured my invocation to Longhena's baroque octagon if not to any spirit dwelling in Santa Maria della Salute. The other day I saw stencilled on a Paris wall an erect penis, its dimensions included in centimetres, and the words 'Faut Pas Rêver' (You mustn't dream). When people's dreams are withdrawn, they get real angry real fast.

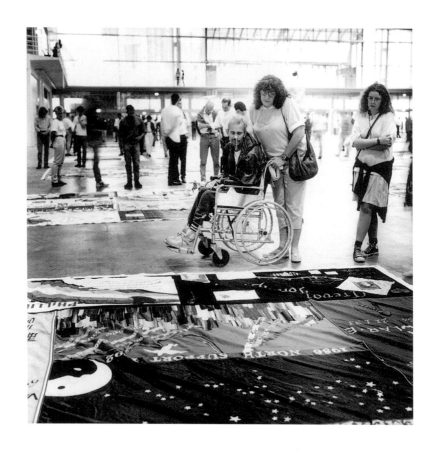

Jamie Dunbar, Australia, *Ron Handley (aka Fanny Farquhar) and friend Rose Lorimer at the Australian AIDS Memorial Quilt* 1994, gelatin silver photograph. Courtesy of the artist.

Psycho-Cultural Responses to AIDS

D ENNIS ALTMAN is a Professor in the Department of Politics at La Trobe University, Melbourne and a member of the Global AIDS Policy Coalition. He is a former vice-president of the Victorian AIDS Council. His many books include *Homosexual Oppression and Liberation* (1972), *Coming out in the Seventies* (1979), *AIDS and the New Puritanism* (1986). He has written extensively on AIDS for a wide variety of journals, and contributed chapters to several books on the subject, including *AIDS in Australia* (1992) and *A Leap in the Dark: AIDS, Art and Contemporary Cultures* (1993). His first novel, *The Comfort of Men,* was released in 1993. This article is based, in part, on a chapter in his book *Power and Community: Organisational and Cultural Responses to AIDS* (London: Falmer Press, 1994).

The shape of AIDS has changed since the mid-1980s, and with it the possibilities and constraints for communal and cultural responses. In some — not all — Western countries it has moved from an overwhelming concentration among homosexual men and men with haemophilia, and spread, via needles and heterosexual sex, to a broader population. In a few areas of the United States, almost all in the inner cities of the east coast, AIDS is now a disease largely defined by poverty and race. By the end of the 1980s non-homosexual cases of HIV seemed far more heavily concentrated amongst black and Hispanic than other Americans. In developing countries early complacency that HIV would be restricted to prostitutes and foreigners no longer remains a plausible delusion.

Australia remains one of about half a dozen countries in which the transmission of HIV remains mainly due to homosexual intercourse, and in which the toll of the epidemic is overwhelmingly experienced by the gay community. Partly because of a fear of inflaming homophobic prejudices —

and partly because of their own timidity — governments have shied away from recognising the full meaning of this; the much vaunted Australian 'partnership' still understates the gay community's stake in the epidemic. It is in our cultural responses that the particular epidemiology of HIV in Australia is largely reflected.

These comments are not meant to deny either the diversity of homosexual men in Australia, nor the potential risk of HIV to other groups for whom appropriate prevention strategies are therefore required. But in terms of communal impact and response, the history of the epidemic has been overwhelmingly experienced in this country by the gay community, which has been the driving force behind the creation of major community based organisations to respond to the epidemic. In forging partnerships with government, with health professionals and with other affected communities there have been major achievements, but there have also been problems and tensions.[1] Increasingly, too, there are unstated tensions within the gay communities themselves, especially as there is a need to balance the demands for direct services for people with HIV and prevention programs, and the need to represent all those who are infected (including those who are not gay) and the larger concerns of the gay (and lesbian/gay) community.

One of the most dramatic ways in which the changing shape of the epidemic impinges on the community sector is the burden of sickness, death, loss and grief on the organisations themselves. Many of the people who founded the earliest organisations, whether they were Australian gay men or African women, are themselves now dead, and the load this places on those remaining is constantly increasing. (I wrote this sentence the day after I attended the funeral of a former worker for the Victorian AIDS Council. At the subsequent wake the leader of his care team said that he had buried three men in the last eighteen months, and it was time for a break.) The sheer dimensions of loss in those communities most affected — whether in Uganda, New York or Sydney — creates an atmosphere of ongoing crisis and pain which has few counterparts in developed countries during peacetime. AIDS organisations may be becoming more permanent, more professionalised, 'in this for the long haul' as is sometimes said, but they grow out of and serve a population which is fragile and in a state of constant crisis as more and more of its members fall sick and die.

Within particular and already stigmatised communities this crisis will have very special consequences, which in turn impinge upon the ability of the community to respond. In his frustratingly opaque piece, 'Mourning and Melancholia', Freud wrote:

> Now the melancholic displays something else which is lacking in grief — an extraordinary fall in his self-esteem, an impoverishment of his ego on a grand scale ... The distinguishing mental features of melancholia are a profoundly painful dejection, cessation of interest in the outside world, loss of the capacity to love, inhibition of all activity, and a lowering of the self-regarding feelings to a degree that finds utterance in self-reproaches and self-reviling, and culminates in a delusional expectation of punishment.[2]

This 'fall in self-esteem' may be linked with grief in many communities hit by AIDS, whether these be the gay communities of the Western urban world or the villages of central Africa. Certainly some of the American literature on grief and loss in the gay community suggests widespread feelings of abandonment, depression, apathy and anger which echo Freud's words, sometimes linked to withdrawal both from the community and even from personal and sexual relations.[3] A feeling that 'we're all going to die', as one of the characters expresses it in Andrew Holleran's very powerful story 'Friends at Evening',[4] haunts some of the most affected communities, and makes rational responses difficult. Similar reactions are reported by Elizabeth Reid from Africa:

> The most striking feature ... is the psychological impact on individuals and communities of so many lives lost, so many parents, siblings, friends, children, colleagues, neighbours dead. In young children this often induces an almost catatonic state, a withdrawal from the world of pain and despair. One story from the Kagera region in Tanzania is of a young girl sitting day after day at the edge of the yard, rocking on her heels and staring into space. Both her parents are dead, brothers and sisters, aunts and uncles. There is little food but she is not hungry. She rocks, grieving.[5]

If AIDS is seen as a curse or a punishment, as much religious discourse suggests, its impact will strengthen deep and irrational feelings of personal

inadequacy, and this in turn will influence communal responses. One of the most common aspects of AIDS politics — an anger directed at those also working in the area — is closely linked to the mechanisms that Freud describes in 'Mourning and Melancholia'. Part of the anger, I would suggest, grows from the experience of enormous loss and grief which remains unacknowledged by the wider community: few people living in rural or suburban Australia understand the extent to which frequent death has become an ongoing part of the experience of gay men in their relative youth.

The Cultural Response

The impact of the epidemic is marked by a distinctive cultural response, itself often shaped by community organisations such as the NAMES Project which manages the AIDS Quilt in the United States. A whole book could be written on cultural responses to the epidemic, ranging from such elaborated forms of community memorials as the Quilt and Candlelight Vigils to small-scale village ceremonies for the dead. Such responses are clearly very dependent on existing cultural norms, and it is not surprising that they tend to be particularly associated with Western gay communities, which had significant pre-existing links to mainstream cultural institutions. Yet it is interesting that the greatest impact of all the cultural responses to the epidemic has almost certainly been the Quilt, which grew out of American popular tradition and was developed into a powerful symbolic form of public grief, now expanding far outside the United States.

The NAMES Project began in San Francisco in 1987, after gay activist Cleve Jones had been inspired by placards memorialising those dead from AIDS during a candlelight march. Drawing on the American tradition of making quilts to mark special occasions, it has become a major communal tribute to those who have died from the epidemic, and literally tens of thousands of panels have been woven, each of them a personal tribute to a particular loss.[6] The full Quilt has been unveiled in several major ceremonies in Washington, but panels are constantly on display across the country and now — as the Quilt has been adopted as an AIDS memorial in many other countries — across the world. At the first major showing of the Quilt at the October 1987 lesbian and gay march on Washington, Cindy Patton noted the contrast with the Vietnam Memorial Wall:

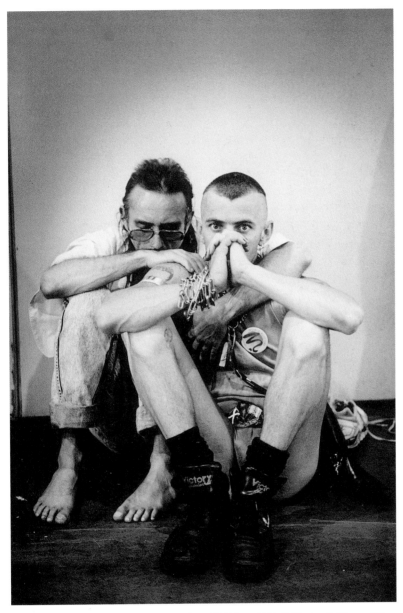

Jamie Dunbar, Australia, *Viewing the Australian AIDS Memorial Quilt: Hearing the Names of Those Who Have Died* 1992, gelatin silver photograph. Courtesy of the artist.

No one could help comparing the brightly coloured quilt, which covered an area greater than two football fields, with the sombre grey granite of the Wall ... Many of the lesbians and gay men who came to the March visited the Wall, where one heard gay men talking about being in Vietnam and compared losing friends there to losing friends to AIDS.[7]

The growth of the epidemic has been matched by the growth of the Quilt: from two football fields in 1987 to twelve (more than 5 hectares), embracing 20,000 panels, when it was displayed again in Washington in late 1992.

Yet if the Quilt grew out of the gay community, it has become a meaningful way of expressing loss to people of all sorts, and its images show the changing patterns of AIDS in America. (Cleve Jones has suggested that the use of a traditional 'feminine art' may make the Quilt acceptable to those who would be anxious about identifying with the homosexual community.[8]) The public expression of grief around AIDS takes on a deeply political purpose. Such collective undertakings will have many meanings, as Marita Sturken has identified:

> For many AIDS activists, mourning is transformed into action through collectivity. AIDS activist Douglas Crimp writes: 'For many of us, mourning *becomes* militancy.' However for others, mourning in the face of AIDS takes different forms: for those in inner-city communities, mourning in the face of AIDS may be more often tinged with the rage of despair rather than the anger of a middle class sense of entitlement. For many families, mourning is a processing of feelings of shame and guilt. Mourning is defined by the Quilt as a cathartic and healing process, one that is ongoing and diminishing in intensity, both angry and hopeful.[9]

While the concept of the Quilt grew out of a specific American tradition, it has been embraced as a global symbol of loss and mourning; there are Quilt projects in over twenty countries, including Brazil, Israel, Thailand and Zimbabwe. Its universality is captured by Peter Blazey's observation that:

> What makes it moving are the evidences of that person's life — comic, personal, loving — that are presented before your eyes,

helping recall if you knew him or her; or summoning the person up if you didn't. This is not a unilateral act. It is a mutual act, like an act of love, requiring give and take on both sides.[10]

Equally, the Candlelight Vigil for those dead from AIDS has spread far from its origins in San Francisco in 1983: ten years later it was reported to have been celebrated in forty-four different countries.[11] (In Malaysia — and presumably other Islamic countries — the reference to candles is deleted as sounding too Christian.) Other forms of memorialising those dead of AIDS include a display of cobblestones engraved with the names of those who have died from AIDS in several German cities, and the dedication of the palm trees that line the centre of Santa Monica Boulevard in West Hollywood, California.

Rosalind Solomon, United States, *Untitled,* from *Portraits in the Time of AIDS*, a series of 60 works (No.XI) 1988, gelatin silver print. Courtesy of the artist.

AIDS has also been recognised across the spectrum of more conventional 'high' culture, particularly in theatre and dance where the losses to the epidemic have been very considerable. Indeed, one of the conventional responses to the epidemic has come to be the listing of cultural icons that it has killed: Michel Foucault, Keith Haring, Rock Hudson, Liberace, Robert Mapplethorpe (whose dying was the basis of a moving story by Susan Sontag, 'The Way We Live Now'), Freddy Mercury, Rudolf Nureyev, Tony Perkins etc. In many of these cases it was only their deaths through AIDS which made discussion of their homosexuality possible, and this in turn has helped to reinforce the conflation of HIV and homosexuality in the public mind. The enormous impact of lesbians and gay men on Western culture has thus been discussed increasingly through the optique of the epidemic, with mixed consequences. (Where others than homosexuals have AIDS, their 'normality' is often stressed to the exclusion of all else, as was shown in Magic Johnson's much reported boasts that however he had contracted the virus it was certainly not through homosexual sex.)

In Australia the best known artist to die of AIDS was Sydney conductor, Stuart Challender, who announced both his illness and his homosexuality in a television interview shortly before his death. He was one of a number of figures who have used their illness as a reason to publicly declare what had not been said before. Indeed, it is doubtful if the push to 'out' closeted homosexuals from groups such as Queer Nation in the United States would have emerged but for the impact of AIDS: both the focus on homosexuality, and the anger against people like Liberace, Hudson and Nureyev who refused to publicly discuss their illness, have been major factors in radicalising those who believe in 'outing'.

More important for my purposes here is the use of artistic channels to express a response to the epidemic. Just to catalogue the plays, books, films, art exhibitions and dance works generated by HIV would be a major project, and one beyond my resources: there is a symphony, John Corigliano's First, which was written as a response to AIDS and has been performed in several countries, a Requiem, the last work of composer Andrew Worton-Steward before his death from AIDS in 1990, and even an opera, Vittorio Furgeri's reworking of the story of *The Lady of the Camellias*. Dance seems to have been a particularly rich field for the exploration of the meanings of the epidemic, particularly in the United States and in France, where the director of the

Festival of Montpelier has publicly committed himself to seeking out HIV-positive choreographers, and where condoms are included with festival programs.[12] Theatre has been particularly accessible to explorations of the meanings of the epidemic, so much so that a few years ago one British critic could begin a review by musing: 'I wonder which Shakespeare play will turn out to be about AIDS.'[13] A number of plays have been more directly inspired by the epidemic: Larry Kramer's *The Normal Heart*, William Hoffman's *As Is*, Tony Kushner's *Angels in America* have all been important contributions to the larger cultural understandings of the epidemic. And there is now a whole genre of novels based on the experience, both personal and communal, of AIDS, with writers such as David Feinberg, Hervé Guibert, Andrew Holleran, Adam Mars-Jones, Paul Monette, Oscar Moore, Sarah Schulman and Reinaldo Arenas making AIDS central to their fiction: indeed, it is almost impossible to write of contemporary gay life without also writing about AIDS, as I discovered when I struggled to write my first novel, *The Comfort of Men*.[14] To quote one of the most recent American novels — but the quote is chosen almost at random — the sentiments are echoed in several shelves of contemporary writing:

> Yesterday Martin and I attended a funeral. Though my first, it was just another in a progression for the other men; for a few it was a brief encounter with their own. We were, in a way, lucky, for there was no grieving lover, no one to lose control and offer useless bargains with death and, worse, to feel the undeserved guilt of a murderer or the unknowing betrayal of the murdered. There was none of that there, just friends to stand in for the last vigil in somber clothing. They were silent; by now they had become inured to words, even their own. At such moments they have strength only to wait for this to pass, in whatever manner it chooses.[15]

As the names cited reveal, the theatre and literature of AIDS largely reflect the responses of American gay men, and their works are read and played throughout the world in ways not true for cultural responses from other countries. This in turn can blind us to the specificities of the American experience; there has been a richer literary, theatrical and artistic response to the epidemic elsewhere than one might guess from the lists usually cited. The dominance by American cultural responses is a particular problem for us in Australia, where in some ways it seems to reproduce almost blindly

the traditional Australian 'cultural cringe' towards the North Atlantic world. Thus an ABC documentary on culture and AIDS, made in 1993, seemed more concerned with the comments of Larry Kramer and Armistead Maupin than those of local artists, writers and performers, even though its maker had originally intended to rectify the over-emphasis on the American gaze which has been so much a part of our images of this disease.

Robert Dessaix has observed that: 'One of the most striking characteristics of gay and lesbian writing in Australia in the 1990s is its brevity',[16] and this is largely true of the literary responses to AIDS, such as Gary Dunne's novella *Shadows on the Dance Floor* (Black Wattle 1992) and a number of short stories in two 1993 anthologies, *Travelling on Love in a Time of Uncertainty* and *Outrage: Gay & Lesbian Short Story Anthology*. As yet there is no Australian literary voice as sustained in a response to the impact of the epidemic as, say, Peter Wells has been in New Zealand;[17] the most moving account to have appeared in this country is John Foster's *Take Me to Paris, Johnny* (Heinemann 1993), the account of his relationship with a young Cuban, who died of AIDS as Foster himself did early in 1994.

But the cultural responses to AIDS are not confined to affluent Western countries, although it is far more difficult, in a world dominated by Western media, to fully recognise and acknowledge the view from the developing world. I am aware of theatrical responses to AIDS from the Philippines, Brazil, Argentina and Zambia (where several theatre groups have been formed to explore the meanings of HIV and ways to slow transmission). In some African countries such as Zaire and Nigeria, song has been a particularly important medium both for expressing the losses from the epidemic and for promoting messages of 'safe sex' and anti-discrimination. AIDS has been less evident in more 'Western' forms of writing; as the African Doumbi-Fakoly wrote:

> Despite the African writers' consistently close alignment with the concerns and desires of the people, they have curiously been absent in the general mobilisation against AIDS.[18]

He provides no very satisfactory explanation for this silence.

The American gay movement has been particularly critical of the failure of Hollywood to see AIDS as an issue to be addressed, and for the first decade

of the epidemic mainstream cinema tended to refer to AIDS obliquely, as in the plague depicted in the film of the science fiction novel *Dune* or in the fashion for vampirism. (One of the best examples of the blending of myths around AIDS and vampirism is Dan Simmons's horror novel *Children of the Night* which manages to link the history of Dracula, AIDS orphans in contemporary Romania and science fiction speculation about retroviruses and immune deficiency.[19] It is surely only a matter of time before it is filmed, combining as it does virtually every aspect of the modern horror/romance.) AIDS was a sub-text to a considerable number of films — a *Newsweek* story speculated that it may lie behind the fashion for films based on the return of the dead — until the success of *Philadelphia* in 1994 ensured that the issue would be picked up in future mainstream cinema releases.

Before Tom Hanks won an Academy Award for his portrayal of the dismissed lawyer dying of AIDS in *Philadelphia*, the direct depiction of AIDS had been largely restricted to marginal cinema. In France Cyril Collard's *Les Nuits Fauves* 1993, a film in which he played the positive antihero and thus foreshadowed his own death shortly afterwards from AIDS, received a number of the industry's main awards, and became a major box office hit. When Collard died, Thomas Sotinel wrote: 'With Cyril Collard, AIDS was no longer a question of poetry, hygiene and morality, but of desire and love. He conveyed something new — that life with AIDS is still life.'[20] A number of non-mainstream films have been made about the epidemic, e.g. Arthur Bressan's *Buddies*, Gregg Araki's *The Living End*, John Greyson's *Zero Patience* and Richard Glatzer's *Grief*. Vincent Ward's (New Zealand) film *The Navigator* is, according to *The Economist* 'the first to have translated [a] perception of the disease into a work of art'.[21]

The visual arts have been enormously rich in responses to the epidemic, and again responses — in posters, painting, photography, performance pieces etc. — come from almost all societies touched by AIDS. As I write, the washing machine contains T-shirts from Portugal, India, Thailand, Brazil and, of course, Australia, all bearing AIDS messages and imagery. Again, as this exhibition demonstrates, when visual representations become commodified as commercial art the American influence is dominant: the works of Haring, Mapplethorpe, Leibowitz etc. dominate the global imagination, not because of their greater strength but because they are situated within a complex pattern of globalising communications, which

privileges the views of the centre and undermines the independence of the periphery, in high art as much as in rock videos or children's television.

One of the crucial roles of the visual arts is to challenge the dominant media images of the epidemic, which Simon Watney has identified as a diptych, 'which constantly narrates AIDS according to two sets of images: one focusing on colour-stained electron microscope-derived images of HIV, usually misdescribed as "the AIDS virus", and other signs of biomedical technology and authority; the other relentlessly constructing people with AIDS as "AIDS victims", physically debilitated and preferably disfigured.'[22] Watney goes on to argue that:

> In the case of AIDS, photographers are particularly well positioned to interrupt the crude flow of images that conflate HIV and AIDS and to challenge the crude and cruel version of the epidemic that continues to regard AIDS as a moral verdict rather than a medical diagnosis. For if we accept that photography participates in the practice of representation that forges our identities, we should be as sensitive to its potential to produce subjects as we are to its undoubted capacity to define objects.[23]

There are many ways in which one can use 'culture' to discuss AIDS, from the polemics of Larry Kramer's play *The Normal Heart* to the inclusion of contemporary gay political images in Derek Jarman's film *Edward II* (and Jarman made no secret of his own positive status long before his death early in 1994). Between the films of Hollywood studios and the community activities of the Quilt there exists a vast range of cultural responses which include thousands of performers, writers and artists, many of them galvanised by the epidemic. People who have previously never thought of themselves as 'artists' have been pushed by the epidemic into artistic responses: one of the better known American performers, Tim Miller, describes himself as 'a loud obnoxious fag' whose 'various performance-art agitating goes towards articulating a queer cultural identity and trying to find an artistic, spiritual and political response to the AIDS crisis'.[24] This sums up very neatly the ways in which AIDS has broken down many of the traditional divides between art and politics. Miller boasts of having been arrested at a number of ACT UP protests, but of having never missed a show from being in gaol. Equally, one of the founders of the PWA movement,

(continued on page 167)

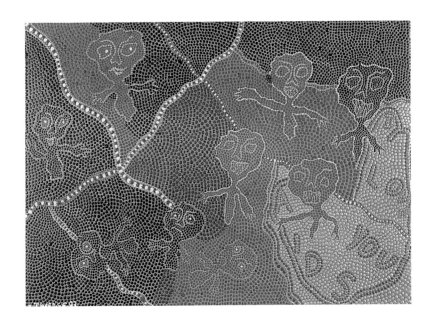

H.J. Wedge, Australia, *AIDS* 1994, acrylic on watercolour paper. Courtesy Boomalli Aboriginal Artists Co-operative, Sydney.

Ross Watson, Australia, *Untitled #1* 1993, oil on hardboard with layered tissue paper and offset lithograph. Courtesy Melbourne Contemporary Art Gallery.

Masami Teraoka, United States, *AIDS Series: Geisha in Bath* 1988, watercolour on canvas. Courtesy Pamela Auchincloss Gallery, New York.

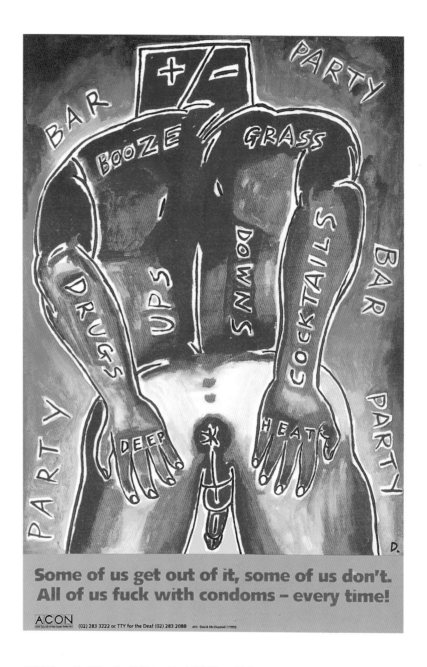

AIDS Council of New South Wales, David McDiarmid designer, *Some of Us Get Out of It, Some of Us Don't. All of Us Fuck With a Condom, Every Time!* 1992, offset lithography. National Gallery of Australia, Canberra, Gift of AIDS Council of New South Wales 1994.

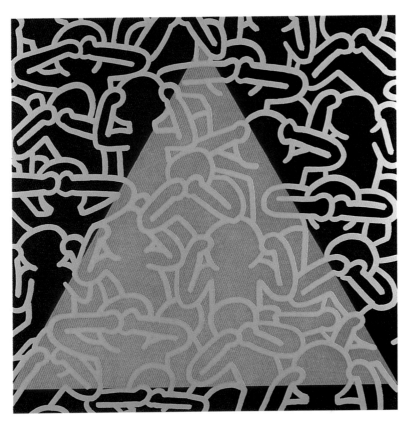

Keith Haring (1958–1990) United States, *Silence = Death* 1989, silkscreen on paper. Collection of Keith Haring Foundation, New York, Courtesy André Emmerich Gallery, New York, © 1994 The Estate of Keith Haring.

The Silence = Death Project (for ACT UP, New York), United States, *Silence = Death*, T-shirt. Private collection, Canberra.

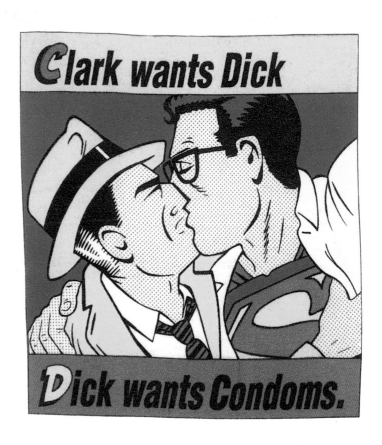

ACT UP/Golden Gate, San Francisco, United States, **G'dali Braverman** designer, *Clark Wants Dick, Dick Wants Condoms*, T-shirt. Private collection, Canberra.

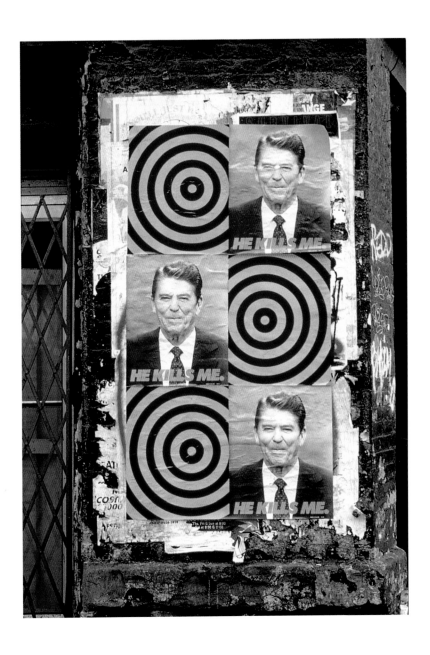

Donald Moffett, United States, *He Kills Me (In Memory of Diego Lopez)* 1987, street poster, offset lithography and colour screenprint. National Gallery of Australia, Canberra, Gift of Donald Moffett 1993.

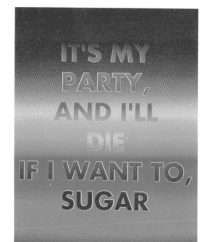

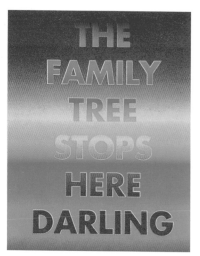

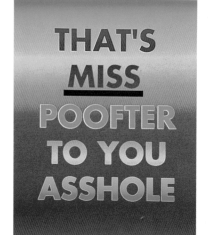

David McDiarmid, Australia, *It's My Party and I'll Die If I Want To, Sugar* 1994, *The Family Tree Stops Here Darling* 1994, *Don't Worry, Die Young, Be Happy, Make a Will* 1994, *That's **Miss** Poofter to You Asshole* 1994, computer-generated Canon laser prints. Courtesy Tolarno Galleries, Melbourne.

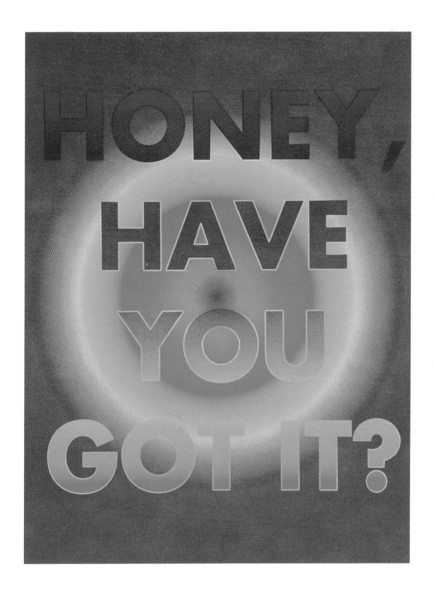

David McDiarmid, Australia, *Honey, Have You Got It?* 1994, computer-generated Canon laser print. Courtesy Tolarno Galleries, Melbourne.

(following pages) **Ron Muncaster**, Australia, *Queen Sequina with Her Nicky in a Twist* 1992–93, Best Group Costumes, Sydney Gay & Lesbian Mardi Gras 1993. Courtesy Ron Muncaster, Sydney.

Ron Muncaster, Australia, *Arabesque* 1991–92, Best Costume, Sydney Gay & Lesbian Mardi Gras 1992. Courtesy Ron Muncaster, Sydney.

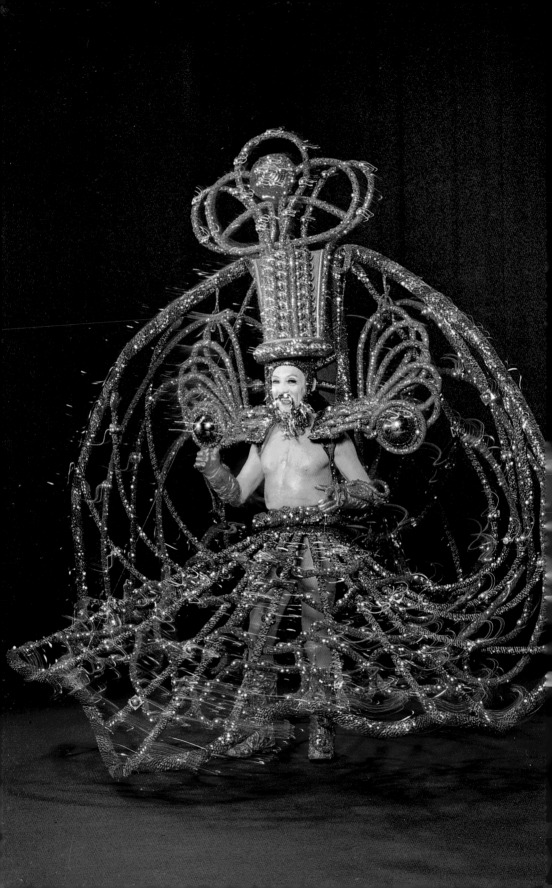

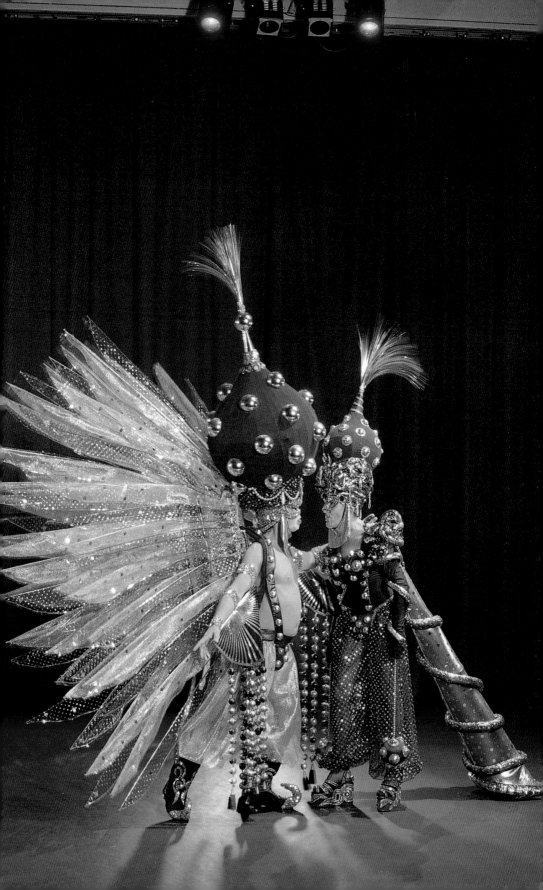

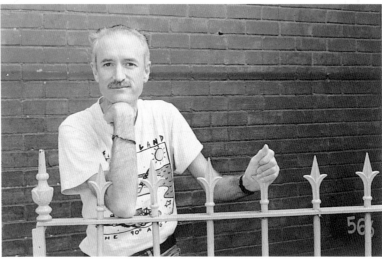

(top) **Lynn Sloan**, United States, *Laverne and Her Daughter, HIV +* 1989, chromogenic print. Courtesy of the artist.

Chris 1990, from ***Self-Documentation, Self-Imaging, People Living with HIV/AIDS 1988-***, Australia, cibachrome photograph. Courtesy *Self-Documentation, Self-Imaging* Project.

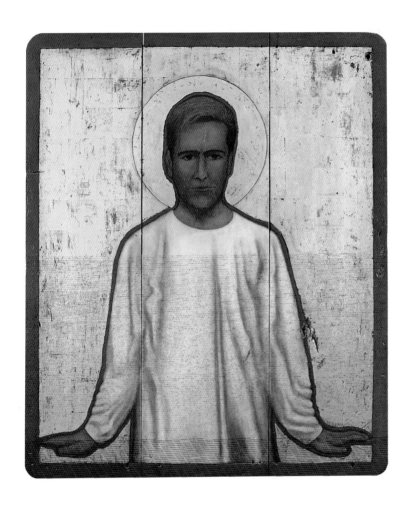

Anna Wojak, Australia, *Acacius (Stigmata)* 1991, oil paint and gold leaf on cedar. Courtesy Michael Nagy Fine Art, Sydney.

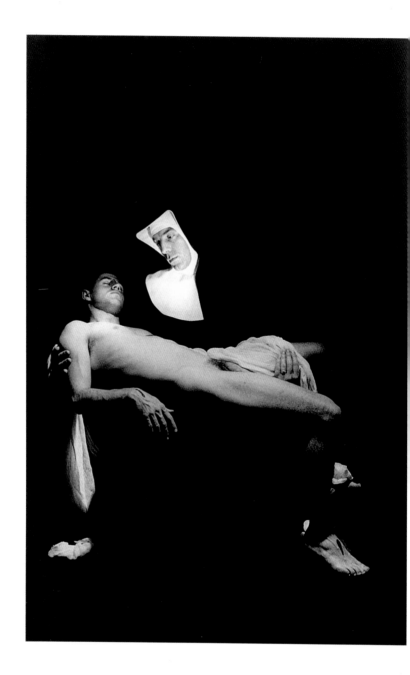

David Edwards (aka Sister Mary Dazie Chain), Australia, *Untitled (AIDS Pietà)* 1992, gelatin silver photograph. Courtesy of the artist.

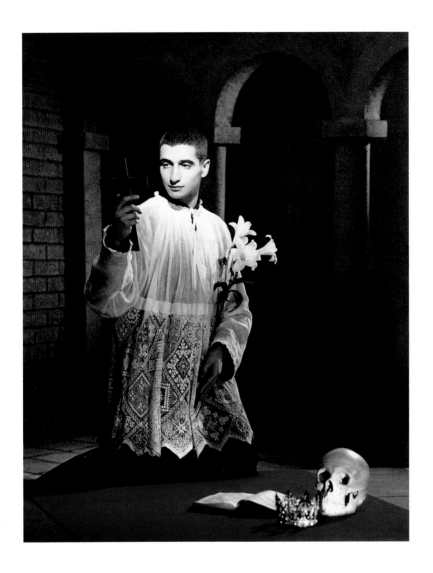

Pierre et Gilles, France, *St Louis de Gonzague* 1993, painted cibachrome. Courtesy Galerie Samia Saouma, Paris.

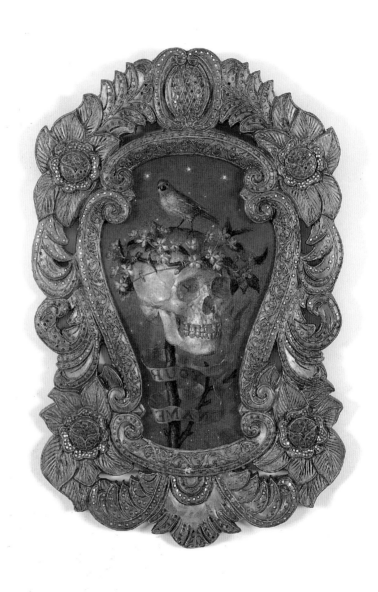

Thomas Woodruff, United States, *Ruoy Eman* 1992, acrylic on canvas, Courtesy of P.P.O.W. Gallery, New York.

Michael Callen (whose visit to Australia in 1988 inspired the early PWA movement here) used his musical skills to bring AIDS issues into popular music, both through his group The Flirtations and through solo performances.

There are a number of ways in which one might interpret the cultural responses to AIDS. At one level it is a subject which contains sufficient drama and emotion to capture the attention of artists, irrespective of their own stake in the epidemic. But what is striking about the great bulk of the response to date is that it grows out of the experiences of those most immediately affected; indeed, many of the writings and performances come from people who are positive, and therefore writing/dancing/singing their own lives. More than in any case I can think of, culture becomes a form of activism and demands to be judged on both criteria: most of the artists who are moved by AIDS are not content with just recording the impact of the epidemic; they wish also to have an immediate effect on how it is perceived and regulated.

The artists' work, too, for the most part grows out of their involvement in the affected communities. There are of course exceptions (for example, the fine Australian novel, Nigel Krauth's *J.F. Was Here*, which deals sympathetically with AIDS without the author having any link to the gay community although the protagonist is homosexual). But for the most part even artists using such formal forms as novels and symphonies credit their

AIDS Council of New South Wales, Jamie Dunbar designer, *In Times of Grief and Loss Let's Face It Together* 1993, offset lithograph. National Gallery of Australia, Canberra, Gift of AIDS Council of New South Wales 1994.

own involvement in the affected community as the inspiration and the motive for their work. Those working with more immediate forms, such as poster art or performance pieces, have become a cutting edge in much contemporary art, so that the graphics of ACT UP now enter into the catalogues of contemporary art (and, ironically, become commodities to be bought by the very elites they are assailing).[25] Cultural workers, too, become major fundraisers for AIDS organisations, and there have been some massive fundraising efforts as in the Red, Hot and ... concerts which have involved some of the biggest names in popular music and reached audiences of millions through global television coverage.[26]

AIDS organisations make use of different cultural forms for education, support and, yes, propaganda: the ways in which, for example, HIV/AIDS has been written into the scripts of a number of soap operas requires analysis (both of content and of audience response) which has yet to be done. Again, the global nature of mass communications makes this important across the world: a number of years ago I met a young gay man in Kuala Lumpur whose knowledge of HIV was largely based on having seen the US telemovie *An Early Frost* on local television. National television in Trinidad and Tobago screened (in 1990) a six-part series, *Tangled Lives*, showing the impact of AIDS on a particular family, and television and radio have told AIDS stories in countries as diverse as Zaire, the Philippines and Israel.[27] Some educators have commented on the usefulness of puppetry and mime for raising delicate issues of sexual behaviour: 'The puppet is one step removed from the human being, so puppeteering is not as threatening as using a human actor could be.'[28]

Contagious Desire: AIDS and Sexuality

All the cultural works discussed above touch in various ways on the new intersections between sexuality and death which AIDS has reintroduced into popular consciousness. The reality will vary enormously between different groups and countries: the meaning of AIDS for gay men in Berlin or Brisbane is very different to that for teenage women in villages in Thailand or Tanzania. Yet in both cases there is the underlying sameness in that sexuality, a force linked with pleasure and reproduction, is once again — and more graphically than ever before — linked to danger and the prospect of death.

Communities most affected by the epidemic face the need to redefine sexuality in ways that can preserve sexual relations while protecting others from infection. This becomes an extraordinary dilemma for those who wish to have children; in many societies, where women's worth is measured by their ability to give birth, HIV infection means a life-threatening dilemma between risking pregnancy or denying the strongest social expectations of women. Even where the pressure to give birth is not enforced by the sort of social sanctions found in traditional African or Indian villages the dilemma remains; many married men with haemophilia who were infected by HIV faced strains on their marriages which were unimaginable before HIV. Moreover, certain traditional sexual practices — for example, in some African societies a widow is expected to become a second wife to her husband's brother — can have major consequences once HIV infection is involved.

Such dilemmas rarely present themselves in Western gay communities, although they may be a reality for individual homosexual men who may wish to father a child, and it has therefore been easier to integrate 'safe sex' into the mores of that community. Thus while it seems true that gay men have changed their behaviour more drastically than any other group it would be silly to deny that they have also faced far fewer dilemmas than do other people, and I am somewhat sceptical of those who see the relative success of the gay community as a model for others.

Comparatively few attempts have been made to develop 'safe sex' programs in ways appropriate for heterosexual intercourse; most programs have targeted women, as if the idea of persuading heterosexual men (who after all are required to wear the condom) was just too hard. One feminist put it:

> Even liberal approaches to AIDS education today ... still endorse rather than question the most macho conceptions of sexuality. The aim of First AIDS [a program on Britain's ITV] was solely to force young men into condoms, enlisting the support of young women. The experts endorsed the idea that men were driven to fuck, and the more often the better, and sat back while the presenter ignored or mocked a few young men who were ready to explore the differences between macho mythologies and their own experience.[29]

Yet even talking of condom use to many men is very difficult, and women who seek to initiate such discussion will often face rejection, abandonment and perhaps violence: 'For those women who are in abusive relationships, a characteristic which transcends racial, economic and social boundaries, the risk of introducing condoms may be more immediate than that of contracting AIDS.'[30]

In the comparatively early days of the epidemic, particularly in Western countries, it was assumed that AIDS would lead to a more repressive attitude towards sexuality, and a rejection of sexual experimentation and adventure. A story on the filming of Brad Easton Ellis's novel *Less than Zero* written in 1987 commented that: '[It's] a kind of pre-AIDS book, so it has a different notion of sexuality than I think you can have now. Bisexuality, I don't think, is fashionable anymore.'[31] Seven years later the comment seems somewhat naive, and not because AIDS has gone away. Instead a whole set of new discourses and practices has evolved, which incorporates a recognition of the need for 'safe sex' precautions into a new form of eroticism. Examples of this approach to sexuality are found in phenomena such as the videos of Madonna, the growth of huge 'dance parties' such as those associated with Sydney's Gay & Lesbian Mardi Gras, the re-emergence of sex-on-premises venues in American cities — some catering to lesbians or heterosexuals as well as homosexual men — incorporating rules about 'safe sex'.

AIDS awareness has been incorporated into the mores of self-conscious gay communities, albeit unevenly (it is taking longer for an acceptance of condoms to become part of the sexual culture in parts of Southern and Eastern Europe which lacked the intense gay peer education programs of North America and Australasia). Homosexual pornography both reflects and helps shape this change; most 'gay' pornography (which is largely American and French in origin) now incorporates condoms into scenes of intercourse, although there was initial resistance to this move.[32] More interestingly an awareness of AIDS issues now occasionally comes into the storyline, as in the US film *More of a Man*[33] which portrays an ACT UP activist as a role model for a confused young man (the final scene taking place during a Los Angeles Gay Pride parade). Any awareness of a larger social or political world is sufficiently rare in pornography for this to indicate that the gay/AIDS politics of the current period has now been integrated into sexual fantasies in a quite

remarkable way: 'the activist' now becomes defined as an object of desire, thus legitimating political activity at the level of the libido.

Outside gay communities the challenge to incorporate an awareness of AIDS into the politics of sexuality and gender has only been outlined. But in different ways this is being attempted; the position of African women is enormously different from that of Western gay men, yet they too are beginning to discuss ways of changing community mores to make sex safer. Thus at an international conference on women and AIDS in Africa, participants recommended studies to better understand the nature and risks associated with polygamy and 'dry sex' (the practice whereby the vagina is dried before or during sex) and, perhaps over-optimistically, recommended that: 'The African concept of "maleness" needs to be re-evaluated in the face of what is known about HIV transmission, so that men's sexual behaviour can be modified.'[34] As Maxine Ankrah has pointed out, this will require the empowerment of women as well as men, in order to build 'better social arrangements which lay a sound base for shared decision-making on matters of relationships, including sex'.[35]

These examples suggest that AIDS has changed the understanding, construction and control of sexualities in ways which we are only gradually coming to understand, and which will vary enormously between different communities, countries and classes. As part of this there is a slowly growing recognition that sexual behaviour takes place within larger social, political and economic constraints. Speaking of Africa, Randall Packard and Paul Epstein wrote:

> For sexual activity is not simply about pleasure. It is also about social reproduction. If efforts to control the spread of HIV infection do not include policies that deal with the underlying causes of both family separation and the high demand for family labor, we may be fighting an uphill battle in trying to reduce the heterosexual transmission of AIDS in Africa through behavioral modification and condom use.[36]

To these factors might be added the need for a more sensitive understanding of the meanings of and reasons for prostitution. Too often, the discourses around HIV/AIDS present prostitutes as primarily a threat to the health of

their clients, even though in many cases it is the reverse that is true: the sex worker is usually more vulnerable to infection than her more powerful customer. The ubiquity of commercial sex co-exists with a great deal of hypocrisy: countries like Thailand, with its very extensive sex trade, pretends that it does not really happen. Where sex work is acknowledged, it is almost always conceptualised in terms of the threat posed by the sex worker, thus taking the onus off the client not to infect her/him or to pass on infection to other partners. Many monogamous wives are at grave risk of HIV infection because their husbands visit sex workers, yet the prevailing discourses paint the workers, not the husbands, as the problem. Not only does this evade the issue of HIV transmission, but it also fails to address the socio-economic conditions which give millions of people little option but to use prostitution as a means of short-term survival.

The spectre of HIV has entered into the political economy of sexuality in ways ranging from the growing trade in young children for prostitution in many countries (where youth is seen as a guarantee of negative status) through complex and heartbreaking choices about pregnancy for women to such 'post-modern' phenomena as safe-sex clubs and the fetishisation of condoms in post-AIDS art. The increasing stress on understanding HIV as a sexually transmitted disease has opened up new spaces for talking about sexuality, and in this process has helped create new sexual identities. (In many countries the use of terms such as 'gay and bisexual men' or 'sex workers' is a product of HIV/AIDS programs and surveillance.) There is a current vogue for interpreting this as very much a product of Foucault-like discursive relations of power. I have real doubts about such analyses, as they seem to me to underrate the role of human agency in creating these identities, rather than being merely subject to the 'disembodied and ubiquitous processes' which some theorists attribute to (post)modernity.[37]

It might be useful to postulate the term 'psycho-cultural' to pull together the very diverse ways in which AIDS has impacted on human life; the combination of these two terms, with their reference to the language of psychology and of anthropology, suggest that we are all affected, both individually and socially. (This sort of analysis needs to be thought of in conjunction with the more hard-headed studies by economists of the growing costs of the epidemic through its impact on production, labour, government and household income.[38]) It is no longer possible to collect all the media

references to AIDS — indeed, even the books on the epidemic now fill a small library. The term, as much as the reality, has entered everyday life and shapes large numbers of social, cultural and sexual responses. We are all, in very diverse and varied ways, 'living with AIDS'.

1. On the Australian response to the epidemic see John Ballard, 'Australia: participation and innovation in a federal system' in D. Kirp and R. Bayer, *AIDS in the Industrialised Democracies*, New Brunswick: Rutgers University Press, 1992; Dennis Altman, 'The most political of diseases' in E. Tinewell, V. Minichiello and D. Plummer, *AIDS in Australia*, Sydney: Prentice Hall, 1992.

2. S. Freud, 'Mourning and Melancholia' (1917) in J. Strachey (ed.), *The Complete Works of Sigmund Freud*, Vol.14, London: Hogarth Press, 1957, pp.244, 246.

3. See Michael Bronski, 'Death and the Erotic Imagination' in John Preston, *Personal Dispatches: Writers Confront AIDS*, New York: St Martin's, 1989; Douglas Crimp, 'Mourning and Militancy', *October*, No.51, Winter 1989.

4. Andrew Holleran, 'Friends at Evening' in George Stambolian (ed.), *Men on Men*, New York: New American Library, 1986, p.95.

5. Elizabeth Reid, *The HIV Epidemic and Development: The Unfolding of the Epidemic*, New York: UNDP, n.d., p.10.

6. See C. Ruskin, *The Quilt: Stories from the NAMES Project*, New York: Pocket Books, 1988.

7. Cindy Patton, 'No Turning Back', *Zeta Magazine* (Boston), January 1988, p.70.

8. See Peter Hawkins, 'Naming Names: The Art of Memory and the NAMES Project AIDS Quilt', *Critical Inquiry*, No.19, Summer 1993, pp.765-766.

9. M. Sturken, 'Conversations with the Dead', *Socialist Review*, Vol.92, No.2, 1992, p.77.

10. Peter Blazey, 'Grief Queens and Primal Screams', *Outrage*, No.122, July 1993, p.48.

11. 'Candlelight Memorial 93' in *The Act, Action for AIDS Singapore*, No.6, 1993, p.1.

12. 'Dans le monde de la danse, les tabous sont déjà tombés', *Journal de Genève*, 7 January 1993.

13. Hugo Williams, 'Rather Shocking', *New Statesman*, 19 June 1987, p.25.

14. Dennis Altman, *The Comfort of Men*, Melbourne: Heinemann, 1993.

15. Dale Peck, *Fucking Martin*, London: Chatto & Windus, 1993, p.158.

16. Robert Dessaix, 'Introduction', *Australian Gay & Lesbian Writing: An Anthology*, Melbourne: Oxford University Press, 1994, p.16.

17. See Peter Wells, *Dangerous Desires*, Reed Books, 1991.

18. Doumbi-Fakoly, 'African Literature: Witness to its time' in Allan Klusacek and Ken Morrison, *A Leap in the Dark*, Montreal: Véhicule, 1992, p.225.

19. Dan Simmons, *Children of the Night*, London: Headline Books, 1992.

20. Quoted in Alan Riding, 'French Cult Figure Posthumously Stirs AIDS Debate', *International Herald Tribune*, 30 April 1994.

21. 'Films and the Fear of AIDS', *The Economist*, 28 May 1994, p.86.

22. S. Watney, 'Photography and AIDS' in C. Squiers (ed.), *The Critical Image*, San Francisco: Bay Press, 1990, p.187.

23. Ibid, p.192.

24. Flyer for *My Queer Body*, a performance piece by Tim Miller, Sydney, February 1993.

25. On ACT UP graphics see D. Crimp with A. Rolston, *AIDS Demographics*, Seattle: Bay Press, 1990.

26. The first of these was *Red, Hot and Blue* in 1990, using the songs of Cole Porter. See interview with Leigh Blake by Yves Averous, *Outrage*, February 1991, pp.31–33.

27. See P. Piotrow, R. Meyer and B.Zulu, 'AIDS and Mass Persuasion', in *AIDS in the World*, pp.733-747.

28. Mike Milvase with Gary Friedman, 'Puppets against AIDS' in *A Leap in the Dark*, p.277.

29. Lynne Segal, 'AIDS is a Feminist Issue', *New Socialist* (London), April 1987, p.9.

30. Marvellous Mhboyi, 'Can a New Sex Culture Save the Next Generation?', *National AIDS Bulletin*, July 1993, p.19.

31. Karen Back, '"Less than Zero" Is Adding Up to a Movie', *New York Times*, 30 August 1987, p.H14.

32. See Wieland Speck, 'Working with the Film Language of Porn' in *A Leap in the Dark*.

33. *More of a Man*, a video by Jarry Douglas Seabag Production, 1990.

34. Summary and Recommendations, Society for Women and AIDS in Africa: Third International Conference on Women and AIDS in Africa, Yaounde, Cameroon, 19–22 November 1991.

35. E. Maxine Ankrah, 'AIDS and the Social Side of Health', *Social Science Medicine*, Vol.32, No.9, 1991, p.972.

36. Randall Packard and Paul Epstein, 'Epidemiologists, Social Scientists, and the Structure of Medical Research on AIDS in Africa', *Social Science Medicine*, Vol.33, No.7, p.776.

37. This phrase comes from J. Gamson, 'Silence, Death and the Invisible Enemy' in M. Buroway, *Ethnography Unbound*, Berkeley: University of California Press, 1991, p.53.

38. See, e.g., D. Bloom and J. Lyons, *Economic Implications of AIDS in Asia*, New Delhi: UNDP, 1993; S. Devereux and G. Eele, *Monitoring the Social and Economic Impact of AIDS in East and Central Africa*, Food Studies Group, Oxford University, 1991.

Faces of AIDS

Lynn Sloan

FACES OF AIDS pictures individuals living with AIDS. These portraits are introductions: 'this is Susan', 'this is Ron', 'here is Laurie and her children', 'Kenn with his mother'. In their directness these portraits invite us, as viewers, to look carefully at those pictured and to think about their lives. The expressions on their faces, sometimes resoluteness, sometimes skepticism, exuberance, vanity, sorrow, doubt, indifference, reflect feelings that each of us has known.

As a group, FACES OF AIDS includes the young and the old, persons living with others or alone, men and women, white, black and hispanic, the wealthy and the poor. The diversity of those pictured challenges the easy categorisations of the 'other' and avoids the belittling melodrama of the 'victim'.

These individuals have one thing in common: they wanted to have their photographs taken. In the three years I worked on FACES OF AIDS, I contacted hospitals, clinics, church-affiliated agencies and private support groups, asking them to inform their clients of my project. Through word of mouth, news spread, and people called, asking to have their photographs taken. Many of those I photographed wanted pictures to give to friends and family; some wanted records made while they were still healthy; some wanted pictures for their obituaries. Except for a number of women who feared the repercussions their children might suffer, everyone wanted their pictures to be seen by the public. They wanted to stand up and be counted. Those I photographed expressed the belief that it is important for the community at large to know that AIDS affects real individuals; and, just as important, that having AIDS doesn't curtail meaningful living.

FACES OF AIDS is not reportage. It doesn't try to explain the lives of persons living with the illness, it doesn't place them in a social or political framework, it doesn't cover the range of their experiences. It does depict with deliberate care the integrity of each individual.

JERRY S.
Living with AIDS since 1984
Currently working for the City of Chicago's Water Department
His brother, a priest, died of AIDS in December, 1989

SUSAN
Living with AIDS since 1986
Husband died of AIDS in 1987
Recovered drug addict
'I'm a Christian now. I turn to Jesus Christ, my Lord and Saviour, every
day and He helps me through it all.' 26 June 1989
DIED 17 SEPTEMBER 1989

DAVE WITH HIS DAUGHTER
Living with AIDS since August 1985
Formerly a chauffeur
His daughter asks: 'Are you going to die?'
Dave: 'Not just yet. I'm a survivor.' 28 December 1988

BETTY WITH HER HUSBAND
Living with AIDS since March 1988
Currently working as an AIDS counsellor
From a letter to her daughter

Dear M.,
'Here I am once again just thinking about you and our future together and your future after I am gone. I get so frustrated sometimes! I don't want anybody else to raise you ...

But I want you to know that I will be with you in spirit always. And when things get real rough on you and you don't know why everything seems to be against you, then you can think about how much I love you and that I will be standing right next to you and my spirit will cry every time you cry and my spirit will be happy every time you are happy.' 15 February 1989

JACKIE WITH HER FOSTER MOTHER
Diagnosed HIV+ on 10 September 1988
DIED 17 JANUARY 1990

ADAM AND JOHN
Adam, formerly a schoolteacher,
and John, a physical therapist, together since 1984
Adam. Diagnosed HIV+ on 31 December 1985
Living with AIDS since 17 May 1988
John. Diagnosed HIV+ on 17 June 1988
'AIDS is not a death sentence unless you allow it to be. Remember, live,
love, thrive, and survive.' Adam, August 1989
DIED 30 JULY 1991
'The AIDS virus may weaken my immune system, but it has increased my
heart's capacity to love, my mind's ability to be understanding, and my
soul's desire to live life to the fullest.' John, August 1989

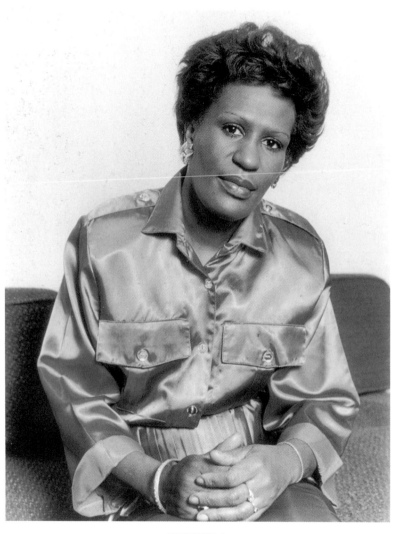

NOVELLA
HIV+ with symptoms
Formerly worked as a medical transcriber
Currently working as an AIDS counsellor
'Speaking for many PWAs, we do not wish to be a burden to our
community. We like to be self-supporting and productive individuals, and
if and when we can no longer be that, we will surely need all the support
we can get. We would like people to be more concerned and involved.'

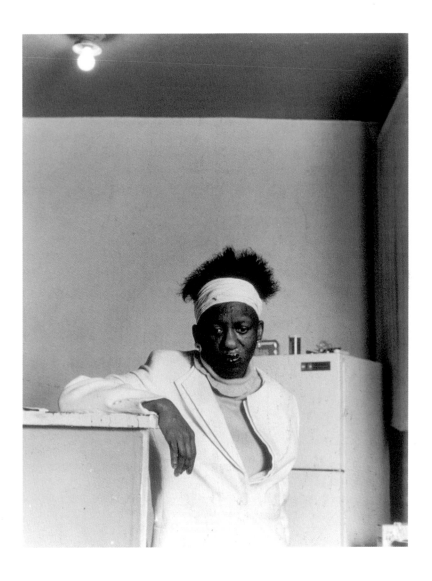

MYRA
Formerly a homemaker
Diagnosed with AIDS in March 1988
Son, Christopher, born 5 October 1987, died of AIDS on 11 May 1988
Was saving to buy a tombstone for her son
DIED 14 SEPTEMBER 1990

LAURIE AND HER CHILDREN
Laurie, HIV+
Husband died of AIDS
E.J., son, DIED OF AIDS AT THE AGE OF 23 MONTHS
15 June 1989

Lynn Sloan lives in Evanston, Illinois, and is a Professor in the Photography Department, Columbia College, Chicago. Her work has been published in numerous photographic journals. 'Faces of AIDS' has been exhibited across the United States, in New York, Colorado and Chicago.

Lovers and Friends

All night you'd lay asleep
enfolded in my arms,
breathing slow and sweet.
I never understood
how it would prove to be
such a luxury to feel
your hand, warm in my hand
your kiss on my cheek.

Lovers and friends
are all that matter.
You'll never know how much it
came to mean to me
to have you by my side
in battles lost and won.

And now I understand
these things can never be
guaranteed.
I wish I could recall
each mundane tenderness,
remember every look, each word,
preserve every breath,
each kiss, each caress.

Lovers and friends
are all that matter.
I never thought that I would
watch you drowning
far from any sea, on crumpled sheets,
white sand in your eyes.

Lovers and friends
are all that matter.
And now when all I have of you
is a memory,
I raise my hand to touch my cheek,
imprinted with your love.

R.Coles
© Mistramark Ltd/Rocket Music Ltd/Zomba Music Publishing Ltd
Reprinted by permission of Rondor Music Australia

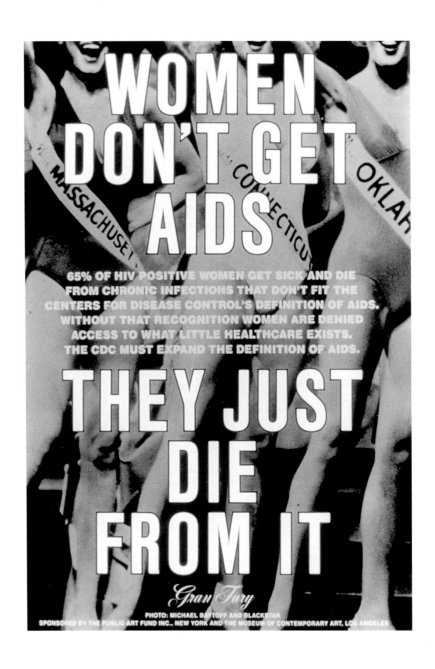

Gran Fury, United States, *Women Don't Get AIDS – They Just Die From It*, 1991, bus shelter poster. A Project of the Public Art Fund, New York City. January – March 1991

Where the Streets Have New Aims:
The Poster in the Age of AIDS

T ED GOTT is a Curator of European Art at the National Gallery of Australia, Canberra. He organised the exhibition 'Don't Leave Me This Way: Art in the Age of AIDS', staged at the National Gallery of Australia in 1994

More than any other issue in recent memory, the AIDS crisis has provided the tragic impetus for public art. While the media furore that has surrounded HIV/AIDS has undoubtedly provided one public arena for debate about the crisis, a host of groups, from governmental and government-allied bodies to private activist organisations, have taken their individual AIDS causes and particular AIDS stances to the streets. It seems that one of the most urgent fields in the war against AIDS is one that needs to be waged for 'control' of the minds and hearts of the populace. The aim of this article is not to present a complete history of public graphics associated with the fight against HIV/ AIDS, but rather to consider a selection of the most successful public 'interventions' that the United States and Australia have witnessed since the onset of the AIDS débâcle.

On the Road

Arguably the most visible 'official' street poster campaign in the United States was initiated by the American Foundation for AIDS Research (AmFAR), as an adjunct to its successful *Art Against AIDS* art auctions. The concept originated with Livet Reichard, a public relations firm which had previously organised AmFAR's *Art Against AIDS* charity fundraisers. The idea was simple, and bold: to ask corporations to 'sponsor' public artworks in the form of billboards, bus shelter posters, exterior bus panel posters, etc. Since the advertising space was also donated by local transit authorities and civic councils, the corporate funds left over and above production costs of the public art campaign would go towards AmFAR's fight against AIDS.

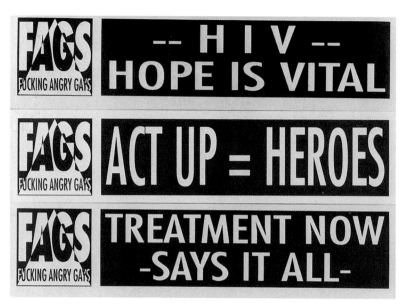

F.A.G.S. (Fucking Angry Gays), Australia, *Street Blitz Stickers* 1991–93, crack-and-peel stickers. National Gallery of Australia, Canberra, Gift of F.A.G.S. 1993.

With this rationale in mind, the project's curator Ann Philbin commissioned twenty-two American artists to design public-space 'statements' about AIDS that could adorn a range of stationary and 'moving' sites, from billboards to buses. Only a few of the artists selected by Philbin had previously addressed the subject of HIV/AIDS in their art — a fact which has been criticised. In this author's opinion, this was an important attempt to broaden an artistic response which had largely come from US gay artists, thereby mitigating the double-edged 'ghettoisation' of AIDS as the 'property' of the gay community and the preserve of gay art practitioners, and broadening public perception of the true universality of the AIDS crisis.

On the Road: Art Against AIDS was launched in San Francisco in April 1989. Philbin's selection resulted in an extremely diverse range of public 'representations' of AIDS, from Group Material and John Lindell's up-front bus panel *All People With AIDS Are Innocent* and Barbara Kruger's stirring billboard message *Fund Healthcare, Not Warfare*, to more didactic designs by Keith Haring and Adrian Piper, enigmatic 'symbols' by Cindy Sherman and Laurie Simmons, or emotional pleas such as Brian Weil's enormous bus-shelter image of an HIV-positive baby, *Prince, New York City*, and Robert

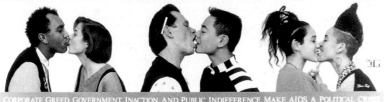

KISSING DOESN'T KILL: GREED AND INDIFFERENCE DO

CORPORATE GREED, GOVERNMENT INACTION, AND PUBLIC INDIFFERENCE MAKE AIDS A POLITICAL CRISIS

Gran Fury, United States, *Kissing Doesn't Kill: Greed and Indifference Do* 1989, bus panel poster. Courtesy AmFAR (American Foundation for AIDS Research), New York.

Mapplethorpe's equally large *Embrace*, with its image of two men clinging desperately together.

In a society as deeply conservative as the United States, *On the Road* represented a courageous attempt to cultivate public debate around AIDS and its attendant social problems. Inevitably, AmFAR's campaign was not without its problems. In San Francisco, a city where 'the streets are deep in loss and anger' and 'most of its citizens are aware of AIDS and are better informed about it than citizens of other cities', the didactic posters from *On the Road* proved less effective; and more ambiguous designs such as Nayland Blake's delicate tracery of flowers entwined among the poignant words *Don't Leave Me This Way* affected more viewers who 'for all the deaths San Franciscans have experienced, [have had] few public, collective expressions of grief'.[1]

Gran Fury's bus panel poster *Kissing Doesn't Kill: Greed and Indifference Do* 1989, which reworked Benetton's slick advertising style, was banned by the Chicago Transit Authority (CTA) from use on buses in the Chicago area — where the *On the Road* project moved in May–June 1990 — after a complaint by one city alderman that its kissing couples (both interracial and mixed/same sex) 'seem[ed] to be directed at children for the purposes of recruitment'.

> So the State Senate voted 49 to 2 to prohibit any depiction of 'physical contact' or 'embrace ... within a carnal, erotic or sexual context by members of the same sex in advertising on vehicles that carry individuals under age 21'. (We can see it now — G-rated buses with heterosexually-oriented ads and images for the 21 and under crowd.[2]

While this poster was attacked by one Chicago CTA official for its 'lewd and lascivious kissing of homosexuâls', its display was also refused when the *On the Road* project went to Washington DC in the spring of 1990, as was Robert Mapplethorpe's bus-shelter poster *Embrace*. (The latter work also suffered at the hands of the Tennessee printing company assigned to the project, which refused to print it on the grounds of its 'unChristian' values.[3])

These controversies serve to highlight the tragic nexus of homophobia — or indeed 'any minority'-phobia — and religious bigotry which has persistently dogged efforts to educate and inform the American populace about the dangers of HIV/AIDS. The correlation between the Reagan–Bush era laws prohibiting 'gay-friendly' or even 'sex-friendly' AIDS education measures (and the cruelly blind assumption related to this: that AIDS remains a gay disease which will end with the successful genocide of America's gay population) and the catastrophic incursion of AIDS into virtually every minority group within the United States (the sum total of which *is* the 'general public') is now tragically indisputable. The history of AIDS in America illuminates the harsh reality that heads in the sand serve only to break the soil for new grave plots.

In this context, while it may seem easy to criticise AmFAR's *On the Road* poster campaign on various ideological grounds, it is perhaps more productive to simply recognise what a bold incursion into the 'loaded' public space of America it actually represented.

ACT UP/New York

Undoubtedly the best graphic 'street' art produced in response to HIV/AIDS has emanated from the AIDS Coalition To Unleash Power, or ACT UP, an activist 'lobby' group which emerged in the face of massive mismanagement of the AIDS crisis by both the United States government and the health system under presidents Ronald Reagan and George Bush.

The situation leading to the formation of ACT UP has been beautifully described, *ad reductium*, by a British observer, Simon Watney:

By the end of 1986, more than 10,000 people in New York had been diagnosed with AIDS, over half of whom were already dead. Many thousands more were beginning to experience pre-AIDS symptoms of HIV disease. Entire networks of friends were dying. Amongst injecting drug users' families, increasing numbers of children were being orphaned. But the great majority of deaths were amongst gay men. There were simply too many names to strike from one's address book, and it became a widespread custom simply to write the letters RIP across the names of the dead, until the pages began to resemble a mortician's diary. The gay community was in shock.

It was also painfully apparent that treatment and service provision were woefully inadequate, and unevenly available. Politicians prevented the establishment of needle-exchanges, whilst bigots of all political and religious persuasions managed to prevent effective health education for gay men. Those most at risk of HIV were being most systematically neglected.[4]

ACT UP was in essence formed by Larry Kramer, a gay activist who had been a co-founder of the New York-based Gay Men's Health Crisis (GMHC) in 1982, the first AIDS service organisation in the United States. ACT UP emerged in response to a fiery speech Kramer — by then disenchanted with GMHC's bureaucracy and avoidance of radicalism — delivered in New York early in March 1987.[5] Two days later, at a second meeting of gay and lesbian New Yorkers, the AIDS Coalition To Unleash Power was established. Within two weeks the new activist group held its first demonstration against the US Food and Drug Administration's slowness in releasing trial drugs for the treatment of AIDS, holding up traffic around Wall Street in Manhattan for several hours and distributing tens of thousands of 'fact sheets' arguing their case about the FDA's mishandling of the AIDS crisis.

By the time of ACT UP's second demonstration on 15 April 1987, the group had adopted its most memorable visual symbol (repr. p.155), what Douglas Crimp has aptly described as 'that simple graphic emblem — SILENCE=DEATH printed in white Gill sanserif type underneath a pink triangle on a black background — [which] has come to signify AIDS activism to an entire community of people confronting the epidemic'.[6] In fact this had started not specifically as an ACT UP graphic, but had appeared on the

streets of New York several months before the foundation of the new group — the product of a small number of gay men who called themselves the Silence=Death Project. These men were also founding members at ACT UP's first meeting, and they quickly 'donated' the use of their design to the fledgling movement.

The repetition of these ACT UP graphics en masse was a galvanising force. Douglas Crimp and Adam Rolston vividly recall the effect of such visible graphics at the October 1987 March on Washington for Lesbian and Gay Rights.

> Leading the 500,000 march participants were people with AIDS, some in wheelchairs pushed by their friends — a reminder that fighting AIDS is now a priority for gay people and that first in the fight are people living with AIDS. ACT UP was positioned toward the back of the march, our legions immediately recognisable from our SILENCE=DEATH T-shirts. SILENCE=DEATH and AIDSGATE posters had been mounted recto-verso on foamcore and hinged together to make a long serpentine of repeated graphic images, like a Chinese new-year dragon adapted for political action. If you were wearing one of our T-shirts, you could be sure to be asked countless times, 'Who is that group?' On the following Monday night in New York, the weekly ACT UP meeting swelled to double its usual number — a sure sign that graphics are an aid to organising.[7]

In this manner ACT UP harnessed the power of the gaze to galvanise power for gays, in addition to its broader aims of health care for all and the elimination of red tape, prejudice and mis-spending in the American health system. From the outset ACT UP benefited from the presence in its midst of a significant number of workers in the commercial design, advertising and film industries, who knew full well how to shape activist imagery into a 'sexy' and fashionable commodity.

Since 1987, ACT UP's graphics have literally plastered New York City, in wave after wave of AIDS demonstrations demanding increased US government funding for health care. It has been cogently, if in retrospect sadly, remarked that 'the purpose of ACT UP's blitzkrieg of images and words is to make an impact on a population that seems to care less about AIDS than

it did about the Vietnam War where much fewer people were killed'.[8] Certainly ACT UP's combined use of street demonstrations with brilliant graphic interventions has served to keep alive before the American public many issues surrounding AIDS, through seemingly never-ending zaps of government agencies or public events. Each demonstration has carried its own graphic, repeated across placards, banners, T-shirts, flyers, stickers and buttons. Designed to be short, memorable, and immediately readable, these graphics were thus guaranteed to find their way into newspaper commentaries and television sound-bites, protecting ACT UP's core message even from hostile or distorted media coverage.

AIDSGATE 1987, for example, was created by the Silence=Death Project to mark an ACT UP demonstration at the White House in June 1987, timed to coincide with the Third International Conference on AIDS, held in Washington DC. This was the occasion when President Reagan made his first public mention of the word AIDS, six years after medical recognition of the epidemic. Acid colours appropriated from Andy Warhol were combined with the catchphrase 'AIDSGATE', referring both to the current Iran–Contra arms sales scandal in which Reagan was embroiled (then known as Irangate or Contragate) and of course the celebrated Watergate controversy, and implying an atmosphere of equal scandal around the Reagan–Bush administration's handling of the AIDS crisis.[9]

Donald Moffett's *He Kills Me* poster (repr. p.157) first appeared on the streets of New York in February 1988, in response to the arrival in New York of Ronald Reagan's Presidential Commission on the HIV Epidemic, not one of whose fourteen members had any recognisable expertise on HIV/AIDS.[10] Moffett was also motivated by personal concerns: 'When I made it, I was embedded in the tragedy of losing a lover to AIDS, and I was feeling really murderous towards Reagan. The bulls-eye is aggressively hostile, designed as a target moving in his direction. All the rest is about making a riotous image that will hold its own on the street.'[11] This poster works best in a repeated sequence, in which Moffett prefers an inversion of the two sides of the image (Reagan and target) to be built into the centre of the configuration.

Vincent Gagliostro's *Enjoy AZT* 1990 and GANG's *AIDS Crisis* 1991 draw upon classic American symbols, relying on a subconscious fusion of their AIDS message with mass consumer recognition of the iconic commercial

product. Gagliostro cleverly reworks the legendary Coca-Cola logo, while GANG reinvent President Bush as the Marlborough Man (a poster lent additional force by the fact that the actor who posed as the 'real' Marlborough man died of AIDS). This use of both artistic (borrowings from Andy Warhol, Barbara Kruger, Jenny Holzer) and commercial appropriation is typical of ACT UP's desire to embrace rather than shun popular culture as a means of reaching the minds and hearts of the populace.

ACT UP's graphics do not rely upon rented billboard space. Too well designed and beautifully produced to be dismissed simply as graffiti, they nevertheless operate in similar spheres, as ACT UP members throw down thousands of flyers into New York streets, cover newspaper vending machines and traffic lights with activist stickers, paste their posters onto construction-site hoardings, and slip placards into the subway and bus systems.

Richard Deagle's subway posters play their part in this subversive media wargame. They are designed to fit perfectly into the advertising grids that adorn the upper walls of trains throughout New York's subway system; and it is an easy task when no one is looking to slide out the standard commercial posters found on New York trains and substitute the handiwork of Deagle and others. Unsuspecting commuters then find themselves confronted not with the standard hard-sell advertising that provides reading material for their journeys, but with more disturbing messages. Deagle's subway posters range from strong use of memorable statistics (for example, the emotive pitch 'The Pentagon spends more money in *one day* than the US government has spent on AIDS in *eight years*' that adorns *One AIDS Death Every 30 Minutes!*), to general disruptive slogans (such as *AIDS / It's Big Business ! (But Who's Making A Killing?)*) and specific attacks on public figures whom Deagle perceives to be ideologically questionable in terms of their response to the AIDS crisis (*Deadlier Than the Virus. Stephen C. Joseph, Commissioner of Health, NYC*). Suzanne Wright's *Women Get AIDS Too*, protesting against the lack of attention to women's needs in the New York health system, was also designed as a subway 'replacement' poster.

These screenprinted images which, like demonstration placards, can be simply printed up overnight to meet current demand, provide a clever means of direct intervention into social consciousness within the New York region. Importantly, the 'look' of Deagle's posters resembles official New York

Department of Health info-sheets about the AIDS epidemic, thereby granting them a certain degree of subversive longevity before they are 'recognised' and removed by subway authorities.

Gran Fury

Some artistic sections of ACT UP have now become mainstream participants in the 'art world'. Gran Fury is the collective title used by a group of designers within ACT UP who collaborate anonymously on guerrilla graphics; their name, Gran Fury, is taken from the brand of car used by New York's undercover police.

In 1990 Gran Fury caused a sensation at the Venice Biennale, with a startling installation which placed a huge photograph of Pope John Paul II next to an 'angrily' erect penis, accompanied by a billboard text attacking the Catholic Church's disapproval of condoms and smothering of AIDS-education programs. Over the body of the Pope, Gran Fury had stencilled a quote from New York's Catholic Cardinal O'Connor, from his address to the Vatican's Conference on AIDS: 'The truth is not in condoms or clean needles. These are lies ... good morality is good medicine.' According to Tom Kalin, a Gran Fury member: '[T]he power of institutions such as the Catholic Church (which pathologically glorifies family and completely disavows tiny little facts such as sex outside marriage, the realities of rape, or that condoms and clean needles save lives) necessitates projects of counter-representation.'[12]

Gran Fury's work aroused the ire of Giovanni Carendente, President of the Biennale; and with 'unexplained' customs delays which held up its unveiling, and subsequent 'inspections' by legal and religious 'censorship' panels, the installation grew into a major scandal.[13] As one observer recalled:

> Even better for Gran Fury, many of the papers quoted the text on the billboard, thereby spreading its message about Safer Sex way beyond the relatively elite crowd that visits the Biennale. 'The Catholic Church has long taught men and women to loathe their bodies and to fear their sexual natures', read thousands of Italians over their espressos. 'This particular vision of good and evil continues to bring suffering and even death by holding medicine hostage to Catholic morality and withholding information which allows people to protect themselves and each other ...'[14]

Gran Fury followed this *succès de scandale* with an equally challenging public 'event'. This time, the Public Art Fund of New York, a non-profit arts organisation dedicated to securing a place for artwork within the urban landscape, commissioned the collective to design a poster for bus shelters across New York. In late January 1991 one hundred posters, printed in both English and Spanish versions, were installed throughout five New York boroughs. In March 1991, the Museum of Contemporary Art in Los Angeles, in collaboration with New York's Public Art Fund, placed a further one hundred posters in bus shelters across Los Angeles. Gran Fury's poster design combined a bitterly ironic slogan, *Women Don't Get AIDS – They Just Die From It* (repr. p.186), with a saccharin image of beauty pageant contestants. The poster not only questioned the limited definition of the Centres for Disease Control (Atlanta) of what illnesses constituted a diagnosis of AIDS in American women, therefore claiming that this restricted their access to health care, it also equated this 'elision' with the traditionally undervalued place of women in American society.[15]

ACT UP/Golden Gate

Simon Watney's tribute to the enduring power of ACT UP/New York graphics, penned in the context of an exhibition of AIDS-activist art in Scotland, argues that there will be a lasting legacy to ACT UP interventions worldwide.

> Walking around this exhibition, you may legitimately feel that you are looking at the record of a most remarkable moment in modern history, when gay men, together with many from other marginalised communities, organised a political and cultural response to a terrible health crisis which was being almost wholly mismanaged at every level, from the White House to the local pharmacy. ACT UP has achieved the extraordinary goal of democratising the process surrounding treatment drug research in the US. It has helped many thousands gain access to clinical trials for which they would not previously have been eligible. It has changed large sections of American public opinion about the epidemic. The role played by the kinds of imagery you see in this exhibition cannot of course be quantified. But nor can it be neglected. This is art which has made things happen. It is art which has saved lives.[16]

ACT UP/Golden Gate, San Francisco, United States, *150,000 Dead from AIDS. Had Enough?*, crack-and-peel sticker. Courtesy ACT UP/ Golden Gate.

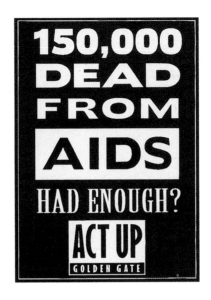

ACT UP/Golden Gate, which is based in San Francisco, was formed in September 1990.[17] From the start the group's 'cultural' activities were marked by a brilliant use of memorable slogans that would be the envy of any advertising agency, and a keen sense of street theatre. One of their first acts, in October 1990, was the production of placards proclaiming *Woman Cannot Live on AZT Alone* and *Man Cannot Live on AZT Alone*, as they became the first group in the United States to call for the US federal government's approval of the drugs ddI and ddC in the treatment of HIV/AIDS. Other unforgettable slogans emerged from their blitz on the 'symbolism' of the 17 May 1993 AIDS Candlelight Memorial (*Red Ribbons=Silence, Silence=Death; Red Ribbons Buy Complacency;* and *Red Ribbons are for Gift Wrapping*); and the group's zap of the San Francisco 1994 Gay Day Parade with smiley-face placards screaming *Have a Nice AIDS*, targeting community indifference or 'shell-shock' in this city which has recorded more than 10,000 AIDS deaths (the majority of the dead being gay men). Memorable among their street theatricals has been a 'Santa Die-In' outside the San Francisco Macy's to protest about that department store's firing of a Santa Claus with AIDS.

ACT UP/Golden Gate has also used crack-and-peel stickers effectively, covering San Francisco's lamp posts, traffic lights and railings with pithy

mottoes printed in primary colours (*150,000 Dead from AIDS. Had Enough? ACT UP*; *Time's Up, Wake Up, ACT UP*; *Do Not Go Gentle ... Rage, Rage, ACT UP*) that also advertise the time and place of the group's weekly activist meetings. And any sunny day in the Castro district one is likely to see Californian citizens wearing eye-catching ACT UP/Golden Gate T-shirts, such as G'Dali Braverman's extraordinary and colourful combination of two legendary comic-strip characters, Dick Tracey and Clark Kent/Superman, locked in passionate embrace and wrapped within the witty legend *Clark wants Dick. Dick Wants Condoms* (repr. p.156). Through this clever use of 'interactive' and wearable street graphics, the group has been able to penetrate San Francisco with a mixture of both obvious and subliminal AIDS-awareness texts, in a saturation manner no government-sponsored campaign could conceive of.

A degree of cross-pollination is evident between east and west coast ACT UP activism as, for example, San Francisco has also become awash with *Silence=Death* T-shirts, placards, buttons, posters, sweatshirts and baseball caps, and has offered a new home to the classic New York imagery of Keith Haring. But while this was happening, ACT UP/Golden Gate's own graphics, such as the vibrant art-deco echoing series of demonstration placards of June 1992 attacking Astra Pharmaceuticals, equally found their way back across the country for use by ACT UP groups in Boston and New York.[18] Similar graphics are being produced by ACT UP chapters across America, and the full history of their origins and meaning has yet to be written. (In California alone, for example, there are the following ACT UP chapters, all producing both locally and universally relevant graphics: Golden Gate, East Bay, Sacramento, San Diego, San Francisco and Los Angeles.)

ACT UP in Australia

ACT UP staged its first Australian demonstration outside the Australian Drug Evaluation Committee's office in Kent Street, Sydney on 27 April 1990. Its members already sported the iconic black and pink *Silence=Death* T-shirts on that first occasion, making an immediate visual impression on the Australian media.[19] Over the following years Australian ACT UP groups in Sydney, Canberra and Melbourne would employ a mixture of imported and home-grown graphics to support their widely publicised demonstrations and zaps. If at times the activities of Australian ACT UP groups have involved

ideologically questionable rationales and actions, even for sections of the gay community, their deployment of 'readable' graphics and dramatic street theatre have nonetheless proved to be effective media attention grabbers.

ACT UP/Sydney recycled Ken Woodard's *AID$ NOW*, a placard first designed for ACT UP/New York's 24 March 1988 protest in the Wall Street financial district.[20] This became a generic graphic which could be brought into the streets on any number of occasions. ACT UP/New York's *Bush AIDS Flag* was also printed up by ACT UP/Sydney as a small but effective crack-and-peel sticker to protest against President George Bush's first Australian visit in late 1991.[21]

Other Australian graphics played with smart reworkings of their American counterparts. ACT UP/Melboune appropriated the slogan of Gran Fury's *Kissing Doesn't Kill, Greed and Indifference Do* 1989 for a new poster publicising a World AIDS Day 'Kiss-In' in Melbourne's main shopping mall on 1 December 1990. According to one of the models for the Australian version, the motivation for this public 'same-sex kiss-in' protest came from two local controversies: 'The first was the opposition to the Victorian AIDS Council's "two boys kissing" poster [see below] and the second was the arrest of two men for kissing a parked car in a suburban street late at night — on a charge of offensive behaviour.'[22] Gran Fury's attack on American 'corporate greed, government inaction and public indifference' was thereby recast in Melbourne as a visually effective image protesting against community homophobia and, by extension, AIDS-phobia. Again adopting similar strategies to their US counterparts (if with different imagery), ACT UP/Melbourne also produced Australian same-sex kissing T-shirts incorporating the Gran Fury motto.

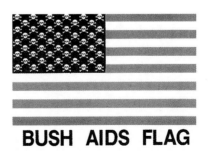

ACT UP/Sydney (after ACT UP/New York), Australia, *Bush AIDS Flag* 1991, crack-and-peel sticker. National Gallery of Australia, Canberra, Gift of ACT UP/Sydney 1994.

ACT UP chapters across Australia, like their American forebears, took art to the streets more immediately as well in the form of a lively use of street theatre. This was particularly well orchestrated on 6 June 1991, declared by ACT UP groups across Australia to be D-Day, the deadline set (rightly or wrongly) by the movement for action by the Australian government on the availability of new drugs for people with AIDS.

In the nation's capital, Canberra, ACT UP demonstrators, wearing evocative 'D-Day graphic' T-shirts in television-ready primary colours, fired off a wave of red flares outside Parliament House. In Melbourne, in the dead of night, ACT UP activists raided the famous Floral Clock on St Kilda Road, ripping out its flowers and replacing them with a field of white crosses. A supreme visual statement (whatever one's political viewpoint) with many layers of symbolic meaning, the full significance of this action was ironically borne out by the unleashing of media and official rage at this 'sacrilegious' vandalising of a beloved civic attraction, highlighting ACT UP's argument that the press and authorities seemed to care more about the fate of Melbourne's flower beds than its dead and dying citizens.[23] As on other occasions, the use of street graphics blended seamlessly with street theatre in these demonstrations, as the vivid D-Day T-shirts and placards worn and waved on 6 June were soon replaced by T-shirts and graphics documenting

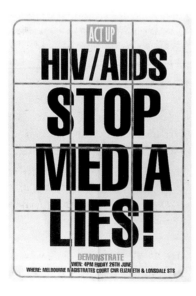

ACT UP/Melbourne, Australia, *STOP MEDIA LIES* 1992, offset lithography. National Gallery of Australia, Canberra, Gift of ACT UP/Sydney 1994.

the arresting sight of protest flares billowing across the statutary heart of the nation.

A different theatrical use of floral imagery was seen in the protest staged at the fifth national conference on HIV/AIDS in Sydney in November 1992 when, during the speeches of the opening plenary session, ACT UP members laid down hundreds of white carnations on the stage, each flower symbolising one Australian death since the fourth conference two years earlier in Canberra.[24]

Safe Sex Down Under

The use of community-sector poster graphics to educate the Australian populace, at both Federal and State government levels, has arguably been more widespread, explicit and effective than any campaign yet undertaken in the United States. Indeed, Australia has now produced so many excellent safe sex and AIDS-educative posters that it is possible to discuss only a selection here: these are analysed purely from an aesthetic point of view, which may not always correlate with their effectiveness as educative tools.

Australian posters *have* been produced which target heterosexuals, injecting drug users, at risk youth, women, Aboriginal communities, and travellers; but the majority of safe sex and AIDS awareness posters produced in this country have been pitched at gay male communities. There is a practical reason for this. Most of these posters have been produced by the States' AIDS councils, which have concentrated closely on tapping into their localised gay target groups. While posters are an effective, inexpensive local community strategy for gay audiences, the National AIDS Campaign has relied on a number of different strategies, including mass media approaches, suited to its different but complementary role. In this manner Australia has developed a highly effective 'partnership' at Federal, State and local levels to achieve good coverage and 'absorption' of safe sex and AIDS education messages across the populace.[25] Arguably Australia has led the world in its open discussion of sexual issues and condom use in mainstream public education campaigns.

While the Victorian AIDS Council (VAC) and the AIDS Council of New South Wales (ACON) are now community-based organisations funded by the State

and Commonwealth governments, each started as a gay-initiated association. The VAC began in June 1982 as the gay-constituted Victorian AIDS Action Committee, which re-formed into the Victorian AIDS Council in December 1984. ACON was formed in 1985 at a public meeting, organised by members of Sydney's gay community, to discuss appropriate ways of responding to HIV/AIDS in New South Wales. Obviously the gay-directed posters produced by these State AIDS councils can be explicit in a way television advertisements could not be, since their distribution has been mostly confined to gay venues and gay publications where discussion of sexuality is not a problem and is not subject to conventional moral views or notions of propriety.

The Victorian AIDS Council upped the ante in 1985, with its extremely clever and highly erotic poster *You'll Never Forget the Feeling of Safe Sex*. Depicting a nude, hirsute man with a 'body by God' sprawling submissively between satin sheets, the poster captured the imagination with its fun reworking of a massive advertising campaign for Sheridan bed-linen, which was then filling Australia's billboards with 'slumbering Adonis' vistas of naked male flesh 'between the sheets'. *You'll Never Forget the Feeling* was a significant contribution to the eroticising of safe sex practices for the gay communities of Melbourne at the time, an important prerequisite for their adoption by gay men (and one that travelled well, if its prevalence in gay venues in San Francisco at the time is any guide).

David McDiarmid's now celebrated posters (repr. p.154) were commissioned by the AIDS Council of New South Wales in 1992. In responding to the commission, the artist stated: 'I wanted to do something which would still be pro-sex, especially gay sex ... when you are doing a safe sex promotion there isn't room for ambiguity. Your message has to be crystal clear.'[26] McDiarmid's posters are the pure, unfettered creations of a prominent gay artist, a former artist-in-residence with the Sydney Gay & Lesbian Mardi Gras, and also a former DJ for the renowned Mardi Gras Party; in other words, someone who knows exactly what to talk about and *how* to talk about it to his target audience — his peer group of party-going, recreational drug-using, sexually active gay men. They are also among the first posters to represent and acknowledge both HIV-negative and HIV-positive gay men, in a climate of 'prophylactic' advertising which focused primarily on educating negative men. McDiarmid's posters have enjoyed enormous

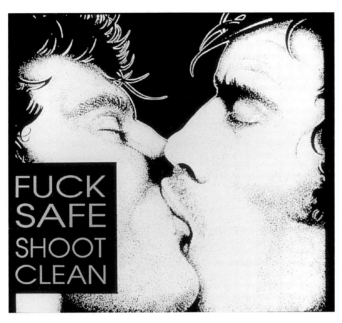

AIDS Action Council ACT (with the assistance of ACT Health), Australia, *FUCK SAFE, SHOOT CLEAN* 1993, offset lithography. National Gallery of Australia, Canberra, Gift of AIDS Action Council ACT 1994.

success in both Sydney's and Melbourne's gay venues, where their 'tripping' colours and magnetic images invite reflection on the serious messages inscribed beneath them; their iconic status was recognised in 1993, where the designs crossed over into the Sydney Gay & Lesbian Mardi Gras Parade in the form of over life-sized 'flats' modelled after McDiarmid's figures.

If earlier poster designs by Australian AIDS councils preferred to offer lists of 'safe' and 'unsafe' practices, after the successful history of this kind of campaigning some Australian safe sex advertising can now venture to be extremely simple. The AIDS Action Council, ACT's *Fuck Safe, Shoot Clean* 1993, is a good example. Designed for distribution to gay venues and the adornment of private gay spaces, the poster employs an arresting coupling of explicit imagery and simple text. It relies on its target audience (educated gay men) knowing the accepted canon of safe versus unsafe sexual acts, and understanding the 'shoot clean' reference to the sterilising of shared syringes before IV drug use. The stark black and white image of two men kissing, drawn from classic gay comic-strip iconography, is at once powerfully erotic

yet also tender (it is, after all, simply a kiss, when it could easily have depicted oral/genital, genital/genital or anal/genital intimacy — the stock-in-trade of the illustrative mode it is copying).

Such imagery is not without its problems, however, particularly when it enters the 'public' arena. In 1990 the Victorian AIDS Council found itself at the centre of a controversy surrounding a seemingly innocuous poster proclaiming *When You Say Yes — Say Yes to Safe Sex* over the image of two young men, fully clothed, kissing.[27] The resulting 'scandal' brought to the fore a conservative society's deep-seated fear of the same-sex kiss.[28]

In a similar vein, an AIDS Council of New South Wales series of safe sex advertisements 'featuring two men in implied sexual poses' was deemed obscene by the Queensland literature review board in 1987 and did not appear in the Queensland issues of the national gay magazine *Outrage*.[29] More recently, the breezy yet confrontational posters produced jointly by the Victorian AIDS Council and the Australian Federation of AIDS Organisations (*Yeah I'm Gay. Got a Problem With That?*), which were aimed at promoting safe sex through the establishment of gay pride and self-esteem, were again refused publication when VAC/AFAO authorities attempted to place them in a national television magazine.[30] Evidence that the problems with these types of posters arise when they attempt to cross over into the 'public' space (be it as a street poster or a mainstreamed advertisement) is provided by the recent defacement of no fewer than three hundred posters placed around the streets of Sydney's gay neighbourhood (Darlinghurst/Surry Hills) by the AIDS Council of New South Wales — these also depicted two men tenderly kissing.[31]

The most successful Australian AIDS awareness poster, in terms of acceptance, memory retention and educative subtlety, must surely be *Condoman*, the lycra-clad comic-book creation urging Australians: 'Don't Be Shame, Be Game — Wear Condoms' (or 'Use Frenchies' in a version of the poster directed at Aboriginal communities; and 'Protect Yourself' in a more discreet poster aimed at school children).

Condoman was created at a Commonwealth-funded workshop for Aboriginal health workers held in Townsville, Queensland in May 1987. This workshop came up with the idea for a superhero, dressed in the red, black

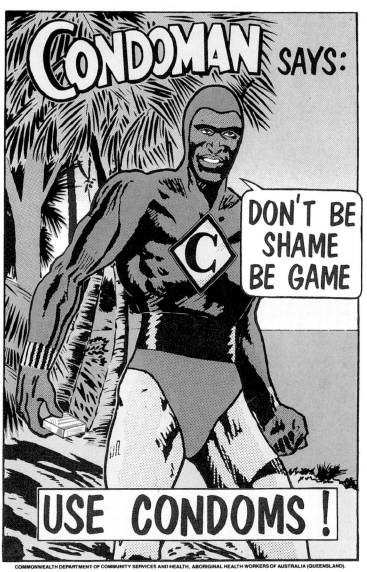

COMMONWEALTH DEPARTMENT OF COMMUNITY SERVICES AND HEALTH, ABORIGINAL HEALTH WORKERS OF AUSTRALIA (QUEENSLAND).

Commonwealth Department of Human Services and Health & **Aboriginal Health Workers of Australia (Queensland)**, *Condoman Says: Don't Be Shame, Be Game: Use Condoms* 1987, silkscreen. National Gallery of Australia, Canberra, Gift of Commonwealth Department of Human Resources and Health 1994.

and yellow colours of the Aboriginal flag, who would appeal particularly to Aboriginal and Torres Strait Islander communities as he spread safe sex information. Since 1987 the popularity of Condoman has spread across Australia, and the condom-clutching hero has become something of a youth cult image, a concept encouraged by the National AIDS Campaign's 'marketing' of his imagery across T-shirts, crack-and-peel stickers, cloth badges for baseball jackets and backpacks, pencils, fridge magnets and frisbees.

Recognising the broad youth appeal of their superhero, the National AIDS Campaign brought the character 'to life' in the form of a brightly clad actor who travelled across Australia promoting the Commonwealth's safe sex message. The 'living' Condoman received his own stand at Sydney's Easter Show in 1991; this was intended to appeal to children, with a range of child-friendly products available for free distribution, filling an attractive Condoman show bag. Such is the subtlety of the Condoman campaign, that this dissemination of vital AIDS education, even to the youngest Australian target audience, has been achieved without any controversy or opposition.

Equally subtle are the series of paintings the National AIDS Campaign commissioned from Aboriginal artist Bronwyn Bancroft. These were intended to be subsequently turned into AIDS-educative posters, which were launched at the first National Aboriginal HIV/AIDS Conference held in Alice Springs in March 1992.

Bancroft's cheerful, life-affirming paintings focus on the positive values of love, caring, respect, dignity and acceptance. The 'brilliant colours' of these posters have been described well as 'emphasis[ing] a more open attitude towards AIDS; breaking down the myth and misunderstanding of AIDS as a scourge or retribution for the "sin" of otherness'.[32] Designed to be able to enter culturally sensitive areas, Bancroft's posters have also 'crossed over' into the mainstream spaces of everyday Australian life. Their frequent appearance in the background sets of Australian TV soap operas, for example, both subliminally reinforces the National AIDS Campaign's consciousness-raising efforts, and affirms the elevation of Bancroft's posters to the status of desirable interior commodities. This can only be a positive phenomenon.

At the time of writing this concluding paragraph, the AIDS Action Council ACT and PLWA (ACT) had just launched an extraordinary new poster in Canberra. Mimicking bar mirrors of the past, it consists simply of an eye-catching gold frame around a large sheet of mirror-reflective metallic paper. Stencilled at the top of the 'mirror' are the words 'A TYPICAL PERSON WITH HIV' — the contents of the frame are the ever-changing reflections of people passing by. This seems to me the perfect poster for our tragic time.

1. Quotations drawn from Jan Zita Grover, 'Public Art on AIDS: On the Road with Art Against AIDS', in Allan Klusacek and Ken Morrison, *A Leap in the Dark: AIDS, Art and Contemporary Cultures*, Montreal: Véhicule Press, 1993, pp.64-66.

2. See 'Editorial', *New Art Examiner*, Vol.18. No.1, September 1990, p.9. The editors here defend Gran Fury's poster as 'one of the more humorously clever, positive and direct AIDS awareness images'; they also remark that the Chicago legislators 'don't seem so concerned about advertising which "subjects" people to virulent racism, sexism or ageism. If they were, we would have little commercial advertising — print or electronic — left'.

3. See Kristen Engberg, '*Art Against AIDS* and *On the Road*: Marketing the (Ad)just(ed) Cause', *New Art Examiner*, May 1991, p.25, where she notes that in Washington DC 'the censoring was more opaque and couched in the pretence of a bureaucratic (scheduling) snafu'. The same Tennessee-based printing company had refused to print one version of Adrian Piper's *Fun* 1990, another AmFAR/*On the Road* exterior bus poster, on account of its dialogue on condom usage among young black Americans, on the grounds that it was 'unChristian'. This poster was also rejected by the Washington DC transit authority, whose board argued that they would only accept the work if the artist removed photographic depictions of (unopened) condoms from it: Piper could not comply with this censorship of her work, and her poster was never seen on Washington DC's transport system.

4. Simon Watney, 'Read My Lips: AIDS, Art & Activism', in *Read My Lips*, Glasgow: Tramway Gallery, 1992, n.p.

5. Kramer's speech was addressed to 250 stunned men and women at New York's Gay and Lesbian Community Centre on 10 March 1987:
 If my speech tonight doesn't scare the shit out of you, we're in real trouble. If what you're hearing doesn't rouse you to anger, fury, rage, and action, gay men will have no future here on earth. How long does it take you to get angry and fight back?

 I sometimes think we have a death wish. I think we must want to die. I have never been able to understand why for six long years we have sat back and let ourselves literally be knocked off man by man — without fighting back. I have heard of denial, but this is more than denial; it *is* a death wish.

 I don't want to die. I can't believe that you *want* to die. But what are we doing, *really*, to save our own lives?

Two-thirds of you — I should say of *us*, because I am in this, too — could be dead within five years. Two-thirds of this room could be dead within five years.

What does it take for us to take responsibility for our own lives? Because we are *not* — we are not taking responsibility for our own lives.

See Larry Kramer, *Reports from the Holocaust. The Making of an AIDS Activist*, London: Penguin, 1990, p.128.

6. Douglas Crimp with Adam Rolston, *AIDS Demographics*, Seattle: Bay Press, 1990, p.14. This volume remains an indispensable guide to the graphics of ACT UP/New York, to its date of publication. Excellent coverage of ACT UP graphics has also been provided by two German exhibitions and their catalogues; see Lutz Hieber, *Bilderschock. Offentliche Kunst gegen AIDS*, Hannover: Bürgerinitiative Raschplatz e.V., 1990; and Lutz Hieber and Gisela Thiesing, *Silence=Death. Kunst und AIDS in New York*, Hannover and Munich: Hannöversche AIDS-Hilfe e.V., 1993.

7. Douglas Crimp and Adam Rolston, *AIDS Demographics*, p.37.

8. Doug Sadownick, 'ACT UP Makes a Spectacle of AIDS', *High Performance*, #49, Vol.13, No.1, Spring 1990, p.31.

9. See Douglas Crimp and Adam Rolston, *AIDS Demographics*, pp.33–34.

10. Ibid., pp.45–46.

11. Quoted in Paul Taylor, 'Art on the Barricades', *Outrage*, No.113, October 1992, p.31. *He Kills Me* is brilliantly described here by the late Paul Taylor, who died of an AIDS-related illness in 1992.

12. See Tom Kalin, 'Prodigal Stories: AIDS and Family', *Aperture*, No.121, 1990, p.25. The Gran Fury installation at the Venice Biennale is reproduced here on p.22.

13. For part of the history of this, see Robert Nickas, 'That Sinking Feeling', *Flash Art*, No.154, October 1990, pp.138–139; and Margaret Garlake, 'Brown Bagging in Venice', *Art Monthly* (UK) No.138, July–August 1990, pp.3–5.

14. Paul Taylor, 'Art on the Barricades', *Outrage*, No.113, October 1992, p.29. The complete text of Gran Fury's installation reads:
 The Catholic Church has long taught men and women to loathe their bodies and to fear their sexual natures. This particular vision of good and evil continues to bring suffering and even death. By holding medicine hostage to Catholic morality and withholding information which allows people to protect themselves and each other from acquiring the Human Immunodeficiency Virus, the Church seeks to punish all who do not share in its peculiar version of human experience and makes clear its preference for living saints and dead sinners. It is immoral to practice bad medicine. It is bad medicine to deny people information that can help end the AIDS crisis. Condoms and clean needles save lives as surely as the earth revolves around the sun. AIDS is caused by a virus and a virus has no morals.

15. See Lance Carlson, 'An Art That Is Also Responsible', *Artweek*, Vol.22, No.18, 9 May 1991, p.3. I am grateful to Lynn Richardson, Archivist, the Public Art Fund Inc., for clarifying the history of these posters.

16. Simon Watney, 'Read My Lips: AIDS, Art & Activism', in *Read My Lips*, Glasgow: Tramway Gallery, 1992, n.p.

17. I am grateful to the members of ACT UP/Golden Gate who provided me at short notice with documentation on their cultural activism. This is in the spirit of the group's charter, which states in part: 'We hold fast to the idea that everybody is at risk for HIV. All people will benefit from reforms in the health care system, and advocates for other life-threatening diseases are recipients of the benefits from the streamlining of the governmental health organisations and

administrative bureaucracy that ACT UP/Golden Gate has caused. We therefore feel while working locally, that our constituency is global.'

18. The most effective of these, *DANGER: AIDS Profiteering* and *WARNING: Astra Pharmaceuticals GREED ZONE* attacked the US $21,500 per year price tag placed by Astra Pharmaceuticals on *foscarnet*, a drug aimed at fighting the opportunistic infection Cytomegalovirus (CMV) which induces blindness in people with HIV/AIDS; this made *foscarnet* the most expensive AIDS drug in history (information drawn from ACT UP/Golden Gate's press releases of June 1992, 'ACT UP Against Astra!' and 'Blind with Rage over the price of Astra's AIDS Drug').

19. See Bill Calder, 'Mark Routley. Acting Up in Sydney', *Outrage*, No.85, June 1990, pp.8–9.

20. See *AIDS Demographics*, pp.46–50. Woodard's 1988 placard was designed to draw attention to the fact that: 'One year ago, this nation [the United States] had spent less on AIDS education and research over the entire course of this epidemic than the Pentagon spent in one day.'

21. George Bush was present in Australia from 31 December 1991 to 3 January 1992. I am grateful to Richard Linden for this information.

22. See Chris Dobney, 'The Serpent's Tongue', *Outrage*, No.92, January 1991, pp.6–7.

23. According to former members of ACT UP/Melbourne, the group's 'attack' on the Floral Clock was motivated by their learning that its flower beds were shortly due to be dug up and seasonally replanted in any case (a point studiously ignored by hostile press coverage). For a quick summary of the 1991 D-Day events around Australia, see Bill Calder, 'Digging in on D-Day', *Outrage*, No.98, July 1991, pp.5–6.

24. The current cessation of activities by both ACT UP/Sydney and ACT UP/Melbourne is the result of a complex mix of achieved goals, recognition of the excellence of the health care system in Australia, death of members and political burn-out within the organisations.

25. Determining all aspects of Australia's response to the HIV/AIDS epidemic is the need for a strong and supportive partnership between many sectors of the community. Australia's National HIV/AIDS Strategy demonstrates the unified approach built on agreed principles. It receives widespread support from the Commonwealth, State and Territory governments, non-government sectors; unions and employers; the scientific and medical communities; and those infected with and affected by the virus.
AIDS: Australia Advances, Canberra: Commonwealth Department of Human Services and Health, 1993, p.4.

26. Quoted in Chris Dobney, 'Kiss of Light. David McDiarmid', *Outrage*, No.108, May 1992, p.33.

27. A good summary of the controversy surrounding this poster is provided by Adam Carr:
Epidemiologists now agree that the level of HIV infection among gay men in Victoria peaked in about 1983, and thereafter fell steadily. This fall corresponds to the launching of AIDS prevention campaigns by VAC [Victorian AIDS Council], and also with repeated publicity about AIDS in the gay press ... But it is also clear that there are still significant problems with unsafe sex among gay men, especially those who do not live in the 'core' gay community, with younger men, with men whose first language is not English and with men in relationships. Tackling these 'pockets of resistance' to safe sex messages has proved steadily harder as the epidemic has dragged on.

The need to deal aggressively with these problems led VAC into a potentially damaging controversy in 1990, when the Education Program's Youth Project Team launched its 'When You Say Yes' campaign aimed at young gay men, featuring the famous 'two boys kissing' poster. The campaign was launched without the knowledge of JAC [the Joint Advisory Committee, established in April 1988 to decide policy for both the Victorian AIDS Council and the Gay Men's Health Centre] or the Health Department, and caused a mainly hostile media and political reaction. The then Minister [for Health, Victoria], Caroline Hogg (who was normally very supportive of VAC), refused to endorse the campaign, and the Liberal shadow minister, Marie Tehan, said that she would impose greater control over VAC's education funding if she became minister (although when

she did become minister nothing more was heard of this). The Youth Team's convenor, Damien Ridge, and Youth Education worker, Mark Goggin, remained unrepentant, and the controversy over the poster meant that even more young gay men became aware of the campaign's message.
Adam Carr, 'A Dangerous Decade. Ten Years of the Victorian AIDS Council', in *Victorian AIDS Council Inc./Gay Men's Health Centre Inc. 1983–1993*, Melbourne: Victorian AIDS Council and Gay Men's Health Centre, 1993, pp.13–14.

ACT UP/Melbourne responded with a clever reworking of the VAC poster, depicting Marie Tehan kissing one of the original boys and proclaiming: 'When You Say No ... Say No to Marie Tehan'. For a reproduction see Martyn Goddard, 'The Epidemic. What's AIDS?', *Outrage*, No.126, November 1993, p.6.

28. In this author's opinion this stems from a wish to keep the 'public' perception of gay sexuality to one of a bestial nature; any depiction of emotional bonding or, worse, love, between two people of the same sex (suggesting that gays or lesbians may have 'real' feelings) produces a violent reaction. Witness the recent spate of homophobic letter-writing which followed the ABC (Australian Broadcasting Corporation)'s televising of an episode of the popular Australian drama *GP*, featuring a male-to-male kiss. See 'One Kiss and You're Out', *Sydney Star Observer*, No.232, 8 April 1994, p.4, where it is also noted that:
> The first same-sex kiss on US mainstream television was between actors Amanda Donohoe and Michelle Greene on *LA Law*. The backlash against gay and lesbian story lines on US TV has since increased with the American Family Association's Director of Governmental Affairs sending a letter to every member of US Congress asking them to withhold funding from public television programs that show 'homosexuals kissing in bed'.

It would be interesting to quantify, for comparison, the number of heterosexual kisses that are broadcast without comment in any average day of television screenings. The author witnessed, at the time of writing, 17 heterosexual kisses and four extended, explicit scenes of heterosexual love-making (including full intercourse [genitals concealed], masturbation, fellatio and cunnilingus) during a single televised evening movie on Australian commercial television, none of which drew a single letter of protest from the 'public'.

One can also offer here recent comments by American talk show host Jay Leno, on the censorship of a gay kiss on the popular television serial *Melrose Place*: 'Everybody in the building has slept with each other at least twice. One of the tenants is a hooker, another pregnant to a guy who is a murderer, two characters tried to commit murder last night, another is having a nightmare about child molestation, and the producers said "We're going to stick to traditional family values on the program".' See 'Morose Place', *Sydney Star Observer*, No.240, 29 July 1994, p.10.

It is also interesting to compare 'public' fear of the male-to-male kiss with society's more complacent attitude towards lesbian affection. Woman-to-woman tenderness is tolerated (or, more truthfully, ignored or 'elided') to a greater extent provided it is expressed purely as affection and does not involve sexual explicitness (and even then it is often tolerated if this sexual openness is evidently directed at the titillation of a male heterosexual 'viewer'). Anger and protest seem to arise when lesbian imagery is self-evidently female-directed and male-excluding — witness the recent removal from a public exhibition in Brisbane of Susi Blackwell's and Angela Bailey's *Dam Dykes* poster, directed at 'women who fuck with women' and depicting woman-to-woman oral sex with dental dams:
> Brisbane City Council has banned the exhibition of a sexually explicit HIV education poster aimed at lesbians, deeming the language 'offensive' and the photograph 'unnecessarily provocative'.
Kirsty Machon, 'Dam Dykes Damned over Poster Affair', *Sydney Star Observer*, No.234, 6 May 1994, p.5. I am most grateful to Lucina Ward for raising the issue of this homophobic double-standard with me.

29. See Chris Dobney, 'The Rough End of the Pineapple', *Outrage*, No.81, February 1990, pp.25–27. Dobney argues that homophobia on the part of Queensland's then-ruling National Party lay behind the prohibition: 'We [i.e. *Outrage*] agreed to run the ads provided that they were approved by the state literature review boards. ACON faxed them off along with a copy of their campaign strategy — it was intended to be aimed particularly at rural gay men, a goodly

number of whom live in outback Queensland. All of the boards admitted that the pictures were beyond what would normally be allowed in an unclassified publication, but all agreed that they were a necessary part of the AIDS education strategy and that they should go ahead. All, that is, except Queensland ... Not only the ads, but any frontal nudity was unacceptable [to Queensland authorities], as was any graphic depiction of two men not only kissing, but even embracing, whether naked or clothed. It became evident that, since opposition to homosexuality appeared to be the only grounds on which the Nationals had any hope of clinging to government, they were going to crack down on us as hard as they could.' (p.27)

30. See, for example, '*TV Week* Bans Ads', *Outrage*, No.121, June 1993, p.2.

31. The poster features the text *HIV Positive or Negative − Choose Safe Sex* superimposed over a photograph of two men kissing. See 'Posters Vandalised', *Sydney Star Observer*, No.229, 25 February 1994, p.4, where it was noted that all 300 posters had been 'spray-painted and the safe sex messages torn off', acts of vandalism that 'showed just how hard it was to do HIV programs for gay men, even in Darlinghurst'.

32. Suellyn Luckett, introduction to +*Positive. Artists Addressing A.I.D.S.*, Campbelltown City Art Gallery, Campbelltown, 4 February – 6 March 1994, n.p.

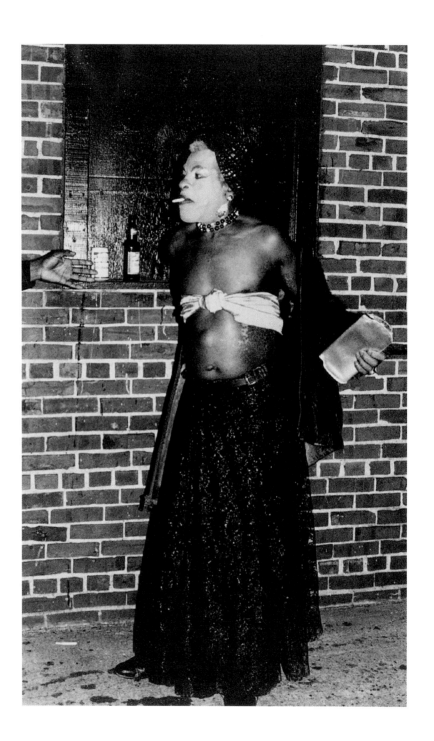

OI:
Opportunistic Identification, Open Identification,[1] in PWA Portraiture

Jan Zita Grover works at the University of Minnesota, Minneapolis. She curated the ground-breaking exhibition 'AIDS: The Artists' Response' at Ohio State University in 1989 and has contributed to several anthologies, most notably *AIDS: Cultural Politics/Cultural Activism* (1987), *Fluid Exchanges: Artists and Critics in the AIDS Crisis* (1991) and *A Leap in the Dark: AIDS, Art and Contemporary Cultures* (1993). Her articles about the cultural politics of AIDS have appeared in journals such as *October*, *High Performance* and *Afterimage*.

A Riddle

September 1986, San Francisco. I photograph a friend in the foyer of the Castro Theatre so he can send his picture to a new boyfriend in New York City. He's wearing a leather jacket, a big grin, and leaning on his tightly wrapped umbrella. A week later he is diagnosed HIV positive. Does this make my picture of him a portrait of someone with HIV/AIDS?

We probably all agree that to say so would be terribly reductive. Certainly his and my subsequent fall from innocence imbues that photograph with an added poignance, but I think that only a ghoul (or someone pathologically anxious to assign my friend to a fixed category) would call this image a portrait of someone with HIV/AIDS.

Why? Are 'portraits of HIV/AIDS' defined by a certain intentionality on the part of subjects/photographers? In other words, would you accept this as a portrait of someone with HIV/AIDS if my friend had already been diagnosed as a PWA at the time the photograph was taken? Would you accept this photograph I've described as a portrait of someone with HIV/AIDS if I'd made it a week after my friend thought of himself as a PWA but not a week before? Would his umbrella-leaning then be read as an adumbration of future debility?

E. Ira McCrudden, United States, *Miss Bailey House* 1990, gelatin silver photograph. Courtesy of the artist.

By now it is a commonplace that cultural identity is the great engine of political and cultural change in late twentieth-century North American life, as indeed it is throughout much of the world. Whether seen in the emergence of the Christian Right in the US, the resurgence of Québeçois identity in Canada, or the development of queer in contradistinction to lesbian and gay identity, North Americans, after a fifty-year period of widespread enthusiasm for melting pot or censensus identity, increasingly make their political and personal choices on the basis of cultural identification.

It's not particularly surprising, then, that the emergence of AIDS, a disease popularly associated with several already-stigmatised groups, has become a focus of identity for those diagnosed with it. From the pre-1982 days when the syndrome was known as GRID (gay-related immune deficiency) until now, AIDS in North America has been viewed primarily as a gay disease — a factoid that has immeasurably complicated public policy and treatment of people suffering from the syndrome. Since 1986, when it became widely known that intravenous drug users and haemophiliacs were seroconverting at an alarming rate, AIDS has been seen also as a disease of poverty, abuse, high-tech medical intervention, and (in the US) inner-city blacks and Latinos. Demographically, it is true that gay men, blacks, Latinos and haemophiliacs are disproportionately represented in the Centres for Disease Control's (CDC) records of PWAs. It has been among people doubly stigmatised by their sexuality, poverty, skin colour, or drug use and HIV/AIDS diagnosis that the meaning of identity around these descriptors has been most persistently questioned.

The following discussion turns on a distinction between members of HIV/AIDS communities (intra-HIV community) and people who are not members of those communities (extra-HIV community). This may seem like an invidious distinction wherever you stand in relation to these proposed categories. Like all such binary oppositions, it's reductive, but I hope I shall also make it instructive — that, like any good hermeneutic, it will justify itself by what it helps to explain. The distinction I am drawing is between people, whether HIV-infected or not, who have joined the struggle against HIV/AIDS — as people living with HIV/AIDS, as buddies, as volunteers for HIV/AIDS organisations, as activists around treatment issues, as hospital or clinic workers, as writers, artists, filmmakers, curators, teachers, healthcare workers, families and lovers of people with HIV/AIDS — and people who

have not yet done or become any of these things.[2] Intra-HIV community people have learned to deal familiarly with the intricacies of health and social service systems, with physical and mental disability, with death and dying, with the effects of prejudice and discrimination, with the everydayness of chronic illness, with the containability of HIV's *transmission* in their own lives as well as the uncontainability of its *presence* in their own lives. Those who order their experience of HIV/AIDS into art have developed a wide range of strategies for exploring the problematics of incorporating HIV/AIDS into representations of their personal and social identities.

People who have not chosen (or been forced into) the HIV community may have learned similar lessons from experience with other diseases or conditions but, judging from the artwork they make about AIDS, their attitudes toward HIV/AIDS reflect those of public policy and journalism; these attitudes have shifted much more slowly than those within HIV/PWA communities. Ten years ago, extra-community understanding of HIV/AIDS consisted, roughly, of a sense that PWAs could be sorted into innocent and guilty victims; that promiscuity and 'unnatural acts' were the root cause of AIDS; that 'guilty' victims (gay men, bisexuals and IV drug users) deserved their fate but that 'innocent' victims (children, haemophiliacs, transfusion recipients, wives) did not. Media representations reflected these biases, with gay PWAs often pictured 'before and after' (handsome, glossy, sexual/worn, emaciated, lesioned), à la the wages of sin. Photojournalists were fond of photographing PWAs at shuttered or blinded windows, reinforcing the popular wisdom that an AIDS diagnosis radically separated sufferers from life.

The situation was very different when portraits of PWAs were made within HIV/AIDS communities. But before discussing the ways in which visual representations of PWAs have changed across the last decade in both intra- and extra-community photography, I want to introduce two rough periodisations that may be helpful in thinking about the conditions under which these images arose. The first is taken from my 1989 article, 'Visible Lesions: Images of the PWA in America'. [3]

Medicine, Epidemiology, **Media, Politics, Culture**
Scientific Research

1981

. Syndrome largely reported in . Reports largely in medical
gay men perceived as gay disease journals
by epidemiologists and clinicians;
given various names — GRID,
CAID, AID, gay plague, WOG[4]

1982

. CDC announces surveillance . Meagre coverage in gay press
definition and name: AIDS . First voluntary AIDS service
. Diagnosis of AIDS commonly organisations are formed:
precedes death by < 9 months Gay Men's Health Crisis (New
 York City) and Kaposi's
 Foundation (San Francisco)

1983

. French researchers isolate LAV . Popular media discover AIDS
. First paediatric cases, . *Journal of the American Medical*
transfusion cases and haemophiliac *Association* publishes report on
cases (involving fraction VIII/IX) 'casual' transmission of AIDS
 . Medical press covers AIDS
 . Gay press increases coverage
 . Voluntary AIDS service
 organisations formed in large US
 cities
 . Advisory Committee of People
 with AIDS formed
 . First gay safer-sex publications

1984

. HTLV-III argued as causative . Medical and gay press
agent for AIDS coverage increases
. Reports of transfusion and
haemophiliac cases increase

1985

. HIV antibody test put on . Rock Hudson dies
market for blood-banking; . Heterosexual panic ensues in
antibody test begins to be popular media
applied by US insurance companies . Gay press begins covering

. First international AIDS
conference held in Atlanta,
Georgia

1986
. Cases involving heterosexuals,
children, IV drug users and
transfusion patients widely
publicised
. Drug trials in coastal cities

1987
. Zidovudine (AZT) licensed for
use
. Presidential Commission on HIV
epidemic appointed
. Project Inform (San Francisco)
urges people to get antibody tests
. Aerosolised pentamidine
prophylaxis for pneumocystic
pneumonia (PCP) begun in
New York City

1988
. Disputes over estimates of HIV
infected
. Presidential Commission returns
report — ignored
. Extent of HIV/AIDS in black
and Latino communities
becomes evident outside those
communities

AIDS extensively
. PWA Coalition formed in New
York City

. Heterosexual panic continues
. LaRouche Initiative proposed
to California voters for
quarantining PWAs

. Helms Amendment forbids
use of federal funds for HIV
prevention materials that
'promote homosexuality'
. Second LaRouche Initiative in
California
. NAMES Project Quilt
unveiled in Washington DC
. Publication of trade and
pocketbook heterosexual
safer-sex guidebooks

. Masters and Johnson furore
. Third LaRouche Initiative in
California
. ACT UP and other activist
groups mount media actions
. Mainstream media highlight
AIDS and the arts but otherwise
back off widespread AIDS
coverage

Anyone involved in the struggle against AIDS will have many amendments
to make to this rough chronology which, after all, covers only the US up to
1989. But I would argue that it is useful as a starting point in discussing the
many strands of the evolving history of *how AIDS has been depicted*. It points
out some of the push-and-pull between dominant and counter discourses
about AIDS over time. (In saying this, I am not suggesting that the many
constructions placed on AIDS can be understood solely in historical terms;
there is far too much of the irrational in our shaping of AIDS to propose
that.)

Paula Treichler's chronology of North American media discourses[5] is another useful and far briefer periodisation:

1981–85
Evolving biomedical understanding of AIDS
July 1985 – December 1986
Rock Hudson's illness and death as a turning point in national consciousness
Fall 1986 – Spring 1987
AIDS perceived as a pandemic disease to which sexually active heterosexuals are vulnerable
Spring 1987 – present
Diversification of discourse about women and AIDS.

Before roughly 1985, intra-community PWA portraits, like extra-community ones, subsumed their subject's personal identity into his or her AIDS diagnosis. The earliest intra-community portraitures I'm aware of took the form of snapshots and videotaped and written interviews with PWAs. Most of these early portraits were elegiac, made after or shortly before the death of their subjects. We need always to remember that, as late as 1986, the average life expectancy of someone diagnosed with PCP was less than ten months. The early portraits, for the most part, were of terminally ill people. I believe the effect of this simple fact was profound: the work tended to be tentative, improvisational, mesmerised by the fact of imminent young dyings. Few of these memorial works rose to the heights of two videotapes made in 1985 — Mark Huestis's videotape about the late Chuck Solomon, a founder of San Francisco's gay Theatre Rhinoceros, a video that not only explored Solomon's thoughts about illness and dying but celebrated his life in theatre; and the late Stuart Marshall's *Bright Eyes*, a complex interrogation of AIDS as the site of many cultural identities. These early intra-community portraits differed from extra-community ones by photojournalists and artists in representing their subjects as individuals, surrounded by friends, pets, the many compass points that secure us to our lives, rather than as walking pathologies. Metaphorically speaking, intra-community portraits were *not* made behind shuttered windows.

Two events in the mid-1980s profoundly affected what had previously seemed, both intra-communally and extra-communally, a rather direct identity between AIDS and gay white men. In 1985, an inexpensive serological

test for antibody to HIV, the virus most researchers believed to cause AIDS, was developed and marketed. This development introduced two complications into the already-established popular image of the depraved gay 'AIDS victim'. First, the HIV antibody test confirmed that haemophiliacs and transfusion recipients, children infected in the womb, and other 'blameless victims' were indeed infected with the gay plague, thereby upsetting the previous identity of AIDS = Gay, AIDS = Guilty.[6] Second, the announcement in 1987 that zidovudine (AZT) had proved efficacious in prolonging life among men enrolled in clinical trials further complicated HIV/PWA identity. Where earlier the majority of people at high risk of HIV infection in North America had chosen not to take the HIV antibody test ('Why bother? It's not as if they have any drugs that can help me if I *am* infected'), by late 1987 many decided to find out their serostatus so that if infected they could begin AZT — by then widely touted as a miracle antiviral — to slow the progression of HIV. In San Francisco, Project Inform, the activist treatment group, began urging gay men to be tested and to seek out the new treatments (prophylaxis for PCP also became available about this time). The shift from PWA identity as a terminal condition to something far more extended and ambiguous had begun.

Thus within a very short period of time, HIV/AIDS went from an untreatable condition commonly diagnosed only shortly before final illness and death to a disease often detectable years before it produced grave symptoms and observable physical changes. This change in the trajectory of illness had immense effects intra-communally on the role of HIV/AIDS in creating personal and political identity. Although there had been intra-community resistance to media depictions of PWAs as 'victims' since the early 1980s — the national Advisory Committee of People With AIDS was formed in 1983 — post-1987 early detection of HIV disease only increased this resistance, for now people were being diagnosed years before they were appreciably affected by illness. Moreover, zidovudine and PCP prophylaxis often extended the independence of people already seriously ill with AIDS, thus swelling demands that those living with the syndrome be seen not as merely terminal ill, not solely as patients.

These shifts in identity accompanied the well-known move toward militancy among members of the HIV/AIDS community, brought about by Burroughs Wellcome's decision to market zidovudine at an initial average cost of over

$10,000 per annum in a country — the US — without national health insurance. An activist movement was sparked, fuelled not only by challenges to drug and treatment availability but also by that organising principle dear to the heart of North Americans, identity politics.[7]

In 1988, members of ACT UP/New York protested about the exhibition of photographer Nicholas Nixon's portraits of PWAs at the Museum of Modern Art. In the celebrated and problematic manifesto they handed out to museum patrons, ACT UP called for:

No More Pictures Without a Context

We believe that the representation of people with AIDS (PWAs) affects not only how viewers will perceive PWAs outside the museum but, ultimately, crucial issues of AIDS funding, legislation, and education.

The artist's choice to produce representational work always affects more than a single artist's career, going beyond issues of curatorship, beyond the walls on which an artist's work is displayed.

Ultimately, representations affect those portrayed.

In portraying PWAs as people to be pitied or feared, as people alone and lonely, we believe that this show perpetuates general misconceptions about AIDS without addressing the realities of those of us living every day with this crisis as PWAs and people who love PWAs.

FACT: Many PWAs now live longer after diagnosis due to experimental drug treatments, better information about nutrition and holistic health care, and due to the efforts of PWAs engaged in a continuing battle to define and save their lives.

FACT: The majority of AIDS cases in New York City are among people of colour, especially women. Typically, women do not live long after diagnosis because of lack of access to affordable health care, a primary care physician, or even basic information about what to do if you have AIDS.

The PWA is a human being whose health has deteriorated not simply due to a virus, but due to government inaction, the inaccessibility of affordable health care, and institutionalised neglect in the form of heterosexism, racism, and sexism.

We demand the visibility of PWAs who are vibrant, angry, loving, sexy, beautiful,
acting up and fighting back.
Stop Looking at Us; Start Listening to Us

ACT UP called for two changes that were already occurring within the HIV/
AIDS community: a more mindful, *representative* representation (e.g. images
of women of colour) and a repudiation of opportunistic identification
(e.g. AIDS = Death, AIDS = Self). But it also called for something just as
selective as Nicholas Nixon's gaunt, dwindling subjects: 'vibrant, angry . . .
sexy, beautiful' PWAs. In other words, it called for positive images — counter-
images to dominant or stereotypic representations.

Positive images have a history almost as old as photographs. They have been
consciously crafted to favourably re-present African–Americans in the
Reconstruction South; German workers in the Weimar era; women home
workers in industrial Britain. Positive images are always haunted by the
images and stereotypes which they are constructed to counter. In the case of
the 'vibrant . . . sexy' portraits called for by ACT UP, the spectre that activists
hoped to vanquish was half a decade's worth of 'negative' media images
recently complemented by what ACT UP perceived as their arty counterparts
in the Nixon exhibition at MOMA and in the Rosalind Solomon portraits on
display at the Grey Gallery (New York City).

It is obviously impossible to fix the meaning of a photograph, so at one level
the outrage that many activists felt about such portraits was open to the
objection that it privileged those activists' interpretations of polysemic images
over others — that what ACT UP found objectionable in the images may
have been projective rather than inherent, peripheral rather than central to
how the photographs functioned for other viewers. The high theoretical and
practical ground of the late 1980s belonged to those espousing *self*-
representation, and in every medium, people with HIV/AIDS, like people
of colour in northern countries, have re-presented their own realities for the
video, film, and still camera. Intra-HIV/AIDS community portraits made
by non-HIV-infected artists have commonly included texts written by the
subjects themselves; this working method is viewed as 'collaboration' or
'empowerment', unlike the 'indignity of speaking for others' seen as implicit
in journalism or portraiture by extra-community artists.[8] ACT UP's argument,

like many made about art in the 1980s and 1990s, focused more upon the photographs' and photographers' social identities and the photographs' possible cultural functions than upon the formal contents of the images. The activists openly challenged the fairness and accuracy of Nixon's representations; more covertly, they challenged the photographer's authority, as an extra-community artist, to represent PWAs at all. Intra-communally since the late 1980s, symbolic representations of all sorts — from visual images to the constitution of boards of directors of AIDS-related community organisations — have increasingly been dominated by the HIV infected, who have the authority of experience to authenticate their leadership. Whether this practical complement to cultural theory will prove any more effective than other schemes for ensuring just representation and efficient operations remains to be seen; all calls to clear the decks for one category of experience or identity seem suspect to me.

So much has changed in less than a decade! In 1986, a bout of PCP amounted to a virtual death warrant, even in San Francisco, the US's epicentre both for treatment and concentration of PWAs. Representing one's own life was an almost unthinkable luxury under the pressure of unremitting illness. Since then, however, people who were antibody-tested in the mid-to-late 1980s and then began prophylactic treatment, whether allopathic or alternative, are living lives in which illness is only one of a number of personal concerns and sources of identity. With adequate health care — always an enormous issue in our country — fewer people living with HIV/AIDS must focus on illness as the sole factor in life until far into the trajectory of HIV disease.

With this earlier detection and slowdown of illness has come an increasing domestication or displacement of HIV/AIDS as the primary source of identity within the HIV/AIDS community. As Californian photographer Albert Winn writes:

> Having AIDS is not central to my full-time self-identity, although having said that, I have to add that I also never forget that I am ill (or at least in some stage of having a fatal illness). In some ways I feel that I am involved in a balancing act, sometimes a tug of war, between a consciousness of wellness and illness . . . I don't want to be obsessed with the illness such that I become nothing more than the illness.

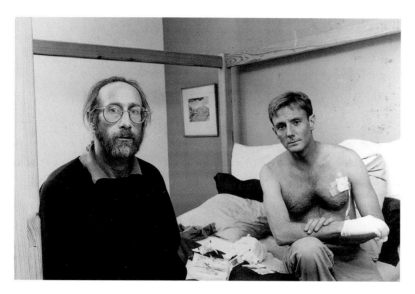

Albert J. Winn, United States, *Tony from My Writing Group* 1994, gelatin silver photograph. Courtesy of the artist.

> . . . I think that my status as a PWA is important to my work. I don't want to be known only as an AIDS artist, anymore than I want to be known as a Jewish or gay artist, but I want all that stuff in my work. It is always there when I think what I do. The same with being a writer, lover, son, Jew, friend, human being.

> . . . I still do dishes, call my mother regularly, say Kaddish for my father, get upset by homelessness, vote, write stories that make no sense, make photographs no one will look at, and walk the dog.[9]

Winn's photographs and accompanying texts are crammed with clues to their maker's personality and interests. The signs of AIDS in these self-portraits are subtle and deeply embedded in an ongoing life. Winn writes:

> The pictures from *My Life until Now* are a progression of thinking about identity. Now I am a gay man, a gay man with AIDS, a Jew, a lover, a person who has books on a shelf, etc., not just another naked gay man with another naked gay man, and I tried to load the photograph[s] with information. I feel I am determining my identity by making the choice to show all this stuff.[10]

223

My Life until Now 1991 consists of formal self-portraits, portraits of Winn's lover and his home, old family photographs, and texts exploring childhood memories of family, sexuality, Jewish and gay identity. AIDS is a part of this mix, but it is present as a tint — a pale wash over the deeper eidetic memories that have formed Albert Winn.

Even in Winn's more recent photographs, such as *Tony from My Writing Group* 1994, nothing in the subjects' self-presentations appeals to the viewer's sense of pity or alienation. Winn's portraits are made out of his own life, his own relationships. The men in his photographs are situated amid things that anchor and reflect their identity. The photographs on the walls, the books on the shelves, the serene pale walls reflect an individual who cannot be reduced to PWA or 'AIDS victim'. ('I know people who have made the illness their life . . . I find it obsessive and quite frankly, boring', writes Winn.)[11]

Albert J. Winn, United States, *Drug-related Skin Rashes* from *My Life until Now*, 1993, gelatin silver photograph. Courtesy of the artist.

Nixon's PWA portraits, in contrast, are close-ups or shallow-focused medium shots that sheer away the markers of personal identity besides AIDS. The final images in his series treat the subject's face as his or her sole possession; hugely magnified, shorn of the relationships, possessions and surroundings that bear so largely on our construction of self, Nixon's subjects become little more than fields on which to read disintegration. Now, arguably this is a state to which most of us eventually come some time before dying; in that sense, Nixon's final, pore-level portraits of his subjects may be distressingly accurate. But they are also distressingly reductive, for they (and his earlier portraits made in a Cambridge, Massachusetts nursing home) strip human lives of their accumulated decades of meaning and dignity, leaving nothing but helplessness and indignity. In effect, they deny the complexity of a subject's *Life until Now* with all its sources of identity besides illness.

If Nixon's project fails to speak movingly to many people in the HIV/AIDS community, it is because, despite the efforts of the photographer and interviewer (Bebe Nixon), it has so little to teach PWAs and their supporters about *living* with HIV/AIDS — it seems less about the journey than the destination, which is death. Extra-community photojournalists and artists, of course, have learned from the demographic shifts and longer life expectancies that have affected the lives of PWAs. One sobering lesson committed reporters have learned, at least in the US, is that AIDS is no longer an editorial must-have; journalists find it difficult to place stories on PWAs, AIDS treatment, and public policy unless their stories have dramatic 'hooks'. Journalistically, AIDS has increasingly assumed the position of yet another dreadful chronic disease. And while this is a positive move in one sense, its implications for vigorous treatment and prevention programs are mostly unfortunate. Journalists for the most part have dropped the innocent versus guilty victim schematic; they recognise and represent PWAs as people experiencing a spectrum of illness. Extra-community portrayers of HIV/AIDS, in other words, have moved close to the positions of intra-community photographers five years ago. What they have not done yet is to question the centrality of HIV/AIDS in the lives of their subjects. But as I shall discuss later, perhaps this should not be expected of them, at least not yet; their quests and audiences lie elsewhere.

Less complex extra-community artists' projects than Nixon's tend to rely on the peculiar (since so often disproved) conceit that 'personalising' the

epidemic (or war, racism, poverty) will inspire sympathy for its victims or prevent similar tragedies. The portrait strategy adopted by these practitioners usually consists of unadorned, uncontextualised studio portraits. Here, even more than in Nixon's work, the subject is reduced to his or her 'condition'; the viewer scans the image, since little or no other information is offered, looking for signs of the subject's identity, which has already become enormously overdetermined for most viewers by the fact of HIV/AIDS. Imagine a portrait titled 'Syphilitic'. Would we be likely to look for anything but signs of incipient madness and decay in such an image? Is it likely that we would look beyond what the portraitist has asked us to see and find anything deeper? If 'Syphilitic' were a tight head shot, would there be anything more for us to read? It is naive at best for artists to believe that portraits framed by a diagnosis will be read as much more than embodiments of that diagnosis.

Few people make art without wishing to learn something from it. The photographers who have chosen to portray themselves or others in this epidemic are questers of this sort. Artists who live on an intimate, day-to-day basis with HIV/AIDS and artists who do not are struck by different aspects of HIV/AIDS, challenged by it in different ways. The self-portraiture of Al Winn, Andi Nellsün (repr. pp.128–129), and Stephen (repr. p.122), for example, consists of sequences or multiple images that deal with imposed, internalised, and/or newly constructed identities; with the precarious act of balancing health and illness, sorrow and happiness, death and life (Andi Nellsün, *Synergy* 1993). San Francisco photographer Mark Chester's portraits of the late Robert Chesley are another case in point. Chester portrayed Chesley bare-chested, his torso covered with KS lesions, in his Superman fetish

Mark I. Chester, United States, *Robert Chesley — ks portraits with harddick & superman spandex #3 and #5* (a series of 6) from *Diary of a Thought Criminal* 1990–91, gelatin silver photographs. Courtesy of the artist.

costume — a fully sexual person with AIDS. These portraits were first publicly exhibited on a San Francisco college campus, where the juxtaposition of Chesley's KS lesions and his visible sexuality were deemed too controversial by the administration and removed from the walls. Chester's portrait series explored Chesley's body as a site marked not only by disease but by desire. These are issues that people living inside the contradictions of HIV/AIDS may be driven to explore and resolve in what is often a flow of images, as if no single photograph could contain the complexity of the journey or destination.

California artist Michael Tidmus addressed similar issues in his 1993 self-portrait, *Prophylaxis: Blind Admonition*, but here the complexity that other PWA artists have distributed over a number of photographs is concentrated

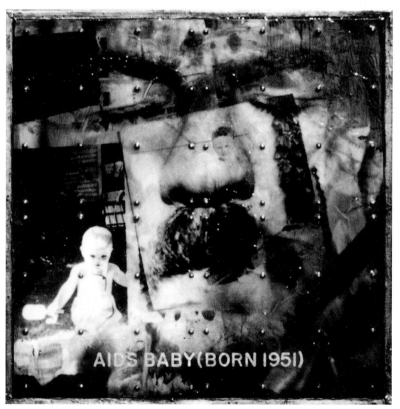

Michael Tidmus, United States, *Phrophylaxis: Blind Admonition*, from *From a Life: Selections Gay and Grave* 1993, iris print. Courtesy of the artist.

in the multiple layers of a single image. Using desktop publishing techniques, Tidmus overlaid childhood snapshots with a current self-portrait, creating a deep map of personal identity. Floating amid these strata of personal visual history is a brief text, the punctum of the piece: 'AIDS BABY (BORN 1951)'. Here, as in so much intra-community artwork, the point of departure in the portrait is dominant — the media's mid-1980s sensationalised and polarising construction of those suffering from HIV/AIDS. In your country as well as mine, I expect, HIV-infected children enjoy an almost sacrosanct public veneration that is rarely extended to adults suffering from HIV/AIDS. Tidmus's image challenges the peculiarly uneven apportionment of compassion for 'innocent' youngsters at the expense of sympathy for the adults most children soon become.

Again, these are issues with day-to-day resonance for people living with HIV/AIDS. Artists not facing those particular challenges have other things to learn about the syndrome and other audiences to address. Where PWA photographers strive to articulate their subjects' full social and personal identity, to challenge HIV as the primary engine of identity, to chart the mercurial ups and downs of chronic illness, to conduct a full life, and as artists to create images that explore these complex issues, sympathetic extra-community artists approach portraying people with HIV/AIDS differently. Extra-community artists are drawn to portraying people with HIV/AIDS for reasons different from those of people living within the epidemic. The disorder their work seeks to vanquish is as much about their own fears as about their PWA subjects; as such, it mines territory closer to that of media than of intra-community discussions.

Lynn Sloan writes of her *Faces of AIDS* 1993:

> In their directness these portraits invite us, as viewers, to look carefully at those pictured and to think about *their* lives [my emphasis].

But who is being positioned here as the 'us' and the 'them'? And what can 'we' learn about these subjects' lives by contemplating these single images of 'them'? Ms Sloan concedes that her work:

doesn't try to explain the lives of persons living with the illness, it doesn't place them in a social or political framework, it doesn't cover the range of their experiences.

What it does do, she concludes, is 'depict with deliberate care the integrity of each individual'.

This form of direct, unadorned photographic portraiture documents the transaction between the questing artist and his informants, between the seeker and those with the oracular knowledge he seeks. The quester arms himself with his art, hoping to use it to acquire knowledge and to live down dread. What he brings back for 'us', his intended audience, proves to be a map to the territory occupied by Michael Tidmus, Andi Nellsün and Albert Winn. What he brings back to his own community is a report from a country that few know personally but that many are fascinated, saddened or moved by. This does not necessarily make his map useful to the people native to the country: they have their own routes and landmarks, their own knowledge of the land. Nor, in turn, are the things that most concern them necessarily of interest to the questing artist; he is, after all, passing through; he has not been consigned to living there.

I ask you to think about these very different but perhaps complementary ways of knowledge as you look at the photographs in this book. No single approach to representing the HIV/AIDS epidemic will illuminate everyone; what this book and the exhibition it derives from offer is a generous cross-section taken from a variety of photographic and community discourses on the epidemic. Each community — indeed, each of us — works his or her way toward an accommodation to HIV/AIDS that will be more or less intimate, more or less mortal. Taken cumulatively, these photographs constitute a palimpsest of our accumulating knowledge about the suffering, striving human creature — 'mortal, guilty, but to me the entirely beautiful'.[12]

1. The use of OI as 'opportunistic identification' comes to us courtesy of artist Michael Tidmus, who writes: 'After [my] ARC diagnosis in 1986, AIDS became an increasingly greater aspect of my identity. In the next seven years AIDS consumed more and more of "me". There was less "whole" me left to apply to the rest of my life and family and work. I woke up one morning and realised I had become just another aspect of AIDS — an OI, opportunistic identification. '

2. I stress here that not everyone affected by HIV/AIDS chooses to work within the communities built in response to it or to incorporate HIV/AIDS into his or her identity; this essay discusses only artists who do.

3. J.Z. Grover, *Afterimage*, Vol.17, No.1 (Summer 1989), reprinted in James Miller (ed.), *Fluid Exchanges: Artists and Critics in the AIDS Crisis*, Toronto: University of Toronto Press, 1992, pp.23–51.

4. GRID=gay-related immune deficiency; CAID=community-acquired immune deficiency; AID=acquired immune deficiency; WOG (a gay black-humour term)=wrath of God.

5. Paula Treichler, 'AIDS, Gender and Biomedical Discourse', in Elizabeth Fee and Daniel M. Fox (eds), *AIDS: The Burdens of History*, Berkeley: University of California Press, 1988, pp.190–266.

6. With the travails of Ryan White, a US child who in effect became that country's AIDS poster child, *Newsweek* introduced into media and popular discourse the term 'innocent victim' and its unspoken, but implicit, opposite.

7. I'm mindful that this is a breezy, over-generalised account of HIV/AIDS in the period 1986–1988. Particularised histories can be found in the work of Dennis Altman, Douglas Crimp, Cindy Patton, Randy Shilts, Simon Watney, and others. My objective here is to provide the portraits in the exhibition and this book in a context that accurately reflects the ideas and events surrounding their making.

8. The phrase comes from Michel Foucault and is often invoked in North American discussions about the politics of representation.

9. Letter to author, 1 May 1994.

10. Letter to author, 10 June 1994.

11. Letter to author, 1 May 1994.

12. W. H. Auden, 'Lay your sleeping head, my love', Edward Mendelson (ed.), *Selected Poems*, New York: Vintage, 1979, p. 50.

DON'T LEAVE ME THIS WAY: ART IN THE AGE OF AIDS
National Gallery of Australia, Canberra
12 November 1994 – 5 March 1995

PAINTING, SCULPTURE, PHOTOGRAPHY,
INSTALLATION

Larry Jens Anderson
United States (Atlanta)

Christian Revenge Theory 1989
leather, steel, wood
243.8 x 335.5 x 12.7 cm
Collection of the artist

Australian AIDS Memorial Quilt Project

Australian AIDS Memorial Quilt 1988–94
sewn fabric panels
6 blocks
(each containing 8 panels 3 x 6 feet)
Courtesy the Australian AIDS Memorial
Quilt Project

Bronwyn Bancroft
Bundjulung
Australia (Grafton, NSW)

Prevention of AIDS 1992
Caring for People with AIDS 1992
gouaches on archive paper
each 91.0 x 71.0 cm
Collection National AIDS Campaign,
Commonwealth Department of Human
Services and Health

Michele Barker
Australia (Sydney)

Lets Fuck 1992
2 Type C photographic prints
face-mounted behind perspex
each panel 73.5 x 110.0 cm
Collection Michele Barker

James Barrett & Robin Forster
Great Britain (London)

X-Ray Series nos #1, #2, #3 1992
x-rays
each 27.9 x 43.2 cm
Collection James Barrett & Robin Forster

An/Aesthetic 1993
low-band u-matic Pal video
duration: 5 mins
Collection James Barrett & Robin Forster

Nayland Blake
United States (San Francisco)

Work Station #2 (Restraint) 1988
steel and leather
76.2 x 97.8 x 121.9 cm
Private collection, New York

Every 12 Minutes 1991
clock movement, aluminium
(from an edition of 10)
27.9 cm diameter
Courtesy Matthew Marks Gallery,
New York

Bouquet #6 1991
aluminium, wood, artificial fruit
and leaves, fabric ribbon
45.7 x 48.2 x 10.1 cm
Courtesy Matthew Marks Gallery,
New York

Bouquet #4 1992
wood, artificial leaves and flowers,
leather
104.0 x 26.7 x 17.1 cm
Private collection, New York

Marcus Bunyan (born Great Britain)
Australia (Melbourne)

How Will It Be When You have Changed
1994
gelatin silver photograph
33.6 x 26.7 cm
Collection of the artist

Tell Me Your Face Before You Were Born
1994
gelatin silver photograph
28.8 x 23.4 cm
Collection of the artist

Bill Bytsura
United States (New York)

from the series *United in Anger*:
Maxine Wolfe 1992
Tigger 1992
Floyd & Dene 1992
Mona Bennett 1992
gelatin silver photographs
each 40.6 x 50.8 cm
Collection of the artist

Tony Carden
Australia (Sydney)

Warrior Blood [work in progress] 1993–
blood swatches on canvas
91.4 x 91.4 cm
Collection Tony Carden
Assembled by Tony Carden for
documentation of HIV/AIDS 'warriors'
in Australia (sero status not revealed).
This work represents a complete cross-
section of society, from Catholic nuns to
school teachers, AIDS patients,
professors and entertainers.

Mark I. Chester
United States (San Francisco)

*Robert Chesley – ks portraits with
harddick & superman spandex #1*
(from a series of 6) 1990–91
gelatin silver photograph
27.9 x 35.5 cm
From the artist's collection

*Robert Chesley / man x'd out #1, #2, #4, #5,
#6, #7*(from a series of 7)
from *Stretching Reality* 1990
gelatin silver photographs
each 27.9 x 35.5 cm
From the artist's collection

John Cole
United States, works in London

*Candlelight Vigil for AIDS, Trafalgar
Square, London* 1986
gelatin silver photograph
61.0 x 50.8 cm
Courtesy John Cole/Impact Photos,
London, England

Juan Davila
Chile/Australia (Melbourne)

LOVE 1988
oil on canvas
200.0 x 200.0 cm
Courtesy Tolarno Galleries,
Melbourne

Jamie Dunbar
Australia (Sydney)

*Taking Centre Stage. Protester holding white
carnation – from ACT UP's mound of white
carnations representing Australians who had
died of AIDS, fifth national conference on
HIV/AIDS, Sydney, November 1992.* 1992
gelatin silver photograph
61.0 x 50.8 cm
Collection of the artist

Jamie Dunbar
Australia (Sydney)
(from a joint design by Andrew Morgan
& Jamie Dunbar)

Posithiv Sex Happens 1993
Posithiv Partner 1993
gelatin silver photographs
each 51.0 x 51.0 cm
Collection of the artist

David Edwards
[aka Sister Mary Dazie Chain]
Australia (Sydney)

Untitled (AIDS Pietà) 1992
gelatin silver photograph
46.6 x 30.4 cm
Collection of the artist

eX de Medici
Australia (Canberra)

Godscience V 1994
Godscience VI 1994
cibachrome photographs
each 60.0 x 50.0 cm
Courtesy the artist and australian Girls
Own Gallery, Canberra

Andrew Foster
Australia (Melbourne)

Untitled 1992
gouache and ink on paper with
sandblasted mirror
9 panels, each 31.5 x 31.5 x 2.0 cm
Collection of the artist

Keith Haring
United States (New York)

Silence = Death 1989
silkscreen on paper
91.4 cm x 91.4 cm
Collection Keith Haring Foundation,
New York
Courtesy André Emmerich Gallery,
New York

*Keith Haring died of AIDS-related complications
in 1990*

Brenton Heath-Kerr
Australia (Sydney)

Homosapien 1994
laminated photomechanical
reproductions and cloth
life-size
Collection Brenton Heath-Kerr

Brenton Heath-Kerr & Peter Elfes
Australia (Sydney)

 Ken — The Safe Sex Character 1992
 laminated cibachrome photographs
 and cloth
 life-size
 Courtesy of People Living With HIV/
 AIDS Program, Victorian AIDS Council/
 Gay Men's Health Centre, Melbourne

Bill Jacobson
United States (New York)

 Interim Portrait #507 1992
 Interim Portrait #522 1992
 Ektacolour prints
 each 50.8 x 61.0 cm
 Courtesy Julie Saul Gallery, New York

Derek Jarman
Great Britain (Dungeness)

 Blood 1992
 oil on photocopy on canvas
 251.5 x 179.0 cm
 Courtesy Richard Salmon Ltd, London

*Derek Jarman died of AIDS-related complications
in 1994*

Mathew Jones
Australia (Sydney)

 from *Silence = Death* 1991
 gesso on cotton duck on stretcher,
 reversed
 210.0 x 165.0 cm
 Courtesy of Tolarno Galleries,
 Melbourne

 Resistance 1992
 latex and plastic, 12 'condoms'
 each 30.0 x 30.0 x 2.0 cm
 Courtesy of Tolarno Galleries,
 Melbourne

Ronald Jones
United States (New York)

 *Untitled (New Human Immunodeficiency
 Virus Bursting from a Microvillus)* 1988
 bronze, wood, limestone
 184.2 x 45.7 x 30.5 cm
 Private collection, New York

Cary Leibowitz/Candyass
United States (New York)

 he was his mothers favorite 1987/1994
 latex on wood
 123.0 x 153.0 cm
 Collection of the artist

 HIV+ 1989–90
 blood on canvas
 22.9 x 30.5 cm
 Collection of the artist

Kate Lohse
Australia (Queanbeyan)

 20 Million Whispers 1992
 neon light, wooden bowl, green tea,
 inscribed ivory pendant on red ribbon
 dimensions various
 Courtesy the artist and australian Girls
 Own Gallery, Canberra

Peter Lyssiotis
Australia (Melbourne)

 The Harmed Circle 1992
 Masterthief Enterprises, Melbourne, 1992
 limited edition artist's book, edition 3/10
 Agfacolour CN312, Type 8 photographs,
 hand-tipped
 National Gallery of Australia, Canberra

 from *The Harmed Circle:*
 *Billy Says That a Person's Broken Heart
 Can Sometimes Smell of Roses* 1992
 Michael 1992
 Cupid on the Stairs 1992
 Type C photographs
 each 56.0 x 41.0 cm
 National Gallery of Australia, Canberra

E. Ira McCrudden
United States (New York)

 Miss Bailey House 1990
 gelatin silver photograph
 53.6 x 43.4 cm (framed)
 Collection of the artist

David McDiarmid
Australia (Sydney)

 Ups and Downs 1992
 Always 1992
 Jackback 1992
 Safe Love, Safe Lust 1992
 Yes 1992
 watercolours on paper
 each 28.5 x 21.5 cm
 Collection AIDS Council of
 New South Wales

David McDiarmid
Australia (Sydney)

It's My Party and I'll Die If I Want To,
Sugar 1994
Don't Worry, Die Young, Be Happy, Make a
Will 1994
Lifetimes Are Not What They Used To Be
1994
That's **Miss** *Poofter To You Asshole* 1994
Darling, You Make Me Sick 1994
Girlfriend, Our Life Is One of Lights and
Shadows 1994
Don't Ask, Don't Tell, Die Alone 1994
Don't Forget To Remember 1994
The Family Tree Stops Here Darling 1994
Honey, Have You Got It? 1994
computer-generated Canon laser prints
laminated onto craftwood
each 36.6 x 27.5 cm
Courtesy Tolarno Galleries, Melbourne

Funeral Hits of the 90s 1994
computer-generated Canon laser prints,
encased in 2 plastic cassette boxes
each 10.6 x 6.8 x 1.6 cm
Courtesy Tolarno Galleries, Melbourne

Arthur McIntyre
Australia (Sydney)

Monument To Intimacy — The Last
Embrace (dedicated to the memory of Garry
Anderson) 1987/1994
installation: charcoal and oil-stick on
paper, coffin
183.0 x 75.4 cm
Collection of the artist

Cynthia Madansky
United States (New Jersey)

Myths 1991
black line print
76.2 x 101.6 cm
Collection of the artist

Robert Mapplethorpe
United States (New York)

Ermes 1986
gelatin silver photograph
48.8 x 48.9 cm
National Gallery of Australia, Canberra

Skull 1988
gelatin silver photograph
58.7 x 48.7 cm
National Gallery of Australia, Canberra

Robert Mapplethorpe died of AIDS-related
complications in 1989

Duane Michals
United States (New York)

The Dream of Flowers 1986
4 gelatin silver photographs
each 12.7 x 17.8 cm
Collection of the artist

The Father Prepares His Dead Son's Body
1991
gelatin silver photograph
40.6 x 50.8 cm
Collection of the artist

Lex Middleton
Australia (Melbourne)

Gay Beauty Myth 1992
gelatin silver photographs
6 panels, each 40.6 x 30.5 cm;
plus 7 panels, each 20.3 x 25.4 cm
Collection of the artist

Ross Moore
Australia (Melbourne)

Of the Visible and Hidden 1992–93
acrylic on linen (triptych)
each panel 184.0 x 184.0 cm
Collection of the artist

Marrnyula Mununggurr
Australia (Yirrkala, Northern Territory)

Untitled (The AIDS Story) 1993
bark painting
180.0 x 80.0 cm
Collection Department of Health and
Community Services, Nhulunbuy,
Northern Territory

Marcus O'Donnell
Australia (Melbourne)

Untitled I [This is My Body series] 1992
photoshop-generated image on
Macintosh, enlarged into tiled print on
Canon colour laser copier
16 sheets, each 30.0 x 40.0 cm
Collection of the artist

Christopher Pekoc
United States (Cleveland)

Broken Ring 1993
paper, shellac, colour and black & white
photocopies, machine stitching
27.6 x 19.4 cm
Courtesy Julie Saul Gallery, New York

Red Arc with Two Hands and Two Circles
1993
paper, shellac, colour and black & white
photocopies, machine stitching
26.0 x 25.1 cm
Courtesy Julie Saul Gallery, New York

Pierre et Gilles
France (Paris)

St Louis de Gonzague 1993
painted cibachrome
135.6 x 107.2 cm
Courtesy Galerie Samia Saouma, Paris

Rea
Gamilaroi, NSW
Australia (Sydney)

Lemons I–IV 1994
4 computer-generated Type C
photographs, each 30.0 x 60.0 cm
Panel I, Collection David Abello, Sydney
Panels II–IV, Collection of the artist

RIDGEWAY BENNETT
South Africa/Great Britain (London)

Reactive Armour 1990
semen, wax, vinyl, resin on metal studs
152.4 x 152.4 x 10.2 cm
Courtesy Wessel O'Connor Gallery,
New York

Infected 1990
blood, liquid plastic vinyl on stretcher
152.4 x 91.4 cm
Courtesy Wessel O'Connor Gallery,
New York

*Jeremy Ridgeway died of AIDS-related
complications on 30 September 1994*

Angel Suarez-Rosado (born Puerto Rico)
United States (Saylorsburg, PA)

The Blue Bed 1991
bed, bedding, mosquito net, sequins,
ribbons, AZT bottles
91.4 x 182.9 x 52.1 cm
Private collection, courtesy INTAR
Gallery, New York

Michael Rosen
United States (San Francisco)

Joyce and Tatiana 1992
gelatin silver photograph
30.4 x 20.3 cm
Courtesy Michael Rosen

John and Frank 1992
gelatin silver photograph
45.7 x 30.4 cm
Courtesy Michael Rosen

Marsha and Friend 1990
gelatin silver photograph
45.7 x 30.4 cm
Courtesy Michael Rosen

Zane Saunders
Australia (Townsville)

Untitled 1993
acrylic on canvas
Collection National AIDS Campaign,
Commonwealth Department of Human
Services and Health

John Schlesinger
United States (New York)

Untitled 1992–94
selenium-toned gelatin photographs,
mounted on steel saw-blades
dimensions various
Courtesy Julie Saul Gallery, New York

Untitled 1994
fingerprints emulsified onto transparent
film, backlit
dimensions various
Courtesy Julie Saul Gallery, New York

Franka Sena (born Italy)
Australia (Melbourne)

You Said You Love Me 1992
cibachrome photographs and rose petals
dimensions various
Collection of the artist

Sear 1993
wood, paint
150.0 x 150.0 cm
Collection of the artist

Andres Serrano
United States (New York)

Untitled XIII (Ejaculate in Trajectory) 1989
cibachrome, edition 1/10
69.7 x 101.5 cm
Courtesy Paula Cooper Gallery,
New York

The Morgue (AIDS Related Death) 1992
cibachrome, edition 2/3
125.5 x 152.3 cm
Courtesy Paula Cooper Gallery,
New York

Andres Serrano
United States (New York)

> Bloodstream 1987
> cibachrome, edition 1/10
> 69.7 x 101.5 cm
> Courtesy Paula Cooper Gallery,
> New York

Cindy Sherman
United States (New York)

> Untitled #179 1987
> colour photograph, edition 2/6
> 186.1 x 125.0 cm
> Private collection, New York

Kaye Shumack
Australia (Sydney)

> Tendances [Tendancies] 1994
> 4 R3 colour photographs
> each 50.0 x 62.0 cm
> Courtesy of the artist

Lynn Sloan
United States (Chicago)

> from the series Faces of AIDS:

> Jerry S. 1989
> chromogenic print
> 50.8 x 40.6 cm
> Lent by the artist

> Laverne and Her Daughter 1989
> chromogenic print
> 40.6 x 50.8 cm
> Lent by the artist

> Novella 1989
> chromogenic print
> 40.6 x 50.8 cm
> Lent by the artist

> Laurie and Her Children 1989
> chromogenic print
> 40.6 x 40.6 cm
> Lent by the artist

Ross T. Smith (born New Zealand)
Australia (Melbourne)

> L'Amour et la mort (sont la même chose)
> [Love and Death (are the same thing)]
> 1990–92
> silver gelatin photographs, plywood,
> tacks
> 120.0 x 240.0 cm
> Courtesy of the artist

Rosalind Solomon
United States (New York)

> Untitled, nos I, XI, XV from Portraits in the
> Time of AIDS (a series of 60 works) 1988
> gelatin silver prints
> each 87.0 x 87.0 cm (image)
> Courtesy of the artist

Marilyn Tabatznik
South Africa/Great Britain (London)

> Monument for Them 1992
> raku-fired clay
> 38.0 x 45.0 x 40.0 cm
> Collection of the artist

Carl Tandatnick
United States (Sarasota, Florida)

> AIDS Virus on White Blood Cell / Grey
> (Virus) Border 1993
> silkscreen ink and paint on canvas
> 140.0 x 122.5 cm
> Private collection
> Electron micrograph courtesy CDC
> (Centres for Disease Control, Atlanta)

Masami Teraoka (born Japan)
United States (Hawaii)

> AIDS Series: Geisha in Bath 1988
> watercolour on canvas
> 274.3 x 205.7 cm
> Courtesy Pamela Auchincloss Gallery,
> New York

Kathy Triffitt
(co-ordinator, Self-Documentation, Self-
Imaging, People Living with HIV/AIDS 1988–)
Australia (Sydney)

> from Self-Documentation, Self-Imaging:

> Chris 1990
> cibachrome photograph and 2 text
> panels

> Michelle 1993
> gelatin silver photograph and 1 text
> panel

> Troy and Vince Lovegrove
> 2 gelatin silver photographs and 1 text
> panel

> Deborah, Sue 1989
> text panel with 2 texts
> dimensions various

> Courtesy Self-Documentation, Self-Imaging
> Project

Ross Watson
Australia (Melbourne)

> Untitled #1 1993
> oil on hardboard, layered tissue paper,
> offset lithograph
> 167.0 x 156.0 cm
> Courtesy Melbourne Contemporary
> Art Gallery

H.J. Wedge
Wiradjuri, born Cowra, New South Wales
Australia (Sydney)
*H.J. Wedge is an artist member of Boomalli
Aboriginal Artists Co-operative*

> AIDS 1994
> acrylic on watercolour paper
> 39.0 x 54.0 cm
> National Gallery of Australia

> *Blood Transfusion* 1994
> acrylic on watercolour paper
> 39.0 x 54.0 cm
> Private collection, courtesy Dr M. Asher

Anna Wojak
Australia (Sydney)

> *Acacius (Stigmata)* 1991
> oil paint and gold leaf on cedar
> 121.0 x 103.0 cm
> Courtesy Michael Nagy Fine Art, Sydney

David Wojnarowicz
United States (New York)

> *Untitled (Buffalo)* 1988
> black & white photograph
> 54.6 x 88.9 cm
> Courtesy P.P.O.W. Gallery, New York

> *Untitled (Violence)* 1988
> black & white photograph
> 69.8 x 80.0 cm
> Courtesy P.P.O.W. Gallery, New York

> *Untitled (for ACT UP)* 1990
> silkscreen, 2 panels
> 57.1 x 69.8 cm
> National Gallery of Australia, Canberra

> *When I Put My Hands on Your Body* 1990
> photograph and silkscreen
> 70.0 x 80.0 cm
> Courtesy P.P.O.W. Gallery, New York

*David Wojnarowicz died of AIDS-related
complications in 1992*

Thomas Woodruff
United States (New York)

> *Esor Teloiv Ysiad* 1992
> *Ruoy Eman* 1992
> *Rettum* 1992
> acrylics on canvas
> each 78.7 x 53.3 cm
> Courtesy P.P.O.W. Gallery, New York

William Yang
Australia (Sydney)

> *Vigil* 1994
> gelatin silver photographs (triptych)
> 36.0 x 165.0 cm
> Collection of the artist

> *Names* 1994
> gelatin silver photographs (diptych)
> 35.0 x 92.0 cm
> Collection of the artist

> *Letter to a Friend* 1994
> gelatin silver photograph
> 35.0 x 40.0 cm
> Collection of the artist

INTERNATIONAL POSTERS

ACT UP/Connecticut
United States

> *Our Anger Comes from Our Pain*
> photomechanical reproduction on paper
> 78.6 x 43.2 cm
> National Gallery of Australia, Canberra
> International Print Archive
> Gift of ACT UP/New York 1993

ACT UP/New York
United States

> *No title [Screaming Head]*
> T-shirt
> transfer on cotton
> size: US XL
> Private collection, Canberra

> *AIDSGATE* 1987
> colour screenprint on paper
> 85.5 X 56.0 cm
> Private collection, Germany

ACT UP/NEW YORK
United States

> *Bush AIDS Flag*
> offset lithography on paper
> 61.0 x 91.4 cm
> National Gallery of Australia, Canberra
> International Print Archive
> Gift of Richard Deagle 1993

> *You Can't Wear a Red Ribbon If You're Dead*
> 1993
> photocopy on paper
> 43.2 x 28.0 cm
> National Gallery of Australia, Canberra
> International Print Archive
> Gift of Richard Deagle 1993

ACT UP & WHAM (Women's Health Action
Movement), New York
United States
Vincent Gagliostro, designer

> *Stop This Man* 1989
> offset lithography on paper
> 43.0 x 28.0 cm
> Private collection, Germany

> *Stop the Church. Stop Gay Bashing* 1989
> offset lithography on paper
> 43.2 x 28.0 cm
> Private collection, Germany

ACT UP/Golden Gate, San Francisco
United States
G'dali Braverman, designer

> *Clark Wants Dick, Dick Wants Condoms*
> T-shirt
> transfer on cotton
> size: US XL
> Private collection, Canberra

Atelier the Hun (Richard Deagle)
United States (New York)

> *Queer Nation* 1990
> T-shirt
> screenprint on cotton
> size: US XL
> Private collection, Canberra

Margaret Crane & Jon Winet
United States

> *Untitled [Total Federal AIDS Budget]* 1989
> exterior bus panel poster in 2 parts
> photomechanical reproduction on plastic
> laminate
> left panel 76.0 x 90.4 cm
> right panel 76.2 x 127.0 cm
> Collection AmFAR (American
> Foundation for AIDS Research),
> New York

Richard Deagle
United States (New York)

> *One AIDS Death Every 30 Minutes!* 1989
> subway advertising poster
> colour screenprint
> 27.5 x 56.2 cm
> National Gallery of Australia, Canberra
> International Print Archive
> Gift of Richard Deagle 1993

> *AIDS / It's Big Business!*
> *(But Who's Making a Killing?)* 1989
> subway advertising poster
> colour screenprint
> 27.8 x 56.4 cm
> National Gallery of Australia, Canberra
> International Print Archive
> Gift of Richard Deagle 1993

> *Deadlier than the Virus. Stephen C. Joseph,*
> *Commissioner of Health, NYC* 1989
> subway advertising poster
> colour screenprint
> 27.4 x 59.8 cm
> National Gallery of Australia, Canberra
> International Print Archive
> Gift of Richard Deagle 1993

Dan Friedman
United States

> *Art Against AIDS* 1989
> part of billboard panel, screenprint
> on paper
> 104.2 x 137.6 cm
> Collection AmFAR (American
> Foundation for AIDS Research),
> New York

Vincent Gagliostro
United States (New York)

> *Public Health Menace (Cardinal O'Connor)*
> 1989
> demonstration placard poster
> photocopy on paper
> 43.2 x 28.0 cm
> National Gallery of Australia, Canberra
> International Print Archive
> Gift of Richard Deagle 1993

Vincent Gagliostro, design
Avram Finkelstein, text
United States (New York)

> *Enjoy AZT* 1990
> offset lithography on paper
> 34.5 x 28.5 cm
> Private collection, Germany

Vincent Gagliostro, text and design
Michael O'Brien, photography
(for ACT UP/New York)
United States

If You Fuck Without a Condom You Risk HIV Infection and Can Get AIDS 1990
offset lithography on paper
57.8 x 43.2 cm
National Gallery of Australia, Canberra
International Print Archive
Gift of ACT UP/New York 1993

GANG
Artists choose not to be identified
United States (New York)

AIDS Crisis 1991
offset lithography on paper
34.0 x 52.0 cm
Private collection, Germany

Gran Fury (first collaboration 1988)
Artists choose not to be identified
United States (New York)

Wall Street Memory, 1988
3 versions:
a) *White Heterosexual Men Can't Get AIDS ... DON'T BANK ON IT.*
b) *WHY ARE WE HERE? Because your malignant neglect KILLS.*
c) *FUCK YOUR PROFITEERING. People are dying while you play business.*
photocopied flyers, each 8.5 x 20.5 cm
National Gallery of Australia, Canberra
International Print Archive
Gift of Gran Fury 1993

All People with AIDS Are Innocent 1988
demonstration placard poster
offset lithography on paper
41.2 x 26.7 cm
National Gallery of Australia, Canberra
International Print Archive
Gift of Gran Fury 1993

Kissing Doesn't Kill: Greed and Indifference Do 1989
exterior bus panel poster in 2 parts
photomechanical reproduction on plastic laminate
left panel 76.1 x 113.4 cm
right panel 76.1 x 193.4 cm
Collection AmFAR (American Foundation for AIDS Research),
New York

Riot 1989
crack-and-peel sticker
silk-screen
13.2 x 29.3 cm
National Gallery of Australia, Canberra
International Print Archive
Gift of Gran Fury 1993

Women Don't Get AIDS – They Just Die From It 1991
posters for 100 bus shelters citywide
(50 in Spanish, 50 in English)
January – March 1991
A Project of the Public Art Fund,
New York
photomechanical reproduction on plastic laminate
174.0 x 120.0 cm
Kindly loaned by the Public Art Fund,
New York

Group Material and John Lindell
United States

Untitled [All People with AIDS are Innocent] 1989
exterior bus panel poster
photomechanical reproduction on plastic laminate
76.4 x 304.4 cm
Collection AmFAR (American Foundation for AIDS Research),
New York

Keith Haring
United States (New York)

Stop AIDS
Gravity Graphics T-Shirt
transfer on cotton
size: US XL
National Gallery of Australia, Canberra
Gift of AmFAR (American Foundation for AIDS Research), New York 1993

Keith Haring
(for ACT UP/New York)

Ignorance = Fear / Silence = Death / Fight AIDS / ACT UP 1989
colour screenprint on paper
61.0 x 109.5 cm
National Gallery of Australia, Canberra
International Print Archive
Gift of the Estate of Keith Haring 1993

Keith Haring died of AIDS-related complications in 1990

Robert Longo
United States (New York)

Men in the City 1993
American Foundation For AIDS
Research T-Shirt
transfer on cotton
size: US XL
National Gallery of Australia, Canberra
Gift of AmFAR (American Foundation
for AIDS Research), New York 1993

Robert Mapplethorpe
United States (New York)

Embrace 1982 (1989)
bus shelter poster
photomechanical reproduction on plastic
laminate
173.0 x 119.3 cm
Collection AmFAR (American
Foundation for AIDS Research),
New York

Robert Mapplethorpe died of AIDS-related
complications in 1989

Donald Moffett
United States (New York)

He Kills Me (In Memory of Diego Lopez)
1987
street poster
offset lithography and colour screenprint
on paper
3 panels, each 59.8 x 95.2 cm
National Gallery of Australia, Canberra
International Print Archive
Gift of Donald Moffett 1993

Call the White House (for ACT UP) 1990
offset lithography on card
14.3 x 29.1 cm
Private collection, Canberra

Kay Rosen
United States

AIDS – Assistance 1989
exterior bus panel poster
photomechanical reproduction on plastic
laminate
53.2 x 183.2 cm
Collection AmFAR (American
Foundation for AIDS Research),
New York

The Silence = Death Project
(for ACT UP/New York)
United States

Silence = Death 1987
T-shirt
transfer on cotton
size: US XL
Private collection, Canberra

Visual AIDS
United States (New York)

Untitled [Red AIDS Awareness Ribbon]
American Foundation For AIDS
Research T-Shirt
transfer on cotton
size: US L
National Gallery of Australia, Canberra
Gift of AmFAR (American Foundation
for AIDS Research), New York 1993

Albert Watson
United States

Mother's Day Card 1991
American Foundation for AIDS Research
T-Shirt
transfer on cotton
size: US L
National Gallery of Australia, Canberra
Gift of AmFAR (American Foundation
for AIDS Research), New York 1993

Brian Weil
United States (New York)

Prince, New York City 1989
bus shelter poster
photomechanical reproduction on plastic
laminate
173.0 x 119.3 cm
Collection AmFAR (American
Foundation for AIDS Research),
New York

Suzanne Wright
United States (New York)

Women Get AIDS Too 1989
subway advertising poster
colour screenprint on paper
28.0 x 56.8 cm
National Gallery of Australia, Canberra
International Print Archive
Gift of Richard Deagle 1993

AUSTRALIAN POSTERS AND COSTUMES

ACT UP/Melbourne
Australia

>Kissing Doesn't Kill 1990
>offset lithography on paper
>59.0 x 63.0 cm
>Private collection

>Kissing Doesn't Kill [Male version] 1990
>T-shirt
>screenprint on cotton
>size: XL
>Private collection

>Kissing Doesn't Kill [Female version] 1990
>T-shirt
>screenprint on cotton
>size: XL
>Private collection

>Shed the Underworld 1991
>photomechanical reproduction on paper
>59.9 x 42.6 cm
>National Gallery of Australia, Canberra
>Australian Art Archive
>Gift of Bruce Rolfe, Melbourne 1994

>STOP MEDIA LIES 1992
>offset lithography
>59.2 x 41.8 cm
>National Gallery of Australia, Canberra
>Australian Art Archive
>Gift of ACT UP/Sydney 1994

ACT UP/Sydney
Australia

>Silence=Death
>demonstration banner
>acrylic on canvas
>132.5 x 219.5 cm (irregular)
>National Gallery of Australia, Canberra
>Australian Art Archive
>Gift of ACT UP/Sydney 1994

ACT UP/Sydney
Australia
Ken Woodard (New York), designer

>AID$ NOW, 1988
>placard, silk screen and stencil
>45.4 x 60.4 cm
>National Gallery of Australia, Canberra
>Australian Art Archive
>Gift of ACT UP/Sydney 1994

AIDS Action Council, ACT
(with the assistance of ACT Health)
Australia (Canberra)

>FUCK SAFE, SHOOT CLEAN 1993
>offset lithography on paper
>59.0 x 63.2 cm
>National Gallery of Australia, Canberra
>Australian Art Archive
>Gift of AIDS Action Council, ACT 1994

AIDS Council of New South Wales
Australia (Sydney)

>Safe Injecting & Safe Sex
>Are in the Same Vein 1992
>photomechanical reproduction on paper
>43.0 x 59.3 cm
>National Gallery of Australia, Canberra
>Australian Art Archive
>Gift of AIDS Council of New South
>Wales 1994

AIDS Council of New South Wales
Australia (Sydney)
Juan Davila, designer

>RePlay 1993
>photomechanical reproduction on paper
>58.8 x 42.0 cm
>National Gallery of Australia, Canberra
>Australian Art Archive
>Gift of AIDS Council of New South
>Wales 1994

AIDS Council of New South Wales
Australia (Sydney)
Jamie Dunbar, designer

>Blasting? Use a New Fit for Every Hit 1994
>In Times of Grief and Loss Let's Face It
>Together 1994
>photomechanical reproductions
>on paper
>each 80.0 x 42.0 cm
>National Gallery of Australia, Canberra
>Australian Art Archive
>Gift of AIDS Council of New South
>Wales 1994

AIDS Council of New South Wales
People Living with HIV/AIDS,
New South Wales
Australia (Sydney)
Andrew Morgan, concept
Jamie Dunbar, photography

> *Posithiv Sexuality / Posithiv Sex Happens*
> 1993
> photomechanical reproduction on paper
> 60.0 x 42.0 cm
> National Gallery of Australia, Canberra
> Australian Art Archive
> Gift of AIDS Council of New South
> Wales 1994

AIDS Council of New South Wales
Australia (Sydney)
David McDiarmid, designer

> *Some of Us Inject, Some of Us Don't*
> *Always Use Clean Needles − Every Time!*
> 1992
> *Some of Us Get Out of It, Some of Us Don't*
> *All of Us Fuck with a Condom,*
> *Every Time!* 1992
> offset lithographs on paper
> each 67.0 x 44.5 cm
> National Gallery of Australia, Canberra
> Australian Art Archive
> Gift of AIDS Council of New South
> Wales 1994

Commonwealth Department of Human
Services and Health
Australia (Canberra)
Bronwyn Bancroft, designer

> *Prevention of AIDS* 1993
> *Education about AIDS* 1993
> *Caring for People with AIDS* 1993
> offset lithographs on paper
> 89.0 x 61.0 cm
> National Gallery of Australia, Canberra
> Australian Art Archive
> Gift of Commonwealth Department of
> Human Services and Health 1994

Commonwealth Department of Human
Services and Health
Aboriginal Health Workers of Australia
(Queensland)
Redback Graphics, designer

> *Condoman Says: Don't Be Shame, Be Game*
> *Use Condoms* 1987
> silkscreen on paper
> 76.0 x 50.8 cm
> National Gallery of Australia, Canberra
> Australian Art Archive
> Gift of Commonwealth Department of
> Human Services and Health 1994

> *You Don't Have To Be a Queenie*
> *To Get AIDS*
> silkscreen on paper
> 50.8 x 76.0 cm
> National Gallery of Australia, Canberra
> Australian Art Archive
> Gift of Commonwealth Department of
> Human Services and Health 1994

> *No Condom − No Way!*
> silkscreen on paper
> 50.8 x 76.0 cm
> National Gallery of Australia, Canberra
> Australian Art Archive
> Gift of Commonwealth Department of
> Human Services and Health 1994

F.A.G.S. (Fucking Angry Gays)
Australia (Sydney)

> *Street Blitz Stickers* 1991–93
> silkscreen on paper
> each 4.7 x 20.8 cm
> National Gallery of Australia, Canberra
> Australian Art Archive
> Gift of F.A.G.S. 1993

Ron Muncaster
Australia (Sydney)

> *Arabesque* 1991–92
> Best Costume, Sydney Gay & Lesbian
> Mardi Gras 1992
> ping-pong balls, place mats, rice balls,
> fibreglass rods, leather, gold mesh,
> sequins, gold foil sheeting, rubber
> galoshes
> dimensions various
> Kindly loaned by Ron Muncaster

Queen Sequina with Her Nicky in a Twist
1992–93
Best Group Costumes, Sydney Gay &
Lesbian Mardi Gras 1993
2 costumes, incorporating polystyrene
tubing, sequin braiding, fibreglass rods,
green sequin dress, lycra tights,
polystyrene boxes, plastic demi-balls,
lurex fabric, rubber galoshes
dimensions various
Kindly loaned by Ron Muncaster

Positive Women, Melbourne
Australia

Equilibrium presents "Unbridled"
a Benefit for Positive Women 1993
photomechanical reproduction on paper
59.4 x 41.8 cm
Kindly loaned by Bruce Rolfe,
Melbourne

Brian Ross
Australia (Sydney)

Man Crab 1992–93
Best Costume, Sydney Gay & Lesbian
Mardi Gras 1993
foam-core, aluminium, holographic
paper
175.0 x 250.0 cm
Private collection

Brian Ross died of AIDS-related complications
on 17 September 1994

Victorian AIDS Council/Gay Men's
Health Centre
Australia (Melbourne)

You'll Never Forget the Feeling of Safe Sex
1985
photomechanical reproduction on paper
60.0 x 42.0 cm
Loaned by Victorian AIDS Council/Gay
Men's Health Centre

When You Say Yes ... Say Yes To Safe Sex
1990
photomechanical reproduction on paper
59.4 x 42.0 cm
National Gallery of Australia, Canberra
Australian Art Archive
Gift of Victorian AIDS Council/Gay
Men's Health Centre, Melbourne 1994

Victorian AIDS Council/Gay Men's Health
Centre and Australian Federation of AIDS
Organisations

When I Told My Mum I Was Gay She
Blamed Herself. Now She Wants To Take All
the Credit. 1993
Yeah I'm Gay. Got a Problem with That?
1993
Which One of Us Is Gay? 1993
photomechanical reproductions on
paper
each 42.0 x 59.4 cm
National Gallery of Australia, Canberra
Australian Art Archive
Gift of Victorian AIDS Council/Gay
Men's Health Centre, Melbourne 1994

GLOSSARY

NB: Entries marked ♦ are based upon the glossaries provided by the *Bulletin of Experimental Treatments for AIDS* published by the San Francisco AIDS Foundation. Entries marked ♥ are drawn from Brigitte Weil's glossary in The Act Up/New York Women and AIDS Book Group, *Women, AIDS and Activism*, Boston: South End Press, 1990, pp.245–250.

ACON: the AIDS Council of New South Wales, Sydney.

ACT UP: the AIDS Coalition to Unleash Power, an activist group founded in New York in 1987 by Larry Kramer as 'a diverse nonpartisan group united in anger and committed to direct action to end the AIDS crisis'. Chapters are now found throughout the world.

♥ **AIDS (acquired immunodeficiency syndrome)**: a viral syndrome that impairs the body's ability to fight disease. The suppression of the immune system leads to a weakening of the body's defences against a variety of infections, viruses and malignancies.

♥ **ARC (AIDS-related complex)**: a loose categorisation of AIDS-related symptoms that are linked to HIV infection but are not included in the specific case definition of AIDS by the CDC.

♦ **AZT (Retrovir)**: zidovudine, also called azidothymidine. A thymidine (genetic building block) analog that suppresses replication of HIV. Adverse side effects may include anaemia, leukopenia, muscle fatigue, muscle wasting, nausea and headaches.

♦ **Antibody**: a protein substance, developed in response to an antigen, that destroys or neutralises bacteria, viruses, toxins or other agents recognised as foreign. This antigen/antibody reaction forms the basis of immunity.

♦ **Antigen**: a substance that stimulates an immune response. The immune system recognises these substances as being foreign, and produces antibodies to 'fight' them.

♥ **CDC (US Centres for Disease Control)**: federal agency of the Public Health Service (US) whose mandate is to track the incidence and trends of communicable diseases and also certain noninfectious diseases. Its responsibilities include disease surveillance, licensing of clinical laboratories, conducting research, and training epidemiologists and health workers.

♦ **CMV (cytomegalovirus)**: a virus in the herpes family. CMV infection can occur without causing symptoms. In people with advanced HIV disease, CMV may reactivate to cause blindness, pneumonia, colitis, nerve tissue inflammation and/or death.

♥ **Dental dam**: a square sheet of latex marketed for dentists and dental hygienists that can be used during mouth-to-vagina or mouth-to-anus contact to prevent transmission of HIV or other sexually transmitted diseases.

♦ **FDA**: the Food and Drug Administration (US), the agency of the United States federal government responsible for the regulation of drug development and approval for distribution.

GRID: gay-related immune deficiency, an early and erroneous American name for AIDS.

♥ **HIV (human immunodeficiency virus)**: a slow-acting virus that is thought to be the sole or foremost causative agent of AIDS.

♥ **HIV positive/HIV infected**: terms describing a person who has been exposed to and is infected with HIV. Also known as seropositive. This status is determined by a positive lab test for HIV antibodies in the blood.

♦ **KS (Kaposi's Sarcoma)**: an abnormal growth in the walls of blood vessels visible through the skin and/or mucous membranes. KS typically appears as pink to purple, *usually* painless spots on the surface of the skin, but it can also occur internally.

♦ **Lesions**: any abnormal change in tissue caused by disease or injury.

♥ **Opportunistic infections**: infections caused by organisms that do not normally cause infections in people with healthy immune systems, but take advantage of an immune system that is suppressed.

Patient Zero: Gaetan Dugas, a French-Canadian airline steward for Air Canada, posited erroneously by Randy Shilts as one of the first North Americans diagnosed with AIDS. See Randy Shilts, *And the Band Played On: Politics, People and the AIDS Epidemic*, New York: St Martin's Press, 1987.

♦ **PCP (*Pneumocystis carinii* pneumonia)**: a life-threatening form of pneumonia that occurs in people with suppressed immune systems.

PLWA: person/people living with AIDS, a term used commonly in Australia.

PLWHA: person/people living with HIV/AIDS, a term also used commonly in Australia.

PWA: person/people with AIDS, a term used commonly in the United States

♥ **Seroconversion**: initial development of antibodies specific to a particular antigen; for example, the development of antibodies to HIV.

♥ **Side effect**: an unintended effect of a drug, mostly undesirable, harmful, or toxic.

VAC: the Victorian AIDS Council, Melbourne.

ACKNOWLEDGEMENTS

A team of warm and committed individuals around the world contributed to the production of both this book and the exhibition which preceded it. I would especially like to thank the following:

In Australia: Richard Perram, Roslyn Oxley, Jonathan Turner, Peter Smith, Jill Bennett, John Turner, David Thomson (1955–1994), Jim Gainsford, Brendan Delahunty, Phil Hunter, John Hedberg, Fred Oburg, Barbara Farrelly, Peter Elfes, Russell Smethurst (1954–1993), Graham Carberry, Chris Gill, Suellyn Luckett, Terry Thorley, Philip Kryszka, Stuart Cameron, Stephen Iverach, Helen Lightburn, Sue Stevenson, Robert Gott, Terry Young, Kirk Peterson, Bruce Rolfe, Bjarne Norden, Graeme Clarke, John Ballard, Rivera Morton-Rajckowski, Stephen Jones, Jeffrey Grad, Tracey Coulter, Marge Macilwain, Kirsty Machon, Lyle Chan, Matthew Gillett, Chris Ashcroft, Stuart Young, Doerthe Jansen, Anne Malcolm, David Edler, David Phillips, Leon Osborne, David Hannah, Ian McMillan, Sue Rowley, Ricky Lyons, Gabe Bilicka, Derek Hand, Craig Judd, Alan Thorpe, Rosalie Woodruff, Judy Silver, Ron Handley, Rose Lorimer, Stephanie Reeder, Ainslie Yardley, Ray Naismith, everyone at PLWA Canberra.

In the United States and Canada: Rick Jacobsen, Richard Deagle, Donald Moffett, Tom Kalin, Pat Hearn, Mary Boone, Sally Cox Morrison, Elizabeth Reid, Gayle Rubin, Brooks Johnson, Danny Lee, Denise Fasanello, Catherine Saalfield, Jennifer E. Jones, Donna Binder, John Giorno, G'dali Braverman, Nadine, David Stark, Diane Neumaier, Andrew H. Arnot, Richard Anderson, Dianne Chisholm, Sarah Ward, Susan Foley Johannsen, Mark Simpson, Bill Cole, Lynn Richardson, Shannon Kelley, Gregg Bordowitz, Jeff Hagedorn, Kim Tomczak, Jim Kepner.

In Great Britain and Europe: Anatole Orient, Emmanuel Cooper, Ian Rashid, Lutz Hieber, Stacey Abbott, Peter Ride, Robin Vousden, Adam Mars-Jones, Michele Field, Hamad Butt, Fiona Cunningham Reid, Simon Light, Richard Salmon.

Just as the exhibition 'Don't Leave Me This Way: Art in the Age of AIDS' was prepared with a more-than-usual degree of haste and one eye continually on the clock, given the encroachment of AIDS upon the lives of a number of artists whose work appears in these pages, so too was this present volume. I am particularly grateful to our editor Pauline Green and designer Kirsty Morrison, whose enthusiasm and commitment to the project has resulted in this handsome publication. Jane Hyden thoroughly monitored rights and reproduction issues. Suzie Campbell oversaw the project carefully from start to finish.

Jeni Allenby, Assistant Curator, International Art, supervised the collation of the wealth of visual material which surrounds this, sadly, gargantuan topic. Roger Leong, Assistant Curator, International Decorative Arts, shored up many areas of concern at the eleventh hour of this undertaking. My intern on this publication and exhibition, Lucina Ward simply had a hand in everything. This project is as much hers as mine.

Sarah·Rennie, Assistant Registrar (Transport and Location) and Michelle McMartin, Acting Assistant Registrar (Lending Program) worked tirelessly to ensure the smooth handling of insurance, loan and transport arrangements for the hundreds of works in the exhibition 'Don't Leave Me This Way'.

I am indebted for advice and encouragement on many levels to all my curatorial colleagues at the National Gallery of Australia, in particular: Michael Brand, Roger Butler, Wally Caruana, Christopher Chapman, Christine Dixon, Kate Davidson, Michael Desmond, Mary Eagle, Tim Fisher, Jane Kinsman, Robyn Maxwell and Gael Newton. Alan Dodge, Manager, Special Exhibitions, offered sound support at every turn.

Staff throughout the National Gallery committed themselves to ensuring the success of this project; and special thanks are owed to my colleagues in the following departments, who all worked very closely on aspects of 'Don't Leave Me This Way: Art in the Age of AIDS'. Photography: Bruce Moore, Brenton McGeachie, Eleni Kypridis, Willi Kemperman; Conservation: Trevor Hoyne, Erica Burgess, Micheline Ford, Allison Holland, Geoffrey Major, Bronwyn Ormsby, Beata Tworek-Matuszkiewicz, Debbie Ward; Public Affairs: Jan Meek, Inge Rumble, Helen Power; Registration: Warwick Reeder, Tess Cashmore, Darryl Collins, Mark Van Veen; Storage and Locations: Valerie Alfonzi, Suzanna Edwards, Bruce Howlett, Bernie Kaak; Corporate Services: Jenny Peachey; Education: Sue-Anne Wallace, Louise Katz, Peter Naumann, Barbara Brinton, Jenny Manning; Administrative support: Elizabeth Malone, Lyn Conybeare, Jay Sargent, Kathryn Weir; Switchboard: John Payne; Library: Margaret Shaw, Gillian Currie, Helen Hyland, John Thomson, Kathleen Collins, Ellen Cordes; Production Manager: Stefanie Pearce; Publications: Bev Swifte, Shirley Purchase, Sybilla Wilson, Lesley Cameron, Helen Ulrich; Travelling exhibitions: Ron Ramsey, Vivienne Dorsey, Jude Savage, Mary-Lou Lyon; Records Management: Kay Richards, Garry Neylon, John Upton; Exhibitions and Design: Ren Pryor, Jos Jensen, Harijs Piekalns; Installation staff: Lloyd Hurrell; Peter Vandermark; Mountcutting: Shulan Birch, Fiona Kemp; Security: Jim Ponting, Sandra Williams, Doreen Kite; Computer Support: Joy McCleary, Janene Burgess; Travel Clerk: Alice Hendry; Bookshop: Ron Serduik.

I would like to take this opportunity to warmly thank the agencies who at such short notice granted us permission to reproduce the song lyrics by Jimmy Somerville and The Communards which grace these pages: Rondor Music (Australia) Pty Ltd, and EMI Music Publishing Australia; particular thanks are offered to Caroline Riddell, Print Music Manager, EMI, and Bob Aird, Managing Director, Rondor Music.

. Ted Gott
National Gallery of Australia

INFORMATION RESOURCE SERVICES
UNIVERSITY OF WESTMINSTER
HARROW IRS CENTRE
WATFORD ROAD 2700096 1487
HWICK PARK
ROW HA1 3TP